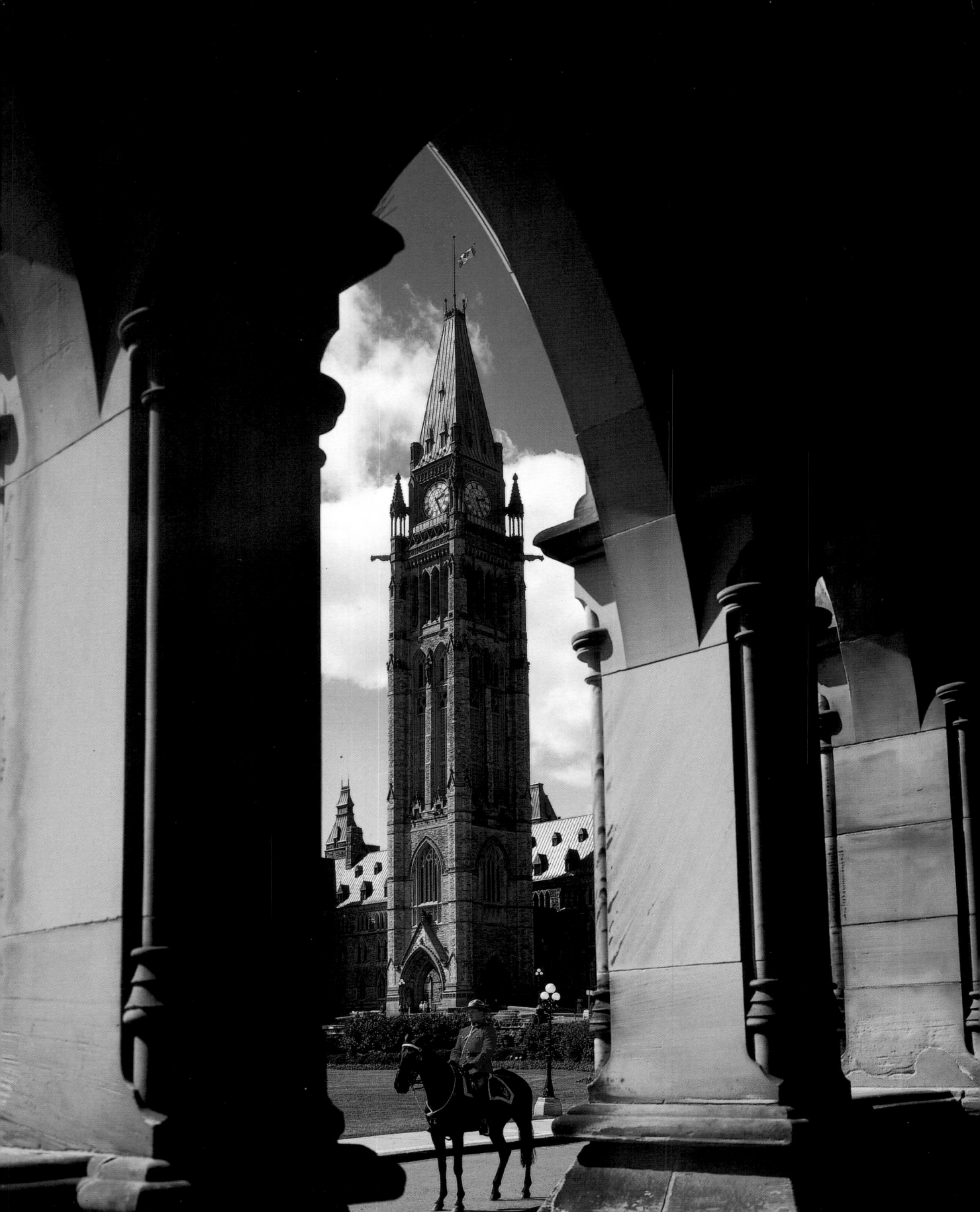

The Parliament Buildings

photography
MALAK

preface by Mark Bourrie

KEY PORTER BOOKS

Canadian Cataloguing in Publication Data

Malak
 The Parliament Buildings

ISBN 1-55263-114-1

1. Parliament Buildings (Ottawa, Ont.) – History. 2. Parliament Buildings (Ottawa, Ont.) – Pictorial works. I. Bourrie, Mark, 1957- . II. Title.

NA4415.C22O77 1999 725'.11'0971384 C99-931503-X

The publisher gratefully acknowledges the support of the Canada Council for the Arts and the Ontario Arts Council for its publishing program.

THE CANADA COUNCIL | LE CONSEIL DES ARTS
FOR THE ARTS | DU CANADA
SINCE 1957 | DEPUIS 1957

We acknowledge the financial support of the Government of Canada through the Book Publishing Industry Development Program (BPIDP) for our publishing activities.

Canada

Key Porter Books Limited
70 The Esplanade
Toronto, Ontario
Canada M5E 1R2

www.keyporter.com

Electronic formatting: Jean Lightfoot Peters
Design: Peter Maher
Printed and bound in Canada

99 00 01 02 03 6 5 4 3 2 1

Page 1: Parliament Hill framed in the snow-covered boughs of an Ottawa Valley white pine.
Title page: Two of Canada's most famous symbols: a Royal Canadian Mounted Police officer and the Peace Tower.

Contents

Foreword / 6

Preface / 9

Vistas of Parliament / 24

The Centre Block / 32

The House of Commons / 48

The Senate / 59

The Library of Parliament / 72

The East and West Block / 84

Foreword

It has been a joyful experience for me to photograph our parliament buildings on countless occasions over the past sixty years. Whether coated with a thick layer of snow, surrounded by a cloud of mist, or hugged by the early green leaves of spring and the vibrant colours of autumn, the parliament buildings continue to beckon and challenge me for yet another picture.

However, in my mind and heart, Parliament is not only that noble stone structure crowning the hill rising from the Ottawa river and certainly it is not only the house of our lawmakers and politicians but is the

visionary and inspiring home of every Canadian who dreams and cherishes our high quality of life, freedom and justice. The parliament buildings are an inspiration to achieve more and higher for ourselves and the world.

Every year, nearly one million people of all ages, cultures and languages visit our parliament buildings to feast their eyes on the beautiful neo-Gothic architecture of our national treasure, and many of them nourish their minds and hearts on what democracy and Parliament stand for. I am proud to present this modest tribute to our national symbol.

Malak O.C.

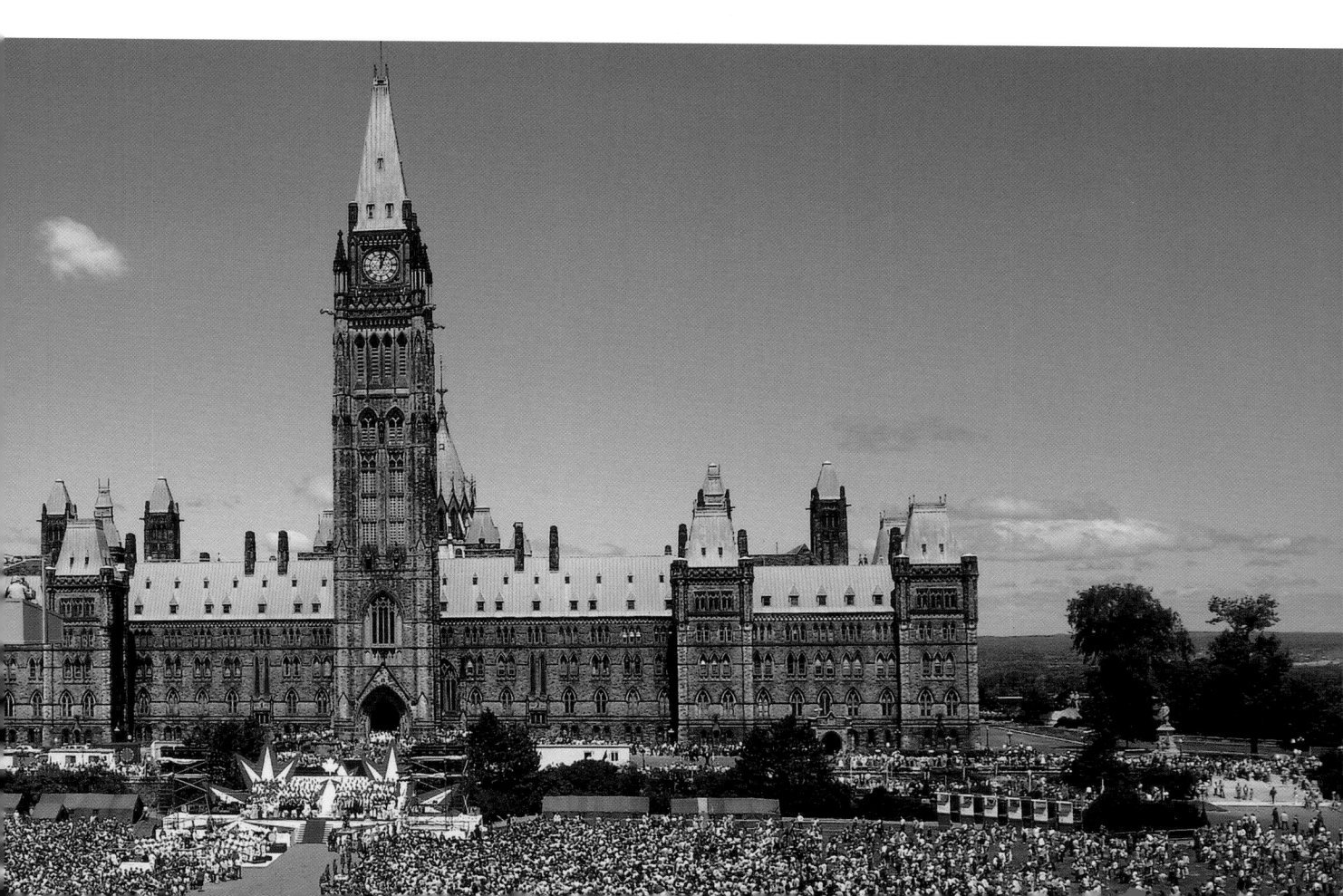

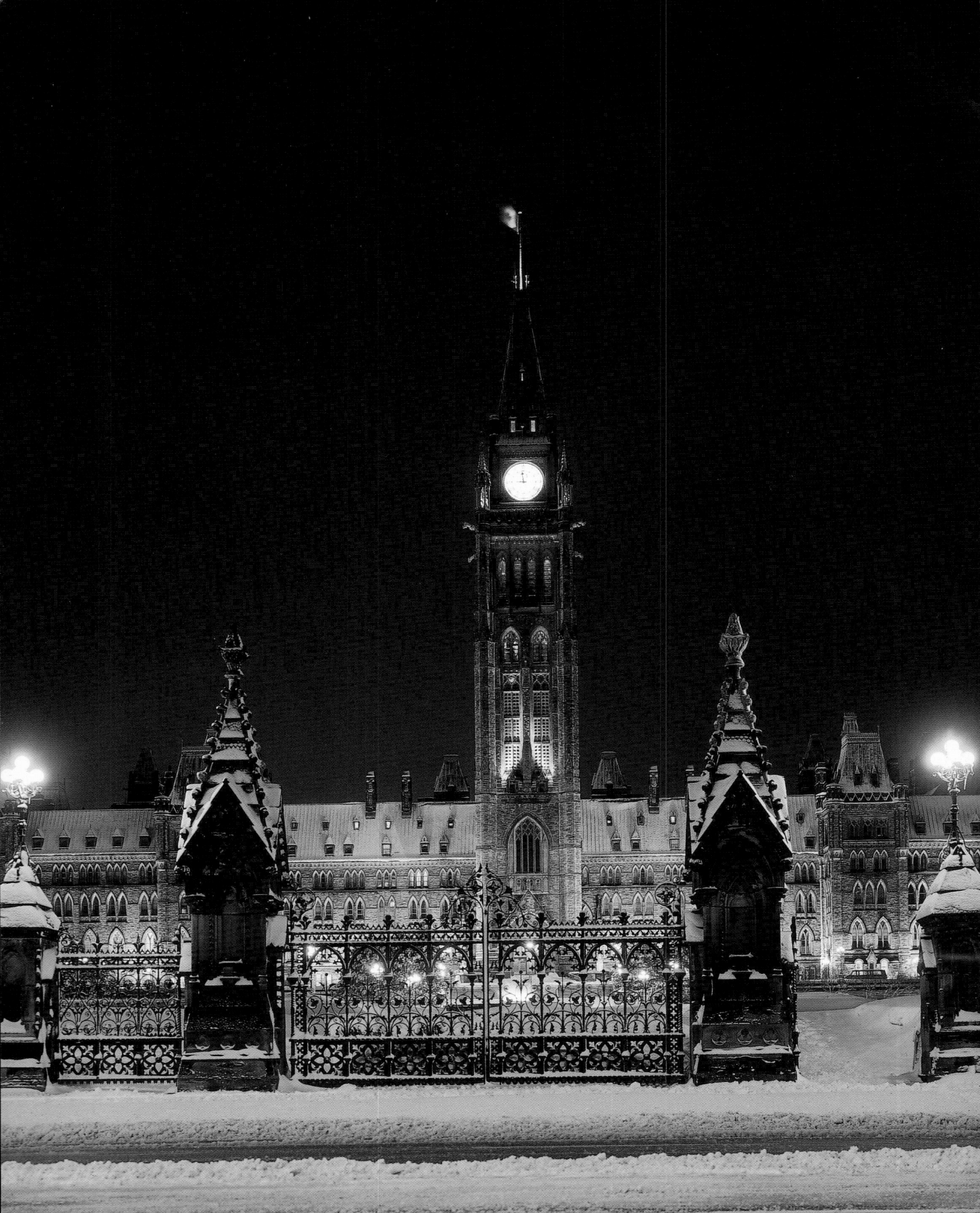

Preface

In 1841, Lower Canada (now Quebec) and Upper Canada (now Ontario) were united by the British Parliament as the Province of Canada. Its legislature moved between Quebec City, Montreal, Kingston and Toronto, each of which vied to be the permanent capital of the province. Every change of capital meant an expensive and inconvenient move, not only for the members of the legislature but also for the legislative officials and senior government staff. Even library collections and parliamentary furniture had to be packed up and shipped. The premier of the province and its most senior politicians usually lived in boarding houses during legislative sessions because of the futility of trying to put down roots in a temporary capital.

At this time, in the mid-nineteenth century, the clearing of the virgin white pine forest was pushing the frontier away from the Great Lakes–St. Lawrence Valley. The Aboriginal peoples who had lived in the Ottawa Valley since the end of the last Ice Age had shown fur traders and missionaries the Ottawa River canoe route that linked the St. Lawrence River to the West. The Rideau Canal, built between 1826 and 1831, and officially opened in 1832, was designed to bring British troops and supplies into Upper Canada in case of invasion. By the time Queen Victoria was asked to choose a permanent capital for the united province, Bytown and neighbouring Hull were booming, and some-

The ornamental wrought-iron fences of Parliament Hill add to the elegance of the Centre Block on a snowy Ottawa night.

what rowdy, little lumber towns at the confluence of the Rideau Canal and the Ottawa River.

Bytown's strategic location on the boundary between Upper and Lower Canada, inland from the United States border but on water routes to the major cities, put it into the running as a potential capital. Its bid was helped by a glowing report of the beauty of the region given to the Queen by one of her friends, Governor General Sir Edmund Head. Nevertheless, when Bytown was chosen, many Canadians were unpleasantly surprised. At first, the government of the Province of Canada rejected the idea.

The construction of the legislative buildings began in 1859 and ended with the opening of the Legislative Assembly of the Province of Canada in 1866. The completed buildings quickly drew converts. The neo-Gothic style of the architecture, with stone towers and spires reaching skyward from the crest of the limestone cliffs, made the new legislative complex one of the most beautiful in the world. Gothic buildings were, in the Middle Ages, a way of communicating. Statuary, carvings and heraldry were used in medieval churches and public buildings to tell Biblical stories, tales of heroism and of the triumphs of kings, and moral allegories. Similarly, Canada's Parliament Buildings were designed to use artistry to record the development of the country. Gargoyles, stone faces, statues, animals, ironwork and other imagery record Canada's natural, social and political history.

These buildings have evolved continuously since 1865. The most sudden and dramatic change came when the Centre Block, except for the Library, was destroyed by fire in 1916. The original Centre Block was much smaller than today's building, and the Victoria Tower at its main entrance was lower and more ornate than the modern Peace Tower. The most striking differences, however, were inside the building. The original Centre Block was a warren of wooden-walled apartments, offices, meeting rooms, and a Reading Room filled with newspapers and records. It was linked to the library by a set of iron doors.

At 9 p.m. on February 3, 1916, a fire started in the Reading Room and spread rapidly to the wooden walls. A quick-thinking librarian slammed the iron doors shut, saving the Library. Pushed by a northeast wind, the fire soon reached the House of Commons. MPs scrambled for their lives as flames shot through the lobbies and stairwells. As the fire spread, senators, building staff and firefighters saved some of the furniture from the Senate side. The clock in the Victoria Tower kept tolling out the hours as firefighters tried to control the blaze. Then, at the height of the fire, the clock's great bell crashed to the ground. It was later retrieved and given an honoured spot on the crest of the cliff.

The most precious artifact rescued from the building was the portrait of a young Queen Victoria by John Partridge. The picture already had a charmed existence, having survived three earlier fires. It had been rescued when a mob burned the Parliament Building in Montreal in 1849, was

Following page: Each spring, over twenty-two thousand tulips bloom in front of the Parliament Hill Peace Tower. They are an annual gift from the Dutch people expressing thanks to Canada for its hospitality during the wartime exile of members of the Dutch royal family in Ottawa.

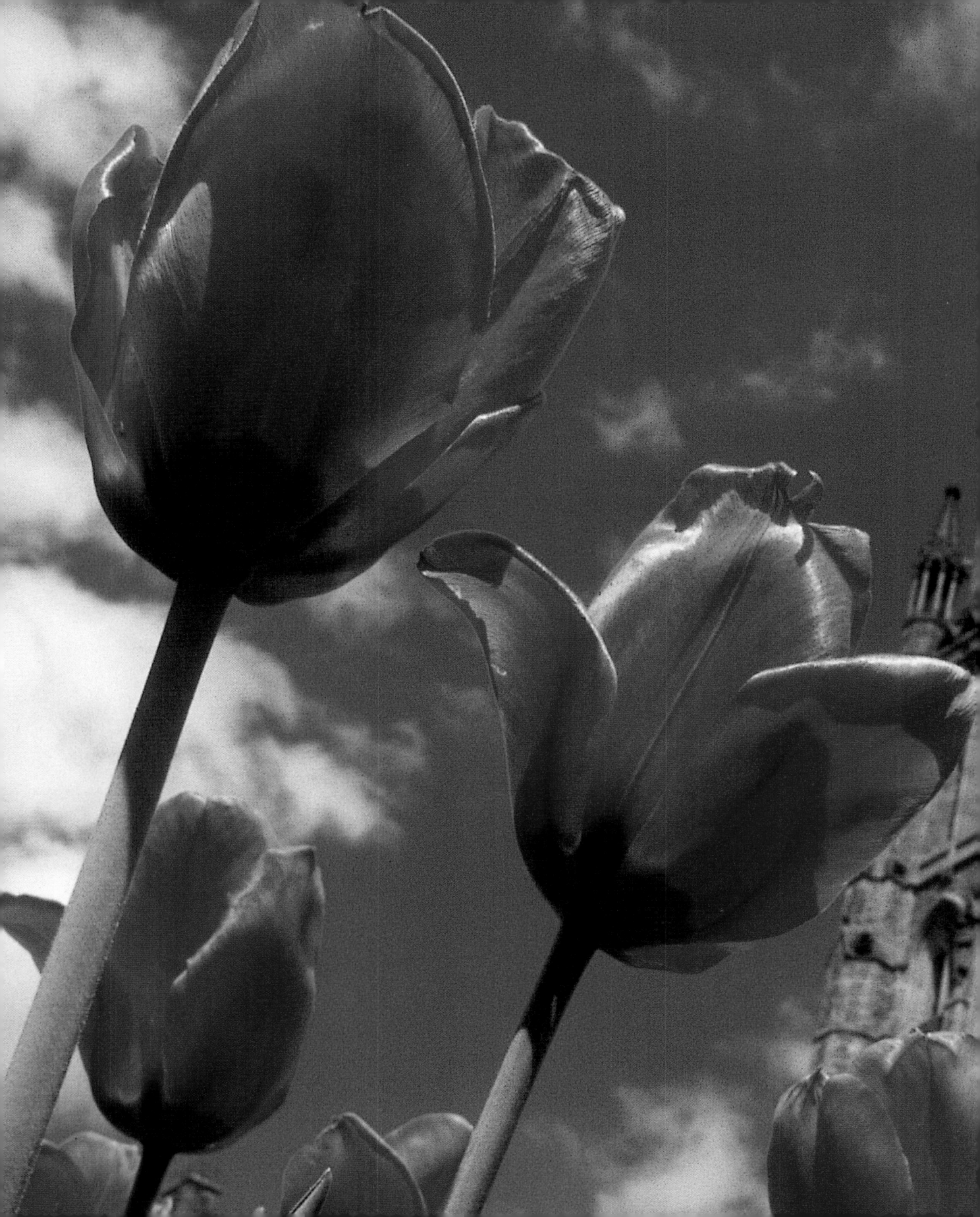

saved again when the hotel where it was stored caught fire, and was snatched from the burning Quebec City Parliament a few years later.

Seven people died in the 1916 fire. Parliament was forced, in this gloomy time midway through World War I, to move to the Victoria Museum (now the Canadian Museum of Nature). The surviving walls of the Centre Block were too badly damaged to be used in the reconstruction, so the ruins were demolished. The Governor General, Arthur, Duke of Connaught, re-laid the cornerstone; he was the brother of the late king, Edward VII, who as Prince of Wales had laid the original cornerstone in 1860. After four years of construction, Parliament was able to move back into the Centre Block in 1920.

We owe an eternal debt of gratitude to the resourceful librarian who closed the iron doors and saved the Library of Parliament, a gem in high Victorian Gothic Revival style, which was completed in 1876. Hundreds of flowers, masks and mythical figures are carved into the Library's white pine panelling. The floor is intricate parquet of oak, cherry and walnut. A full-length statue of Queen Victoria, carved in white marble, dominates the room. Above the statue rises the Library's magnificent lantern, with a cupola decorated in gold leaf.

With Confederation in 1867, there was a larger public service to be headquartered. So, in the mid-1870s, the West Block was expanded and the tall Mackenzie Tower was built. Over the succeeding decades, the various government departments moved to buildings throughout the

National Capital Region and to other cities in Canada, and the West Block now houses committee rooms and the offices of cabinet ministers, MPs and support staff.

The East Block was, until the 1960s, the political centre of Canada's government. It had offices for the governor general, the prime minister, the cabinet and senior ministers of early governments, such as Sir George-Étienne Cartier, the political partner of Sir John A. Macdonald, who led the Quebec delegation in the Confederation conferences. These historical offices have been carefully restored and are open to the public. Since the prime minister's office was moved to the Langevin Building directly across Wellington Street, the East Block has mainly served as offices and committee rooms for senators, cabinet members, MPs and parliamentary support staff.

The Centre Block—the centrepiece of Canadian democracy, which reopened in 1920 after the fire—is also a modern office building. The prime minister's legislative office is on the third floor, to the south of the foyer of the House of Commons. The offices of the Speaker of the House of Commons, the government house leader, the leader of the official opposition and the leaders of Canada's smaller opposition parties are in the west side of the Centre Block. East of the Confederation Hall and the Hall of Honour, which divides the building, are the offices of the Senate Speaker, the government and opposition leaders of the Senate, and many senators.

Sculptors continued to work on the interior of the Centre Block long after Parliament returned to the Hill in 1920. The ornate Confederation Hall, with its wavy blue stone floor tiles, representing the oceans, and the coats of arms of Canada and the provinces, depicting the nation, is the most striking example of their work. Other impressive sculptures in stone are found throughout the building. Just off the Hall of Honour is a lovely bronze statue by Rodin, a gift to Canada from the government of France for coming to that nation's aid during World War I.

The House of Commons, to the left of the Confederation Hall, is where Canada's elected representatives meet to make laws. The chamber is decorated in green, in the tradition of Britain's House of Commons. Its stained glass windows depict provincial flowers in brilliant colours. Extinct animals are carved into walls of 450-million-year-old Manitoba limestone, itself filled with fossils from an ancient sea. Along the chamber's sides are depictions of the important roles of governments. The ceiling is a masterpiece of hand-painted linen.

The Speaker of the House of Commons sits in the large green chair at the north end of the chamber. Members of the government sit to the right of the Speaker. To the left are the desks of opposition MPs. The press gallery is above the Speaker's chair. Seats are reserved in the other galleries for guests of the Speaker and of MPs, for the diplomatic corps, senators and their guests, and the public. On the table in front of the

Speaker rests the mace, symbol of Parliament's power. The original mace was lost in the 1916 fire. London's Guild of Goldsmiths incorporated gold salvaged from the original into the replacement they made. In the House of Commons foyer is the wooden mace that was used during Parliament's years in the museum. It is used in the House of Commons each February 3 as a reminder of the fire.

The Senate, with its red decor harkening back to Britain's House of Lords, is Parliament's upper chamber. Paintings portraying Canadian soldiers in World War I hang on its walls. The beautiful gold leaf ceiling, set with heraldic imagery, augments the rich sculpture, furniture and carpeting. Two bronze chandeliers, each weighing two tonnes, light the chamber. Canada's throne, used by the Queen or the governor general at the opening of Parliament and when bills are given royal assent, stands behind the Speaker's chair. To its left is a smaller throne for the consort of the sovereign or the spouse of the governor general.

Throughout the building are pieces of whimsy: the faces of the sculptors wearing Viking helmets in the Senate foyer; the carving of a golden dog gnawing a bone over the House of Commons door, commemorating a pub in Quebec City long favoured by politicians; the delightful gargoyles playing medieval instruments on the Peace Tower, who just happen to resemble the building's architects. Small carved heads throughout the Centre Block commemorate Canadians who contributed to their country, and the designers of the building have left

Following page: Parliament Hill on a summer night, from the Hull side of the Ottawa River: a view of the Centre Block, with the Library of Parliament and the Peace Tower, and the West Block's Mackenzie Tower on the right.

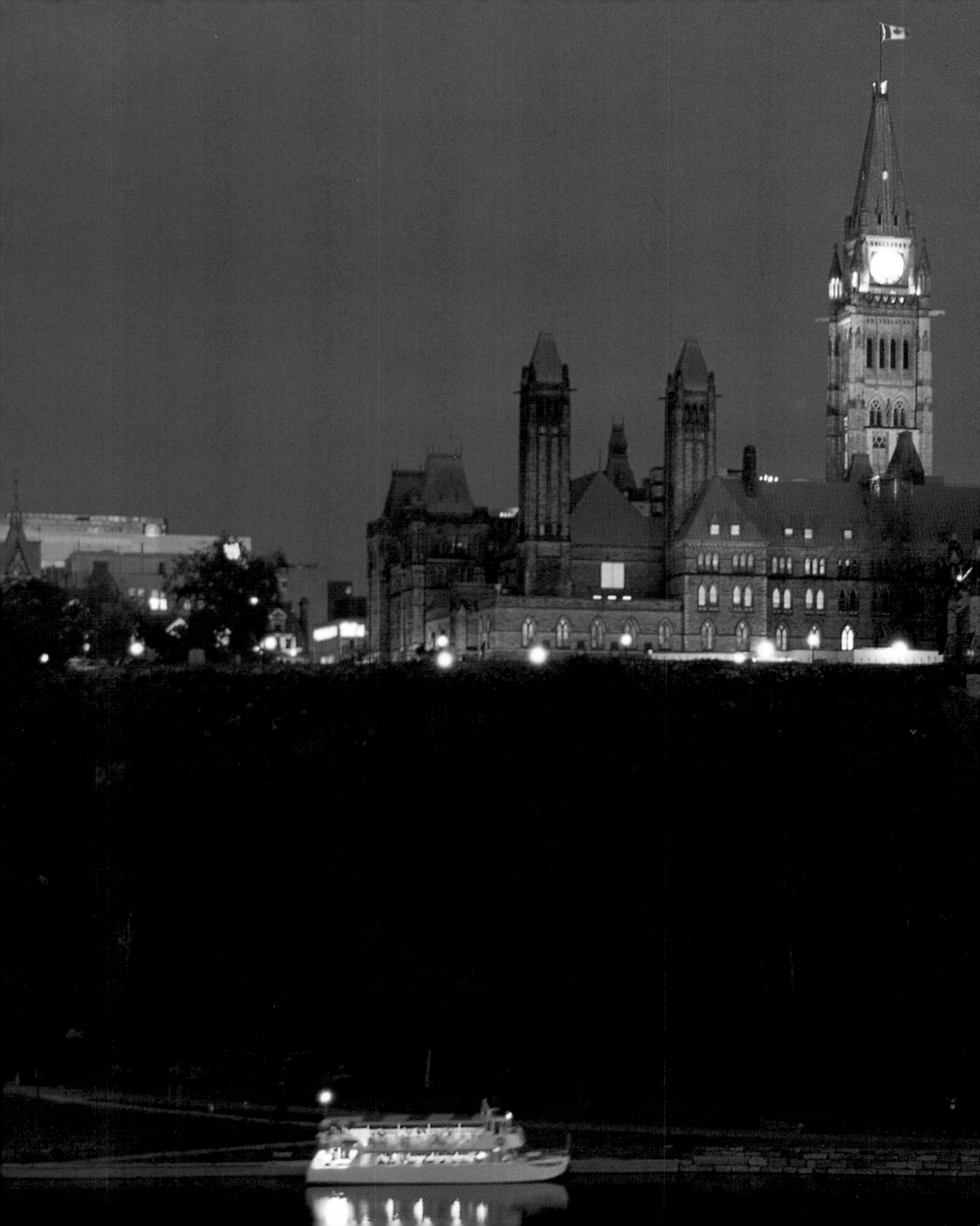

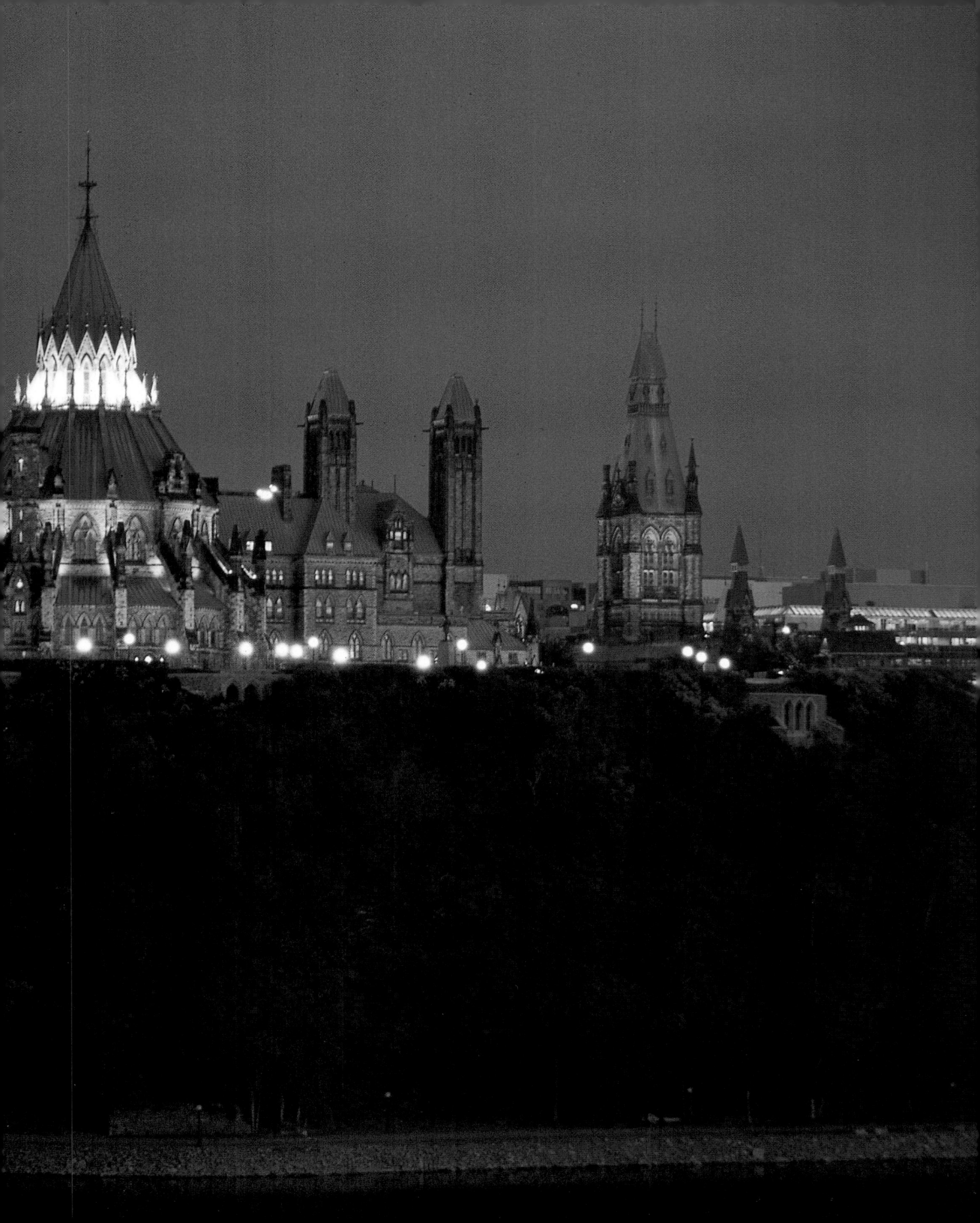

room for many more, so that the Centre Block remains a living, evolving monument.

The Peace Tower was completed in 1927. Within the tower is the Memorial Chamber, perhaps the most sacred secular space in Canada. The chamber is elaborately sculpted with the names of the battlefields of World War I. Beautiful books with exquisite calligraphy on their parchment pages record the names of every Canadian killed while serving in the armed forces and merchant marine. Each day, in a solemn ceremony, the pages of these books are turned, so that the names of all of Canada's war dead are shown at least once each year. Even the animals that served in World War I are commemorated: the dogs and pigeons that carried dispatches, the birds used to sense gas attacks, the horses that hauled supplies to the trenches and pulled the heavy artillery. A carillon of fifty-three carefully tuned bells makes the Peace Tower a giant musical instrument, one that is played with a keyboard partway up the structure.

Visitors to Parliament Hill should try to spend some time exploring its grounds. A charming pagoda dedicated to officers who lost their lives while on peacekeeping duty offers a breathtaking view of the Chaudière Falls and the Museum of Civilization. Statues of several prime ministers and politicians who struggled for responsible government and Confederation ring the Centre Block. Among them is a bronze image of D'Arcy McGee, the Irish rebel who became a Father of

Confederation and was assassinated on nearby Sparks Street. Cast at a Belgian foundry in 1914, it had to be buried when German soldiers occupied the region during World War I. Had it been discovered, it would have ended up as shell casings. After the Allied victory, it was finally shipped to Canada.

Despite the evolution of the buildings on Parliament Hill, the architectural vision of the original planners and builders has been respected. Parliament Hill was designed to be a place that would instill pride in Canadians. Its architects succeeded in creating buildings that inspire visitors with a sense of the majesty of Canada and the ancient traditions of parliamentary government. The buildings record in stone the history of Canada and the desire of its people for peace, order and good government.

Carvings of Tyndall and Indiana limestone in the House of Commons foyer, portraying Canada's history from the arrival of the Native peoples to that of the Loyalists.

Following page: The National Capital Region's rich autumn colours draw thousands of visitors to the Ottawa Valley. The Peace Tower and the Mackenzie Tower reach skyward through the multicoloured canopy.

Vistas of Parliament

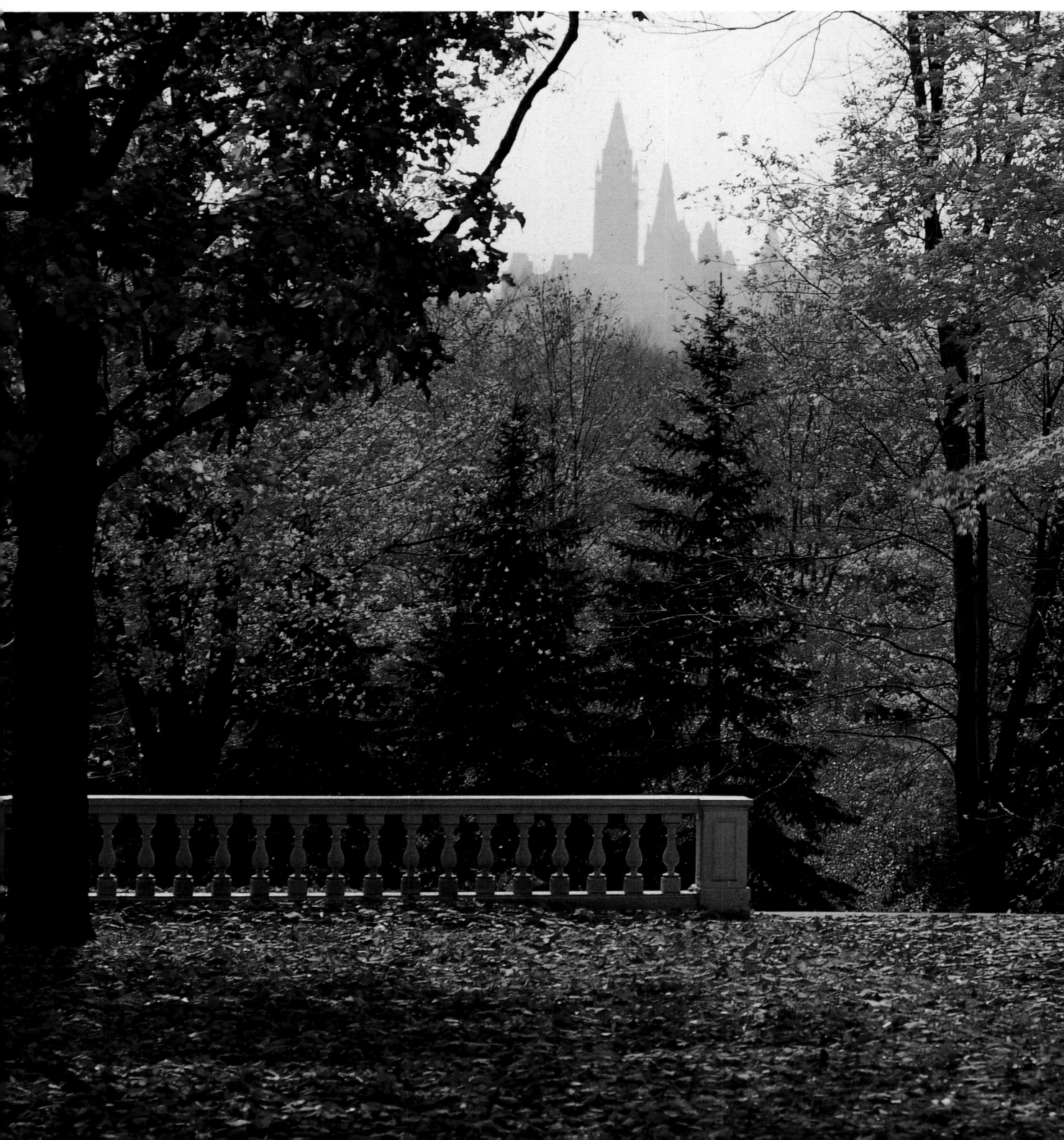

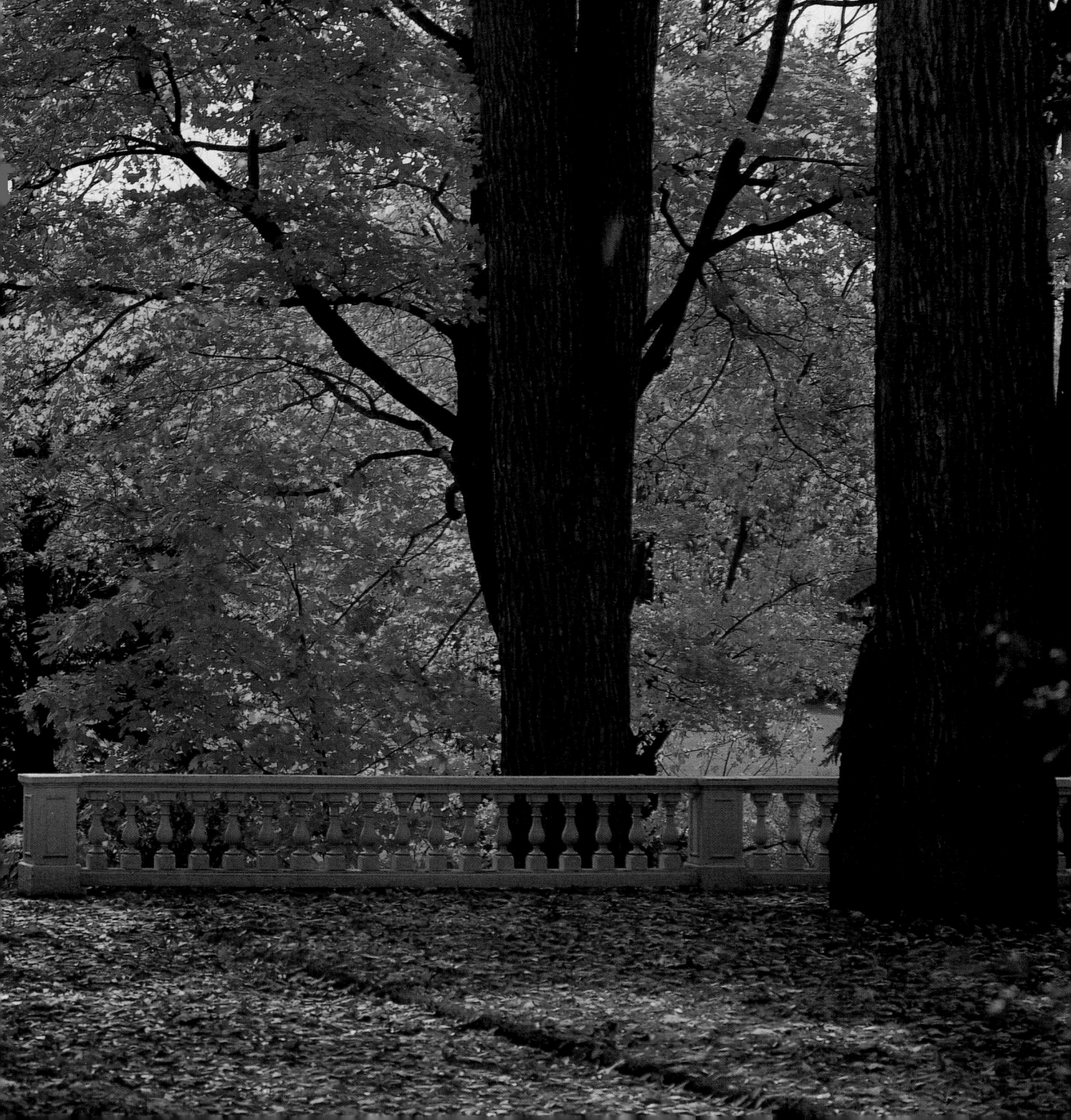

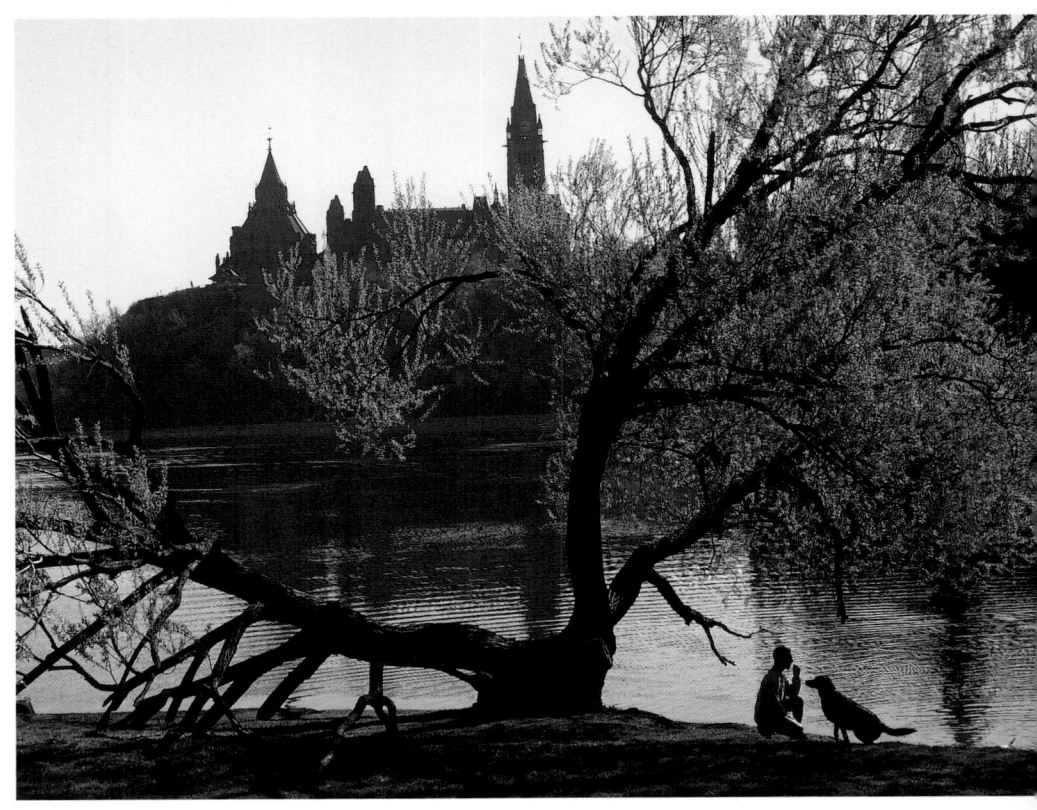

Above: Parliament Hill from Major's Hill Park, highlighting the Peace Tower and the Library of Parliament.

Right: The ribbon of parkland along the Ottawa River is an oasis of calm and quiet in the middle of the busy capital.

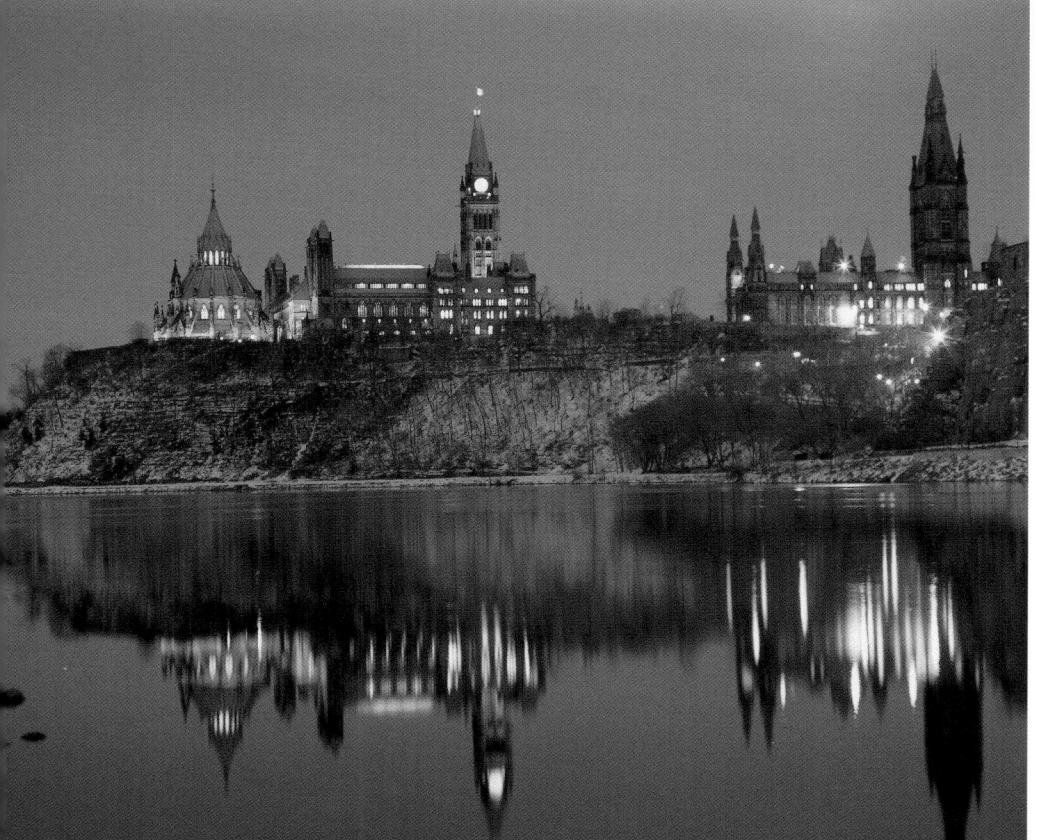

Above and left:
Parliament Hill changes
dramatically with each
season. Flowering trees,
fragrant lilacs and the
dazzling colours of the
capital's tulip beds are
sharp contrasts to the
stark winter that ended
only a few weeks earlier.

Following page: A full
moon rises over the
Centre Block on a hot
summer night.

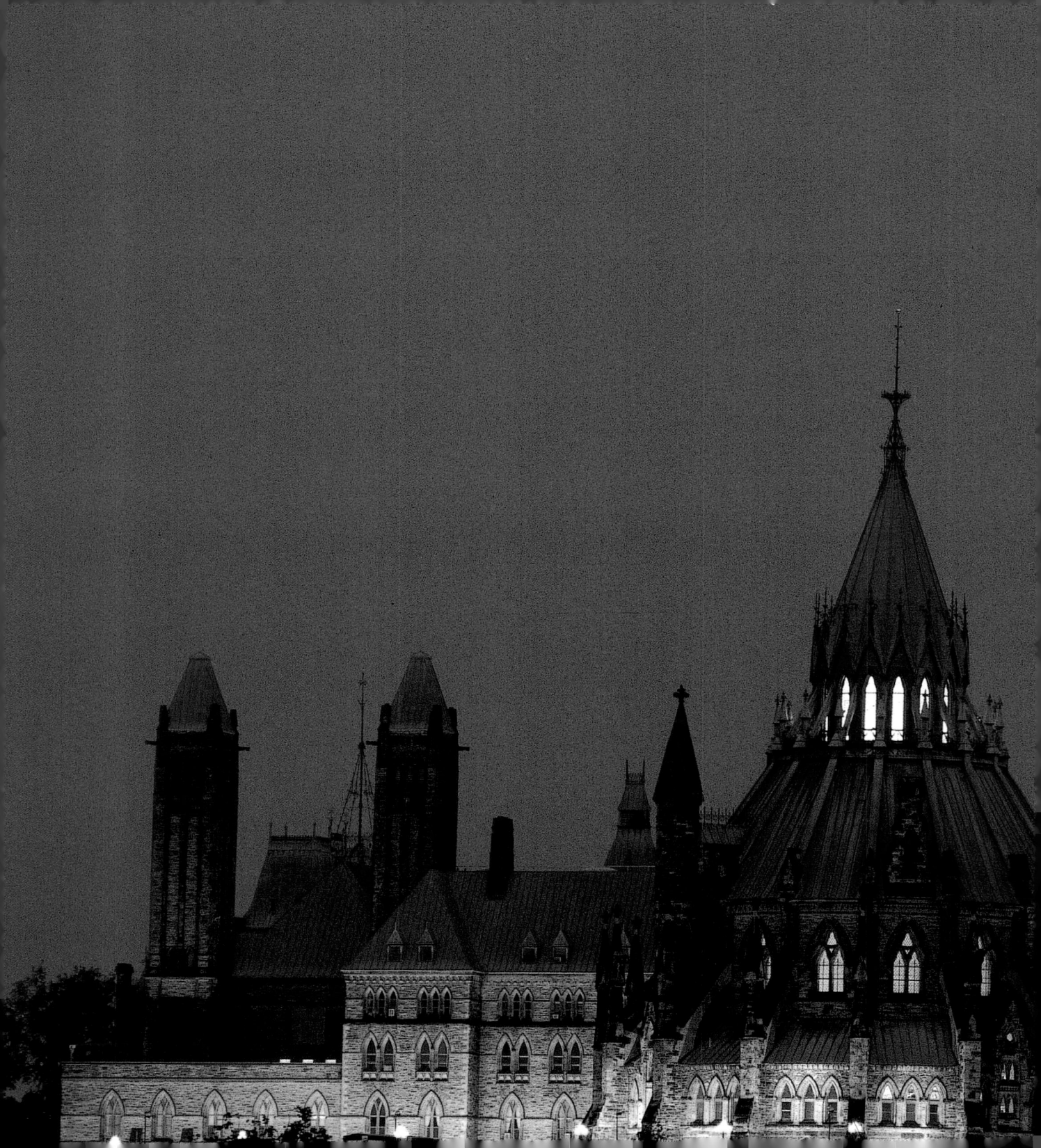

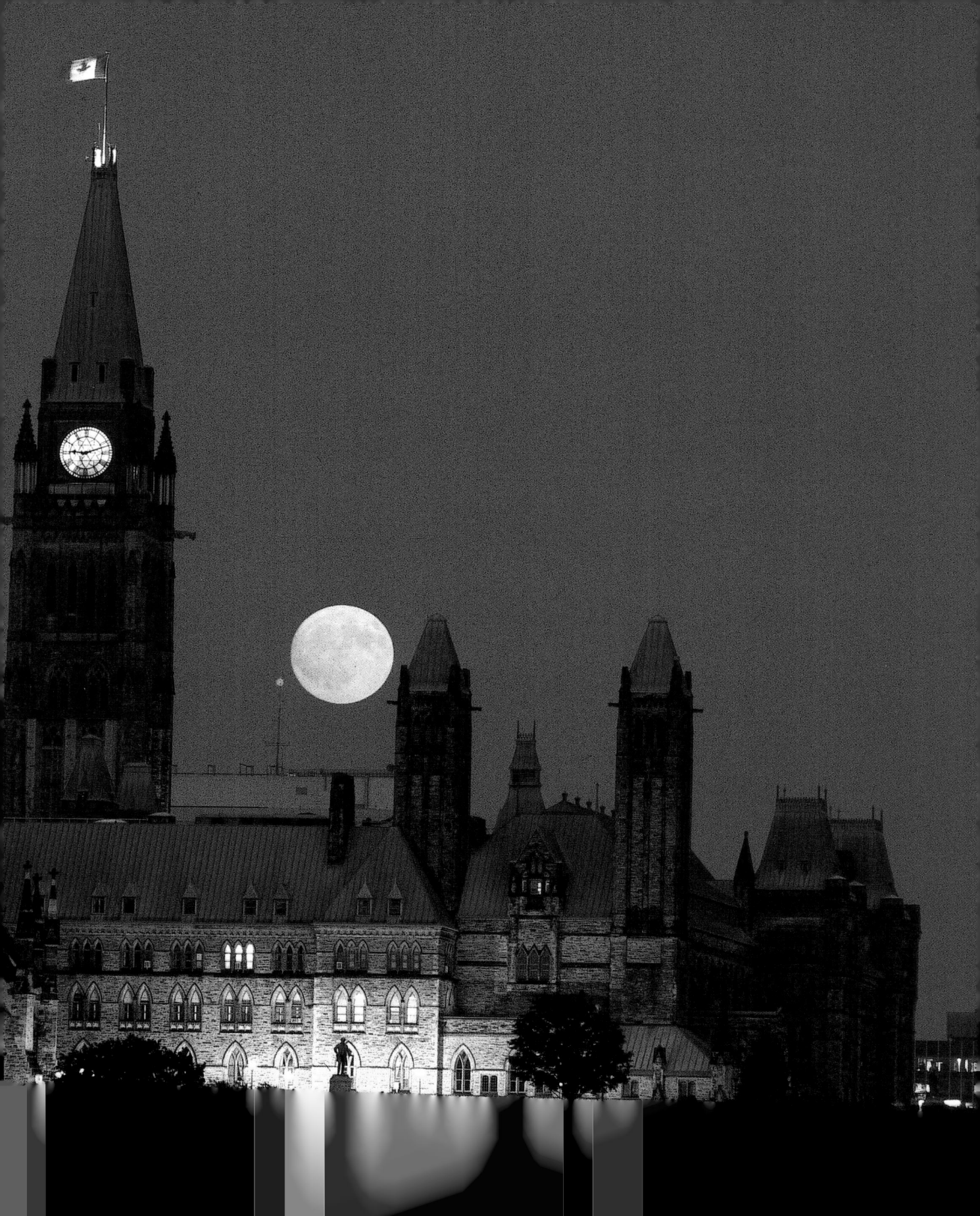

In the summer, flower beds add to Parliament Hill's loveliness. They contrast sharply with a view of the parliamentary precinct on a frigid day, when steam rises from a still-unfrozen Ottawa River.

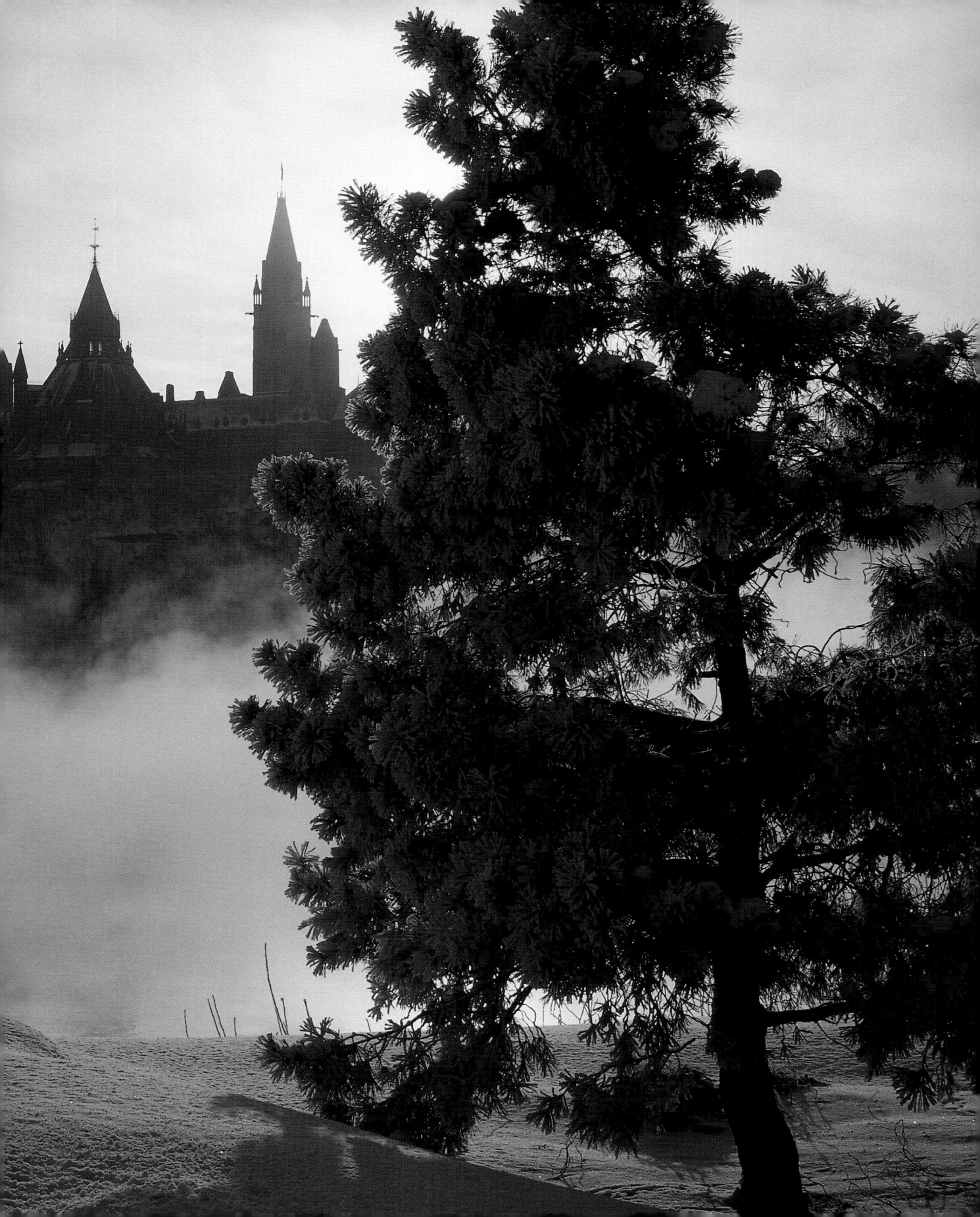

The Centre Block

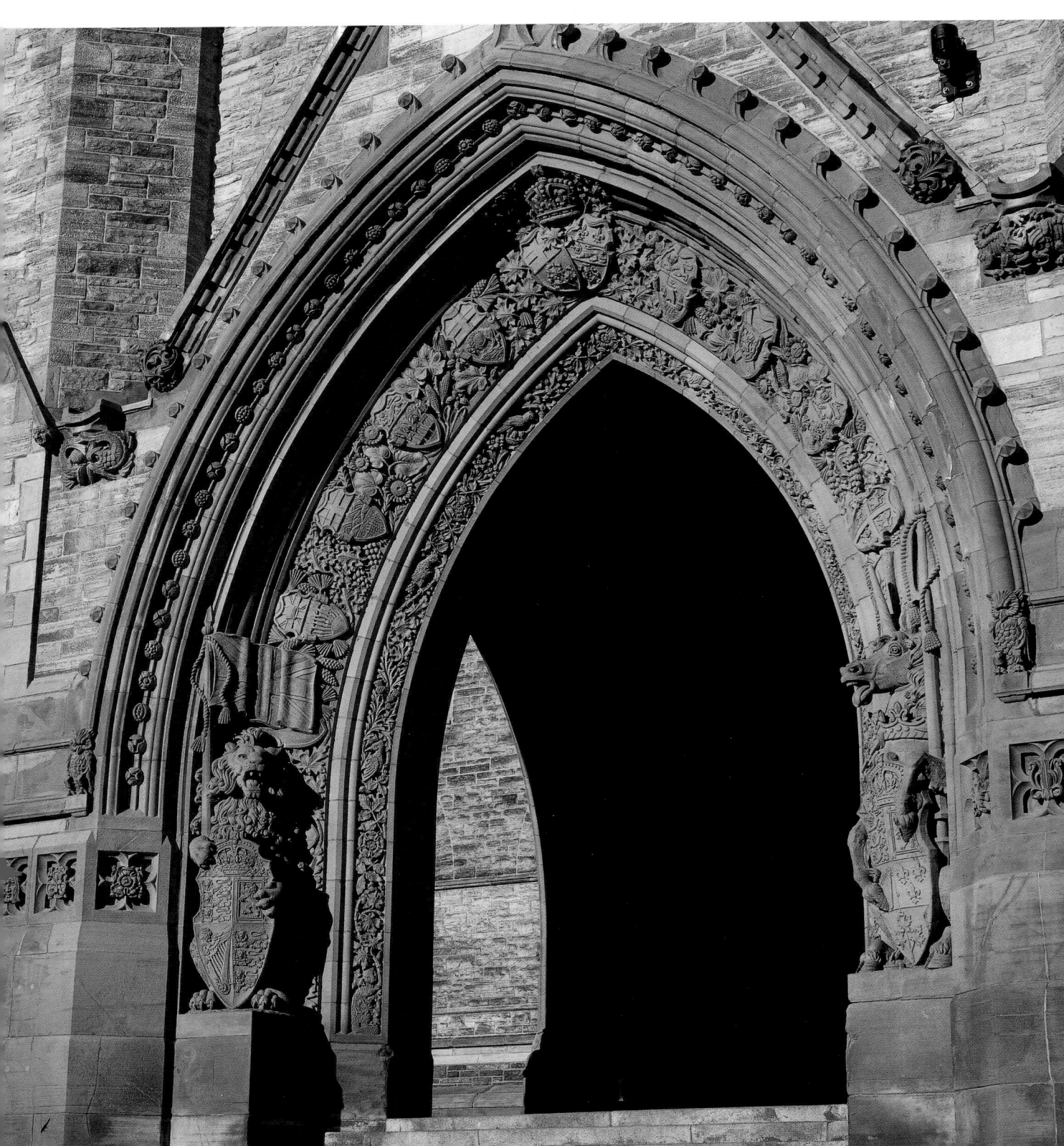

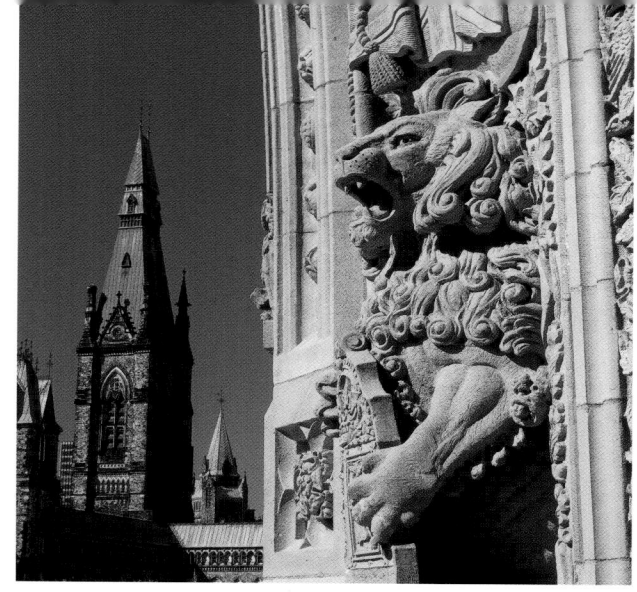

Top left: A lion, an ancient heraldic symbol, guards the main door of the Centre Block

Below: The Hall of Honour links the Library of Parliament to the Confederation Hall and divides the Centre Block into the House of Commons (West) and Senate (East) sides.

Played by an expert carillonneur, the finely tuned bells of the carillon make the Peace Tower a musical instrument that can be heard throughout the capital's downtown.

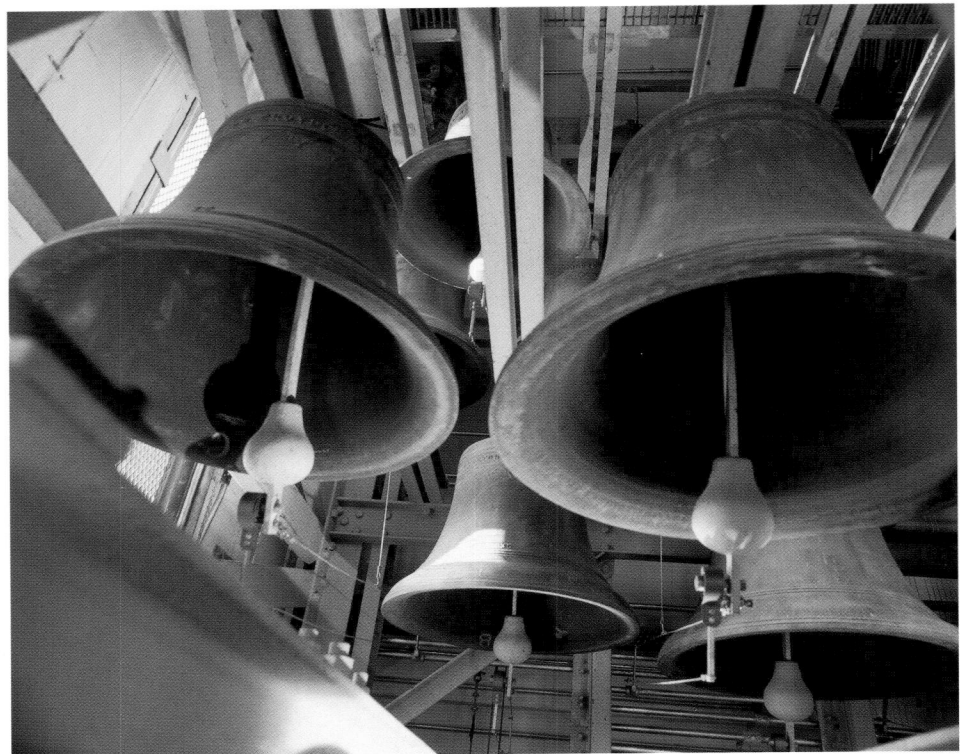

A plaque near the doors of the Library of Parliament commemorates the London negotiations that led to Confederation in 1867.

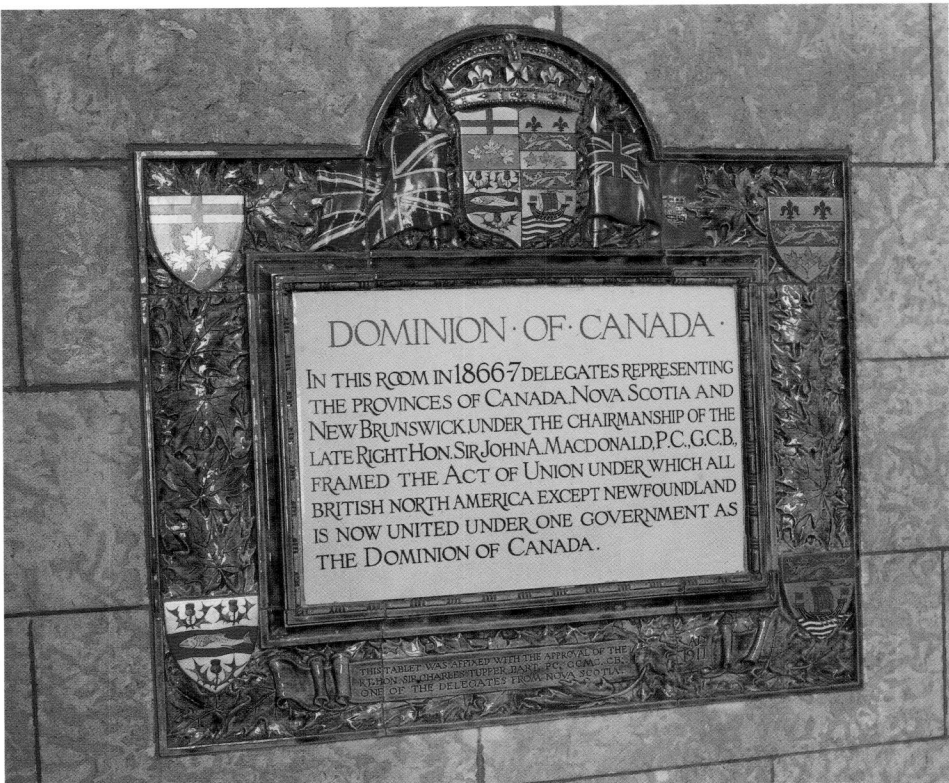

DOMINION·OF·CANADA·

IN THIS ROOM IN 1866-7 DELEGATES REPRESENTING THE PROVINCES OF CANADA, NOVA SCOTIA AND NEW BRUNSWICK, UNDER THE CHAIRMANSHIP OF THE LATE RIGHT HON. SIR JOHN A. MACDONALD, P.C., G.C.B, FRAMED THE ACT OF UNION UNDER WHICH ALL BRITISH NORTH AMERICA EXCEPT NEWFOUNDLAND IS NOW UNITED UNDER ONE GOVERNMENT AS THE DOMINION OF CANADA.

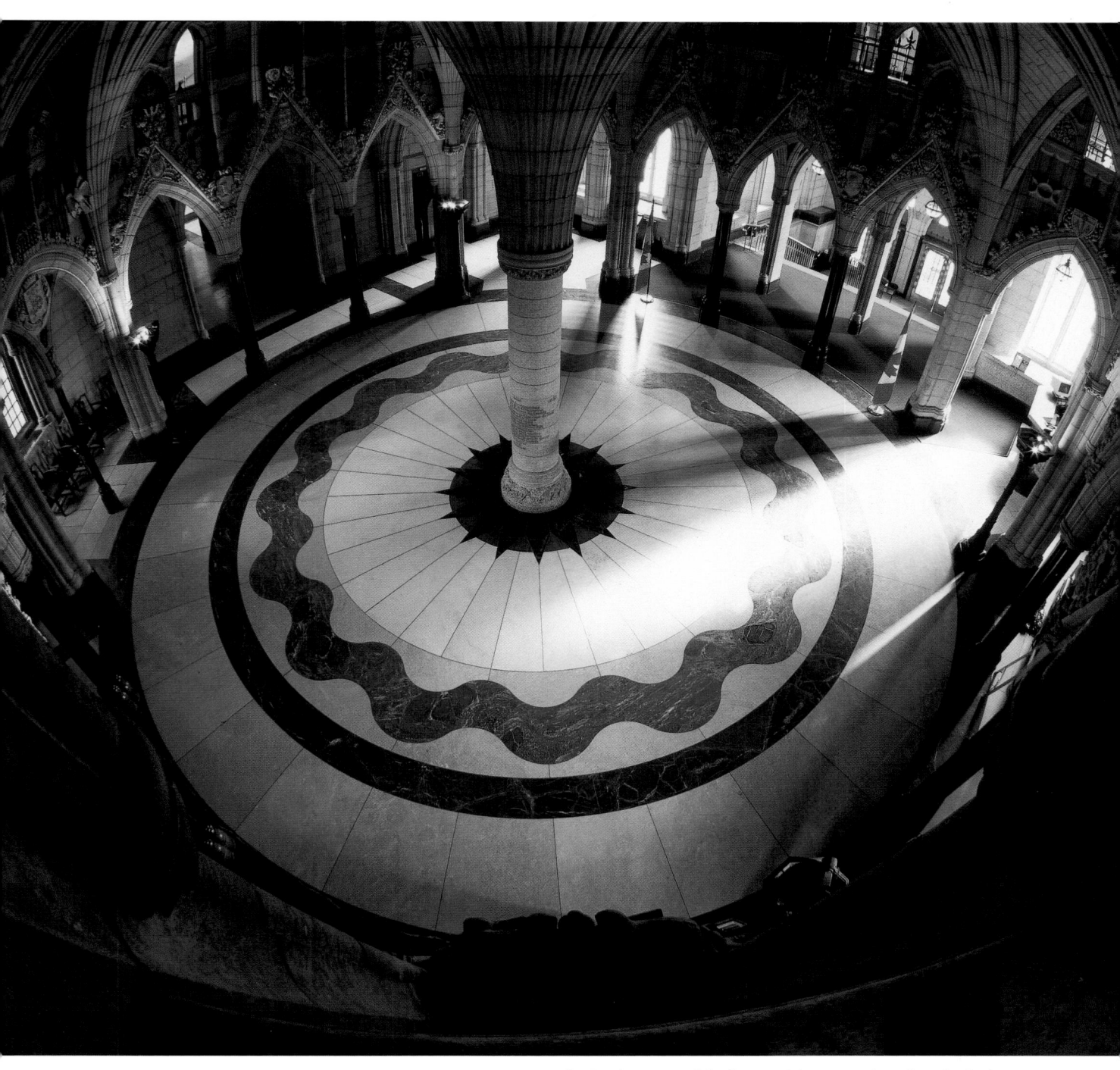

An intricate marble floor with a wavy band and wind-rose design representing the sixteen points of a mariner's compass adorns Confederation Hall.

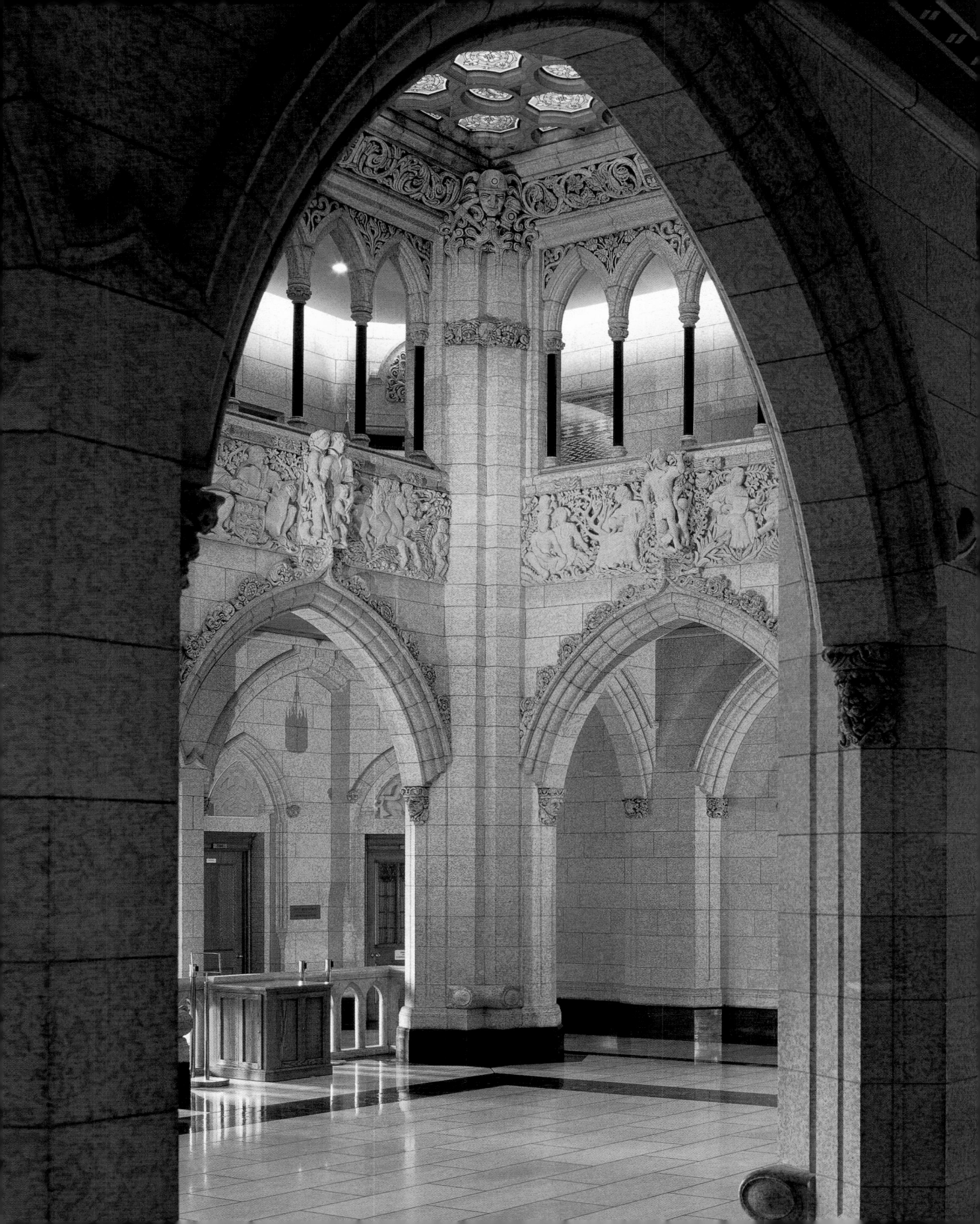

Left: The story of Canada's peoples is told in the artistic and symbolic stone carvings of the foyer leading to the House of Commons Chamber.

Below: The face of a Native Canadian is one of the historical images carved into the walls of the Peace Tower.

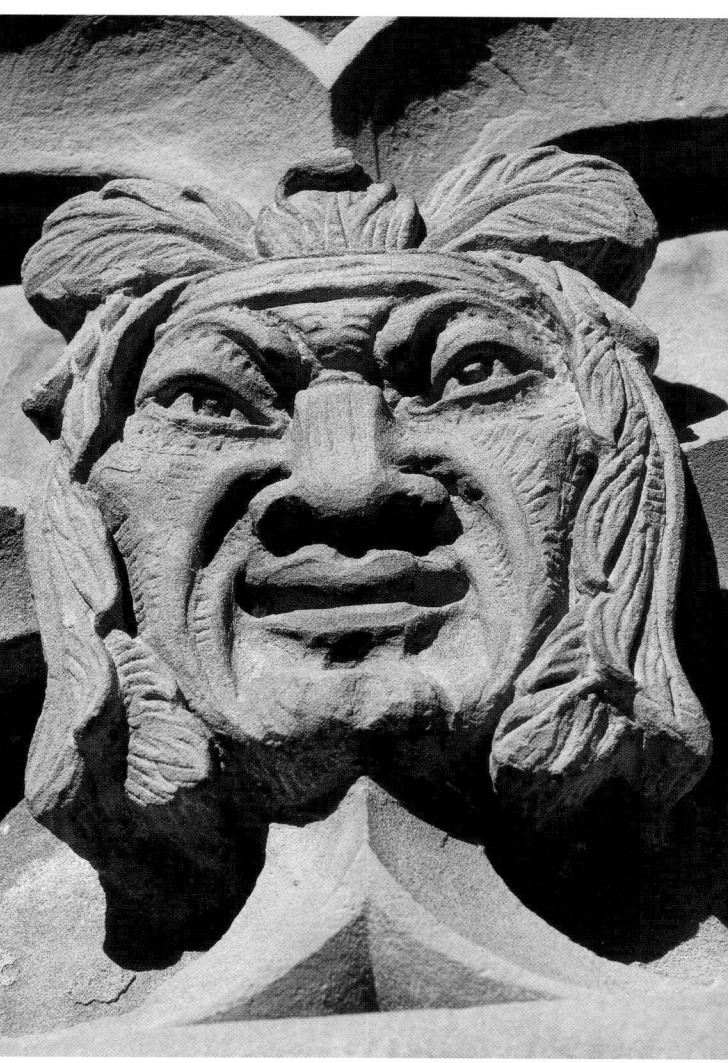

Right: Tadadaho, the snake-haired wizard who helped form the first Iroquois government centuries ago, looks down from a wall in the House of Commons entrance hall.

Opposite page: Exquisite wrought-iron gates, Château Gaillard stone and fine sculptures decorate the entrance to the Memorial Chamber in the Peace Tower.

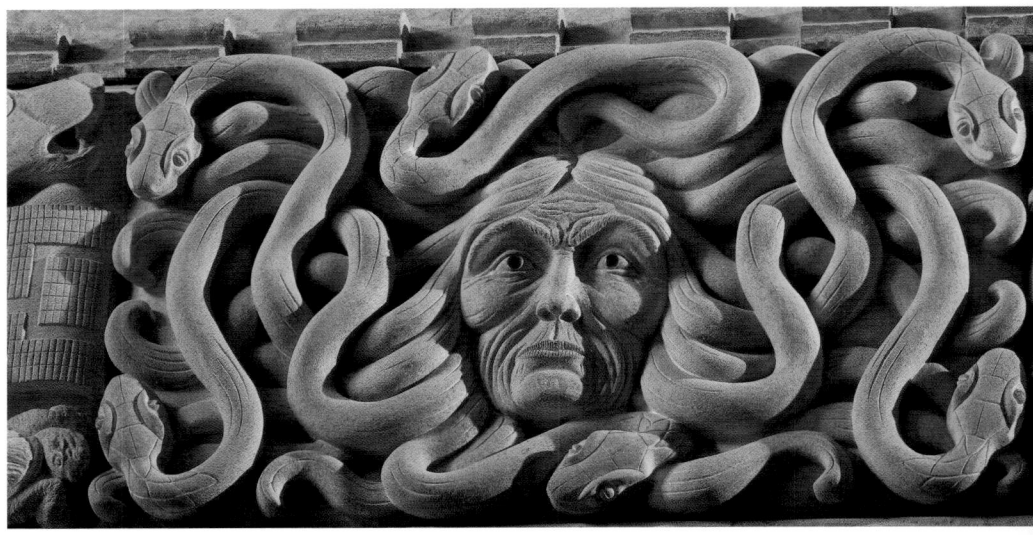

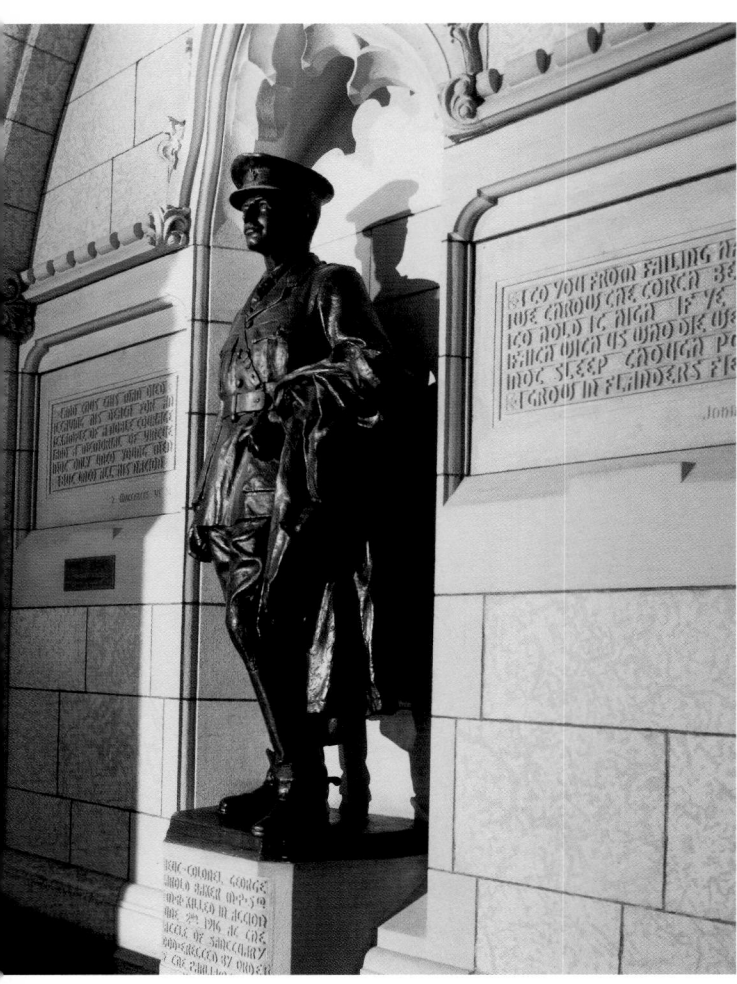

Lt. Col. George Harold Baker, who was killed during World War I while a Member of Parliament, is commemorated by this statue in the House of Commons foyer.

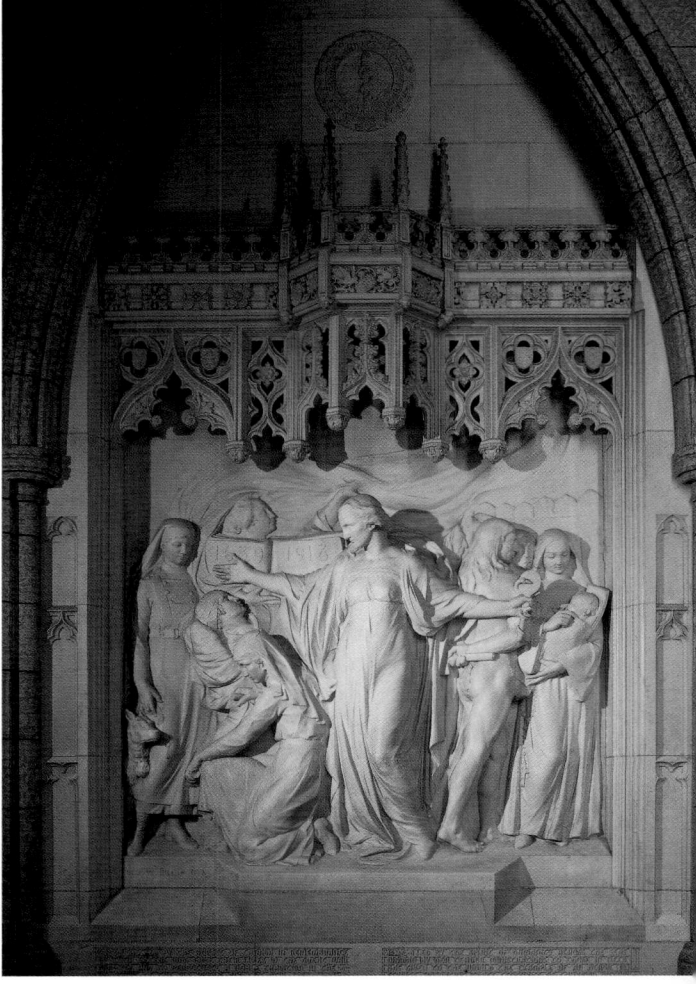

The Canadian Nurses Memorial sculpture commemorates nursing in Canada from 1639 to 1918.

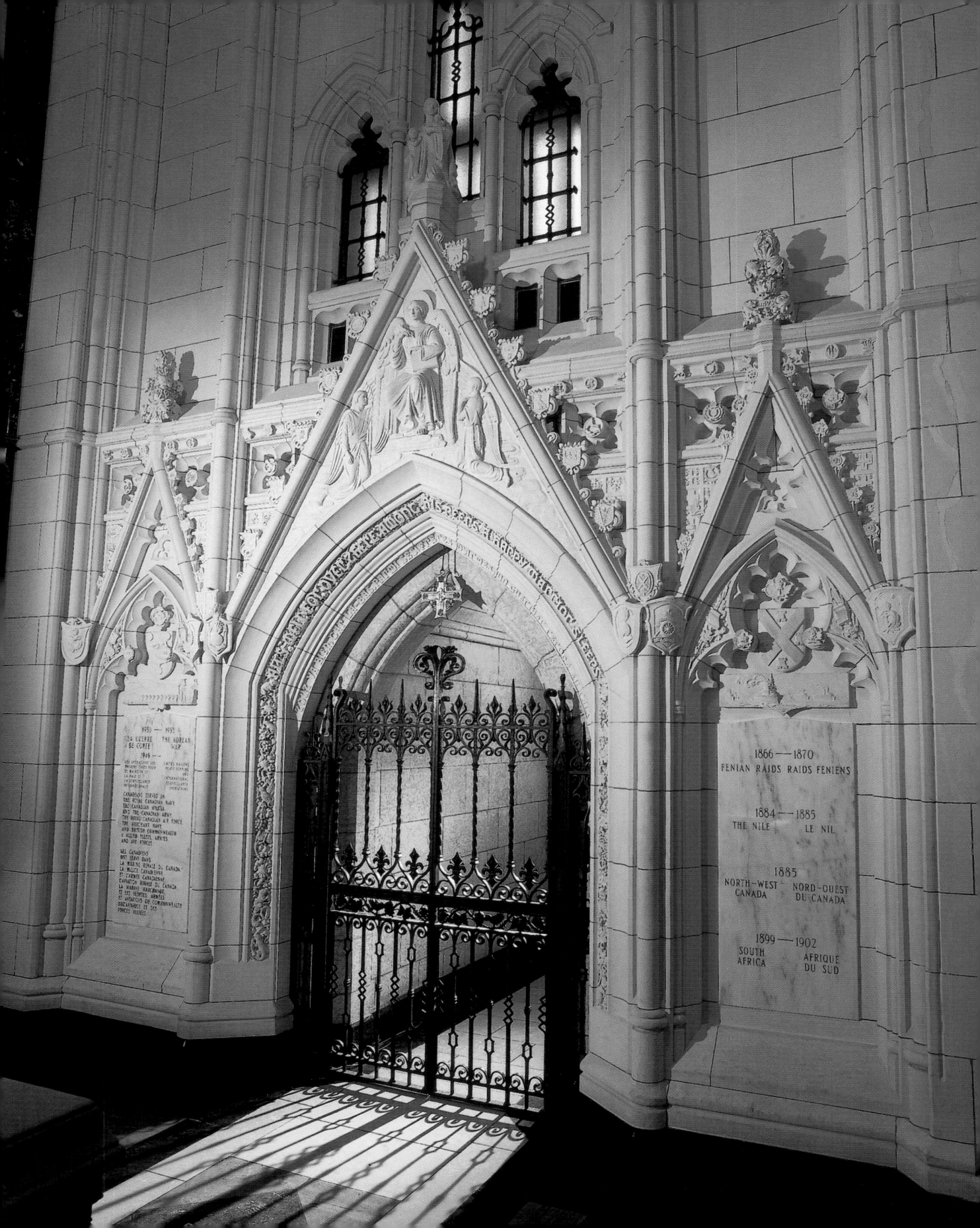

1950 — 1953
LA GUERRE THE KOREAN
DE CORÉE WAR
1994

LES OPÉRATIONS DES UNITED NATIONS
NATIONS UNIES POUR PEACE KEEPING
LE MAINTIEN DE AND
LA PAIX ET INTERNATIONAL
LA SURVEILLANCE SURVEILLANCE
INTERNATIONALE OPERATIONS

CANADIANS SERVED IN
THE ROYAL CANADIAN NAVY
THE CANADIAN MILITIA
AND THE CANADIAN ARMY
THE ROYAL CANADIAN AIR FORCE
THE MERCHANT NAVY
AND BRITISH COMMONWEALTH
& ALLIED FLEETS, ARMIES
AND AIR FORCES

DES CANADIENS
ONT SERVI DANS
LA MARINE ROYALE DU CANADA
LA MILICE CANADIENNE
ET L'ARMÉE CANADIENNE
L'AVIATION ROYALE DU CANADA
LA MARINE MARCHANDE
ET LES FLOTTES ARMÉES
ET AVIATIONS DU COMMONWEALTH
BRITANNIQUE ET DES
FORCES ALLIÉES

1866 — 1870
FENIAN RAIDS RAIDS FÉNIENS

1884 — 1885
THE NILE LE NIL

1885
NORTH-WEST NORD-OUEST
CANADA DU CANADA

1899 — 1902
SOUTH AFRIQUE
AFRICA DU SUD

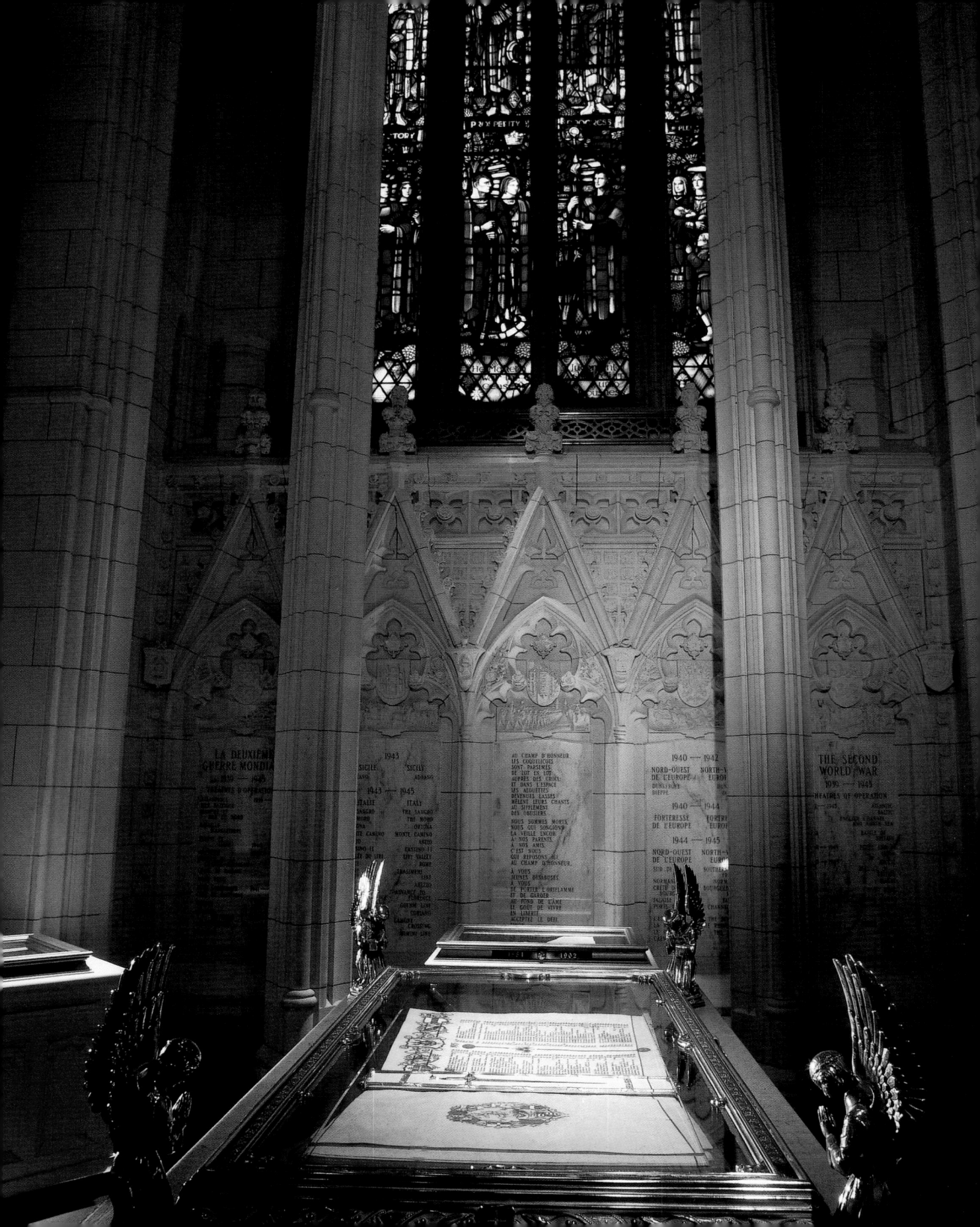

Opposite page: The Memorial Chamber stands as a testament to all Canadians who gave their lives for peace and freedom.

Left: Stone for the floor of the Memorial Chamber was brought from the World War I battlefields of France and Flanders.

Bottom: The names of the Canadians who died while serving in conflicts outside Canada since Confederation are recorded in the six Books of Remembrance.

CANADA

The Battle of Britain

Within this Book are recorded the names of those gallant Canadian Airmen, who, fighting in the stricken skies of Britain died to defend and save a sanctuary of our ancestral freedom. Their motherland, remembering her young sons, rejoices that such men once lived, & will forever grieve that they died so young.

"Born of the sun they travelled a short while toward the sun, And left the vivid air signed with their honour."

La Bataille de Grande-Bretagne

Dans ce livre sont inscrits les noms des aviateurs canadiens tués en combattant dans le ciel envahi de la Grande-Bretagne pour la défense et le salut de l'un des sanctuaires de nos libertés. Se rappelant cette fleur de sa jeunesse, la patrie, heureuse qu'ils aient vécu pleurera a jamais leur mort prématurée.

Heureux ceux qui sont morts dans les grandes batailles,
Couchés dessus le sol à la face de Dieu.
Heureux ceux qui sont morts sur un dernier haut lieu,
Parmi tout l'appareil des grandes funérailles.

1939-1945

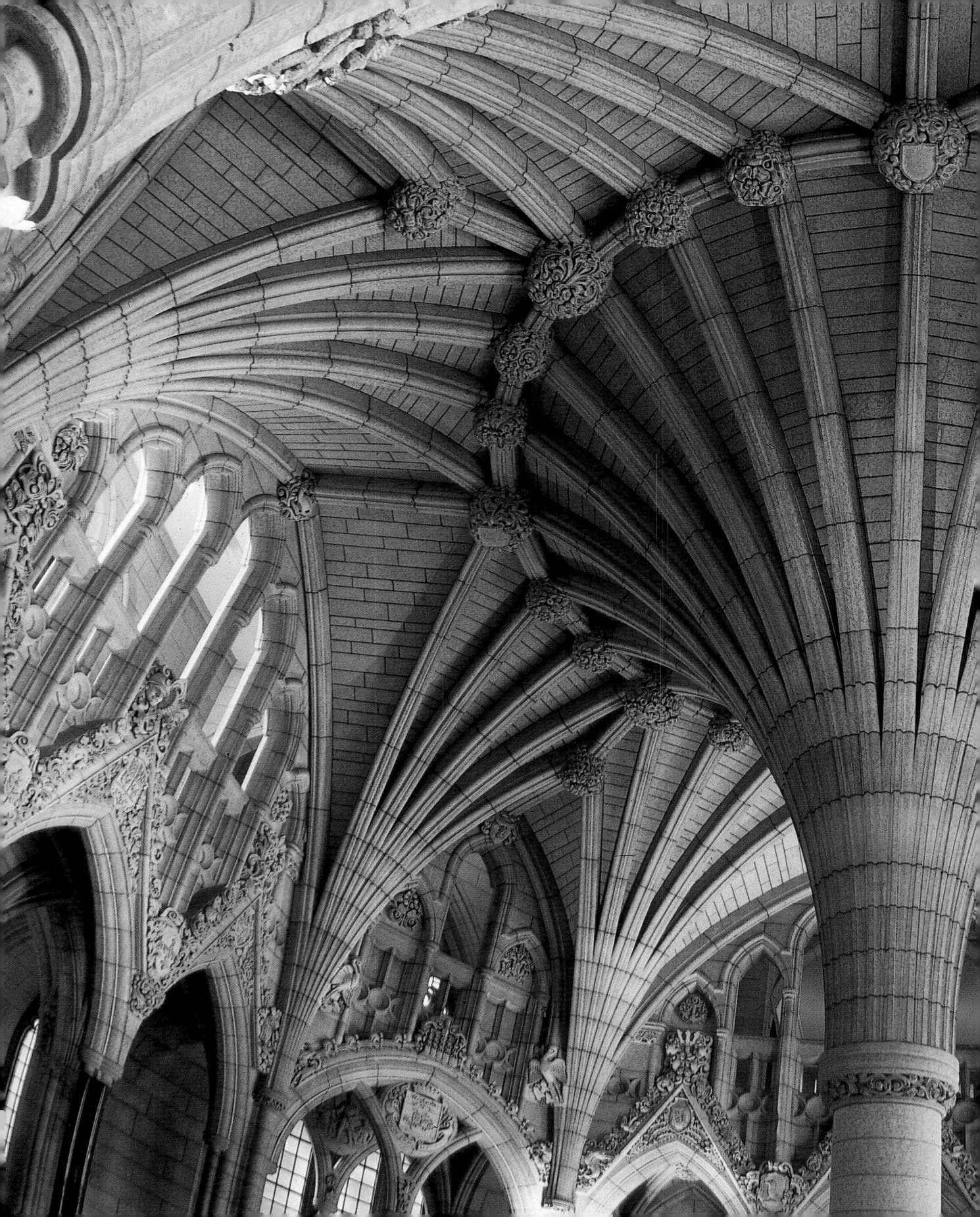

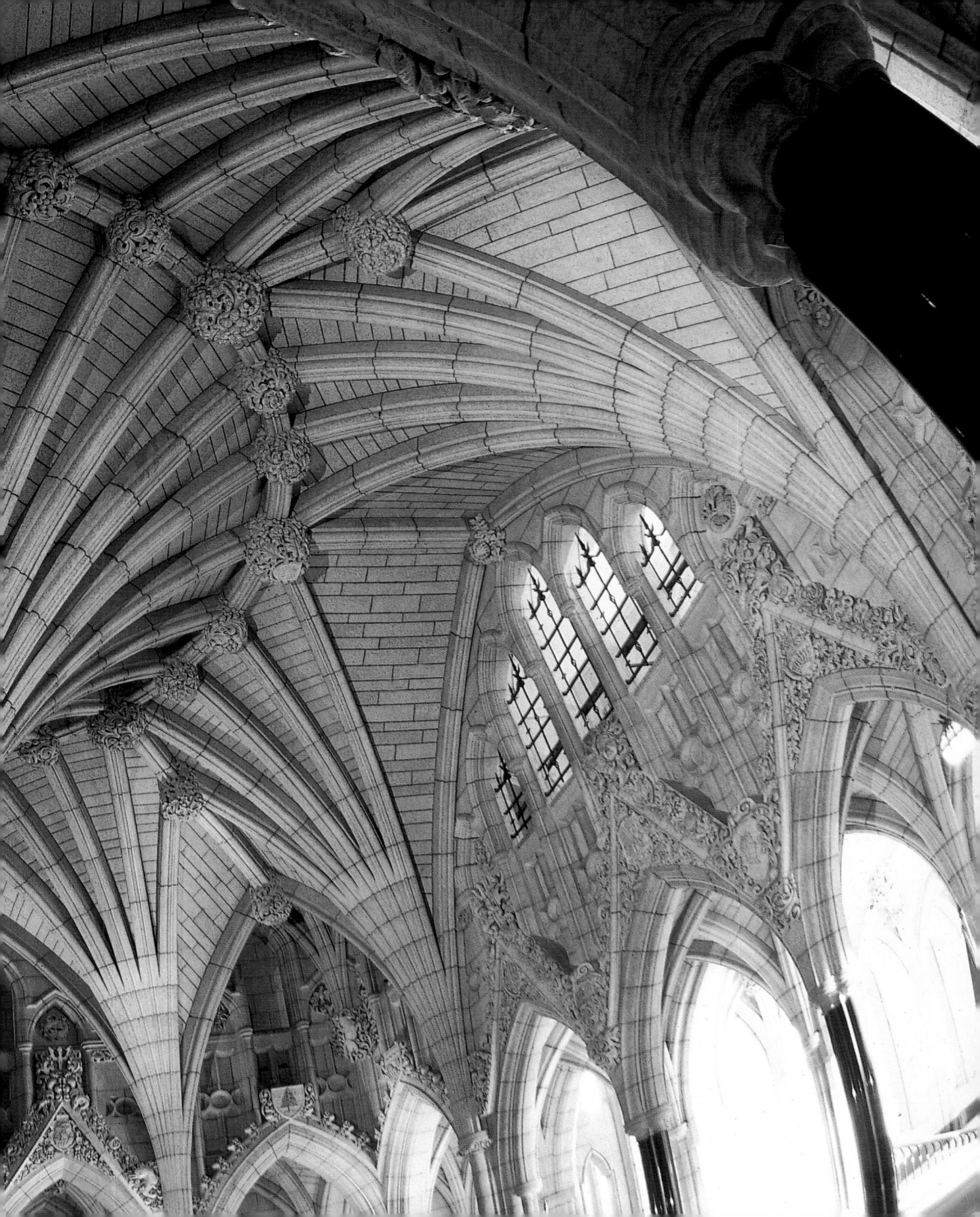

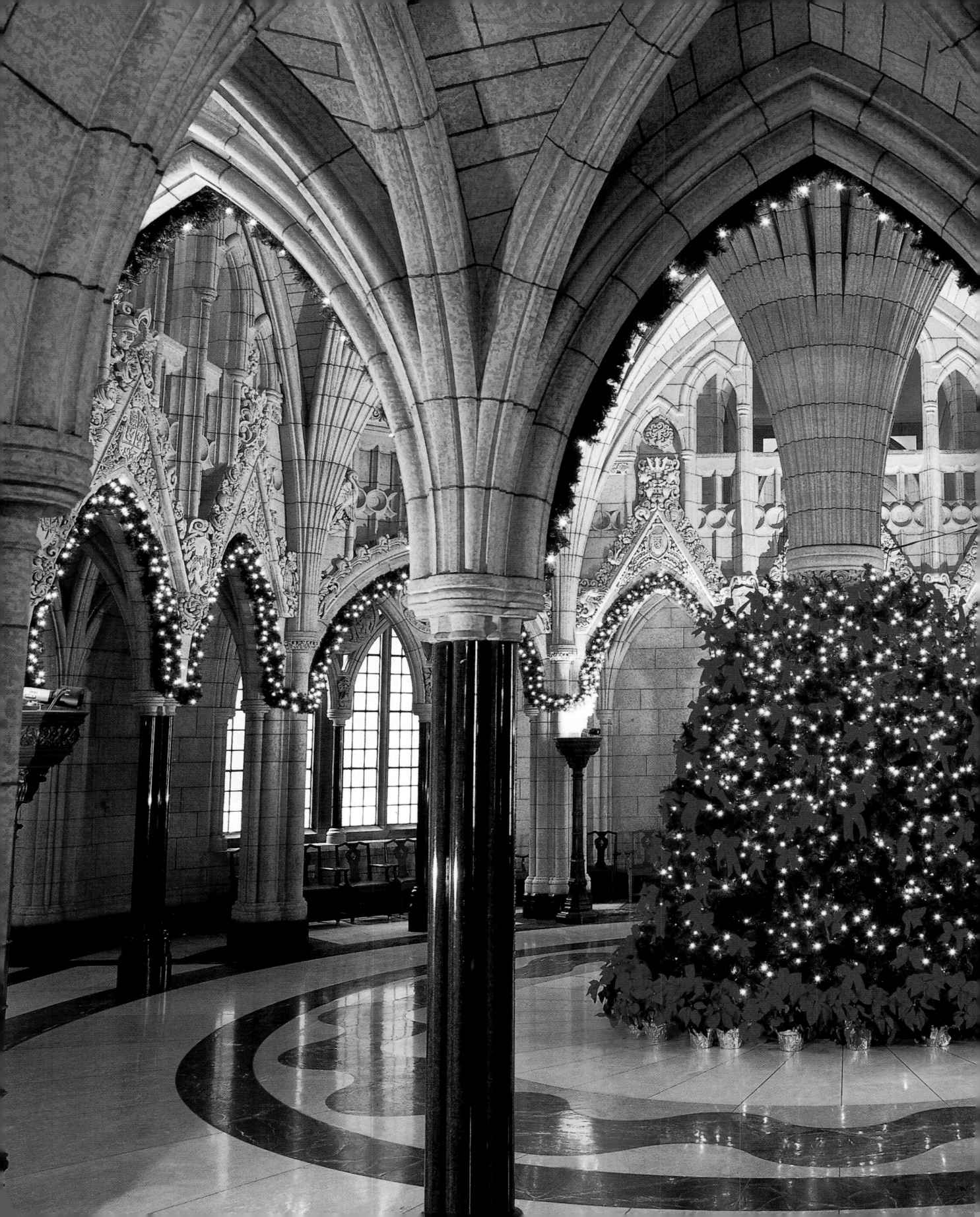

Previous page: The Confederation Hall is the heart of the Centre Block, with its magnificent umbrella vault, Windsor green syenite pillars and gables with richly ornate carved bosses. The gables are decorated with a variety of symbols, figureheads, Canadian flora and fauna, and heraldic symbols.

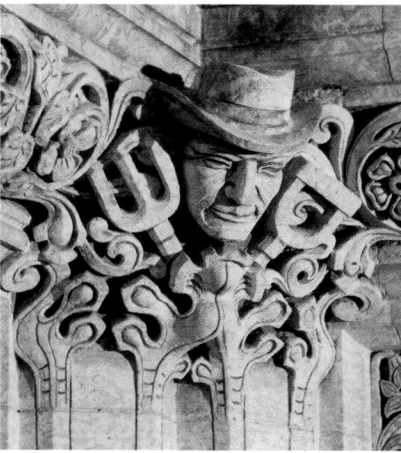

Left: Every Christmas, Confederation Hall is ablaze with hundreds of Christmas lights and decorations.

Above: The carved face of a farmer with a big-brimmed straw hat, a spade and a fork for mixed farming. (Commons Foyer Frieze, South Wall)

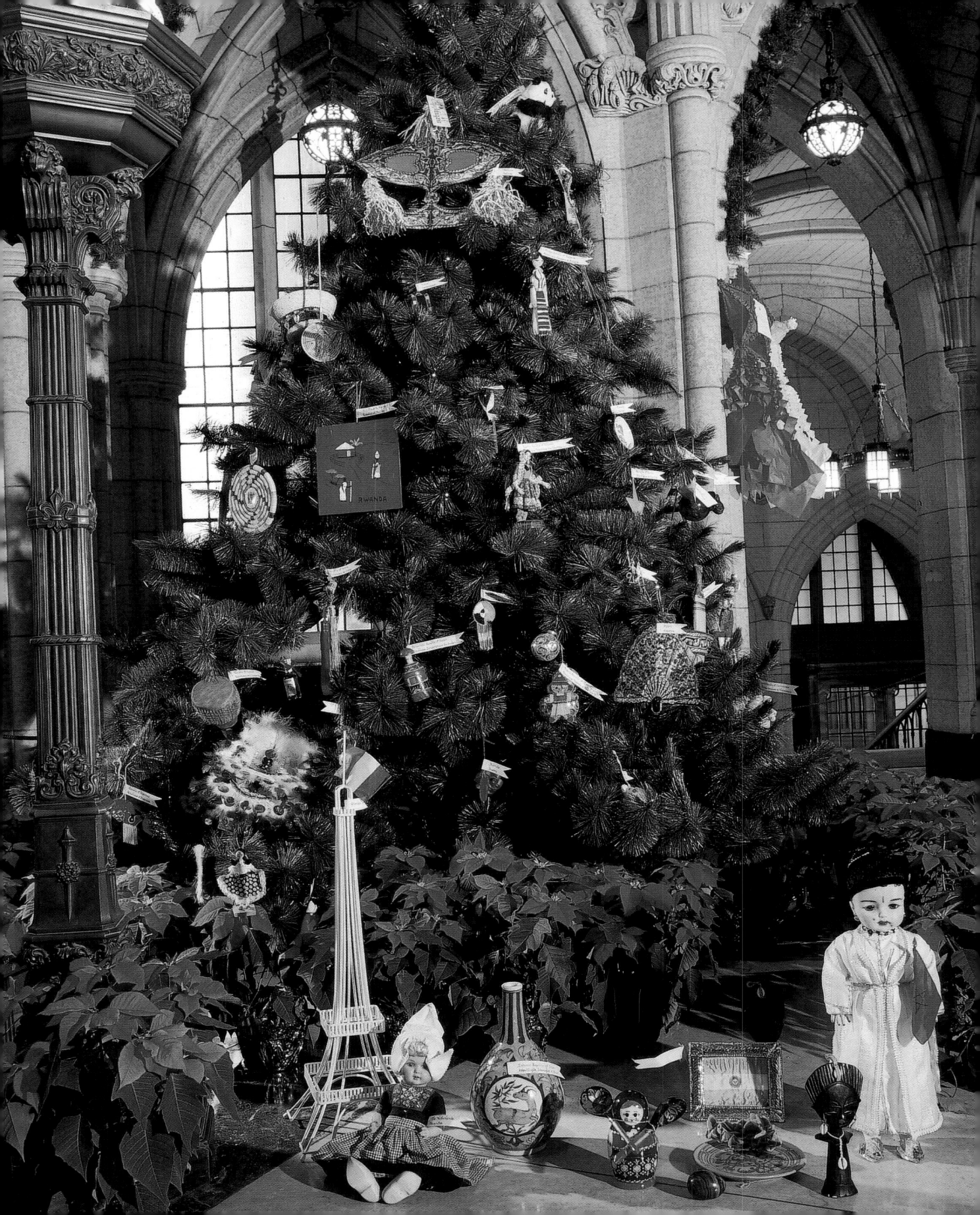

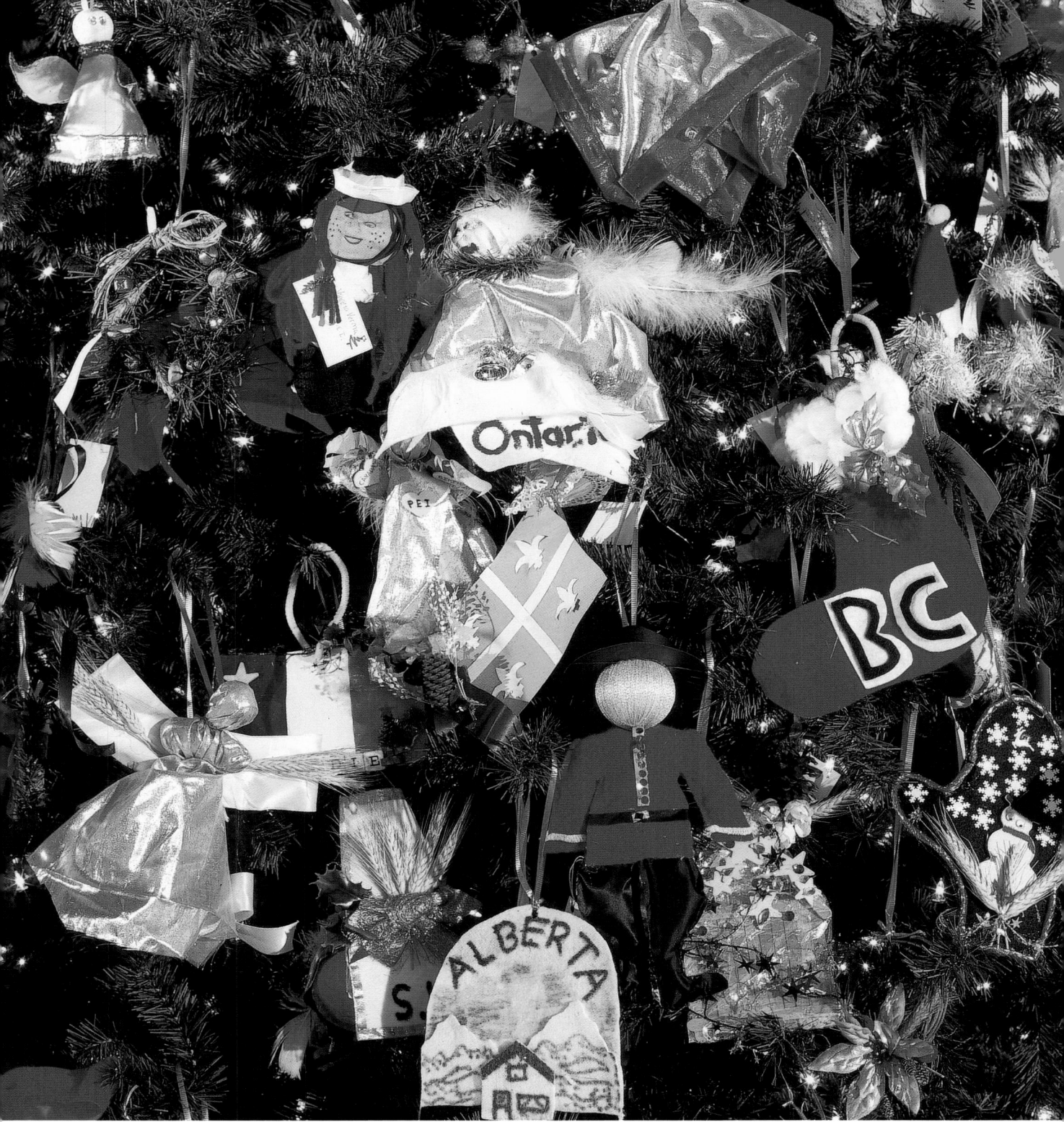

Left page: Decorated with children's toys from around the world donated by foreign embassies in Canada, the Friendship Tree adds to the Christmas spirit in the Confederation Hall.

Above: A Christmas tree in the Confederation Hall is decorated with ornaments handmade by young Canadians aged 15 to 17.

The House of Commons

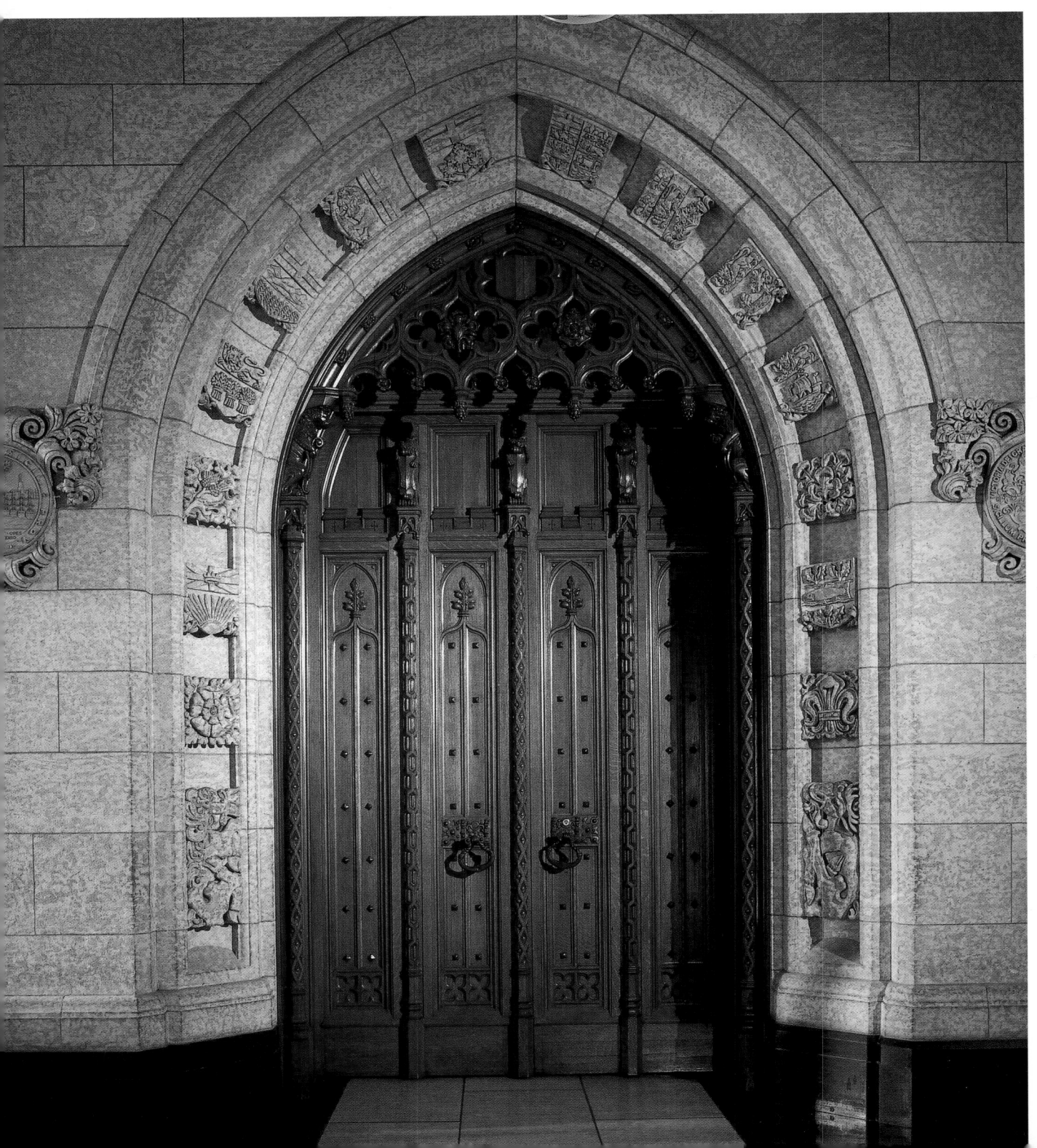

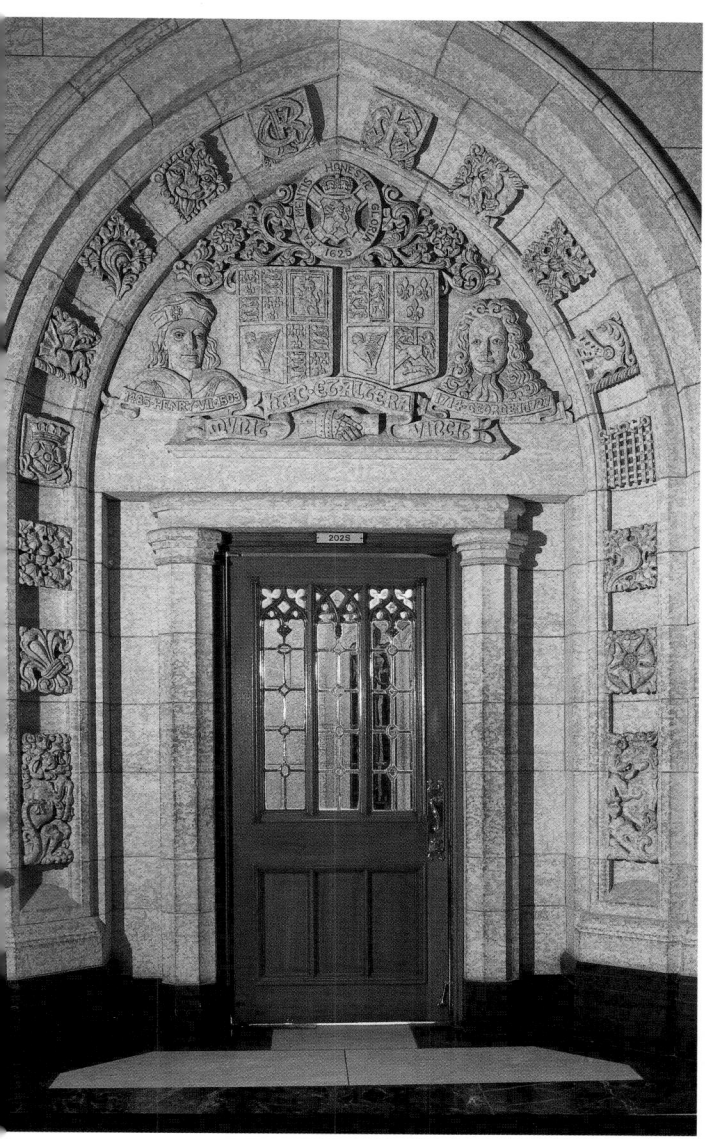

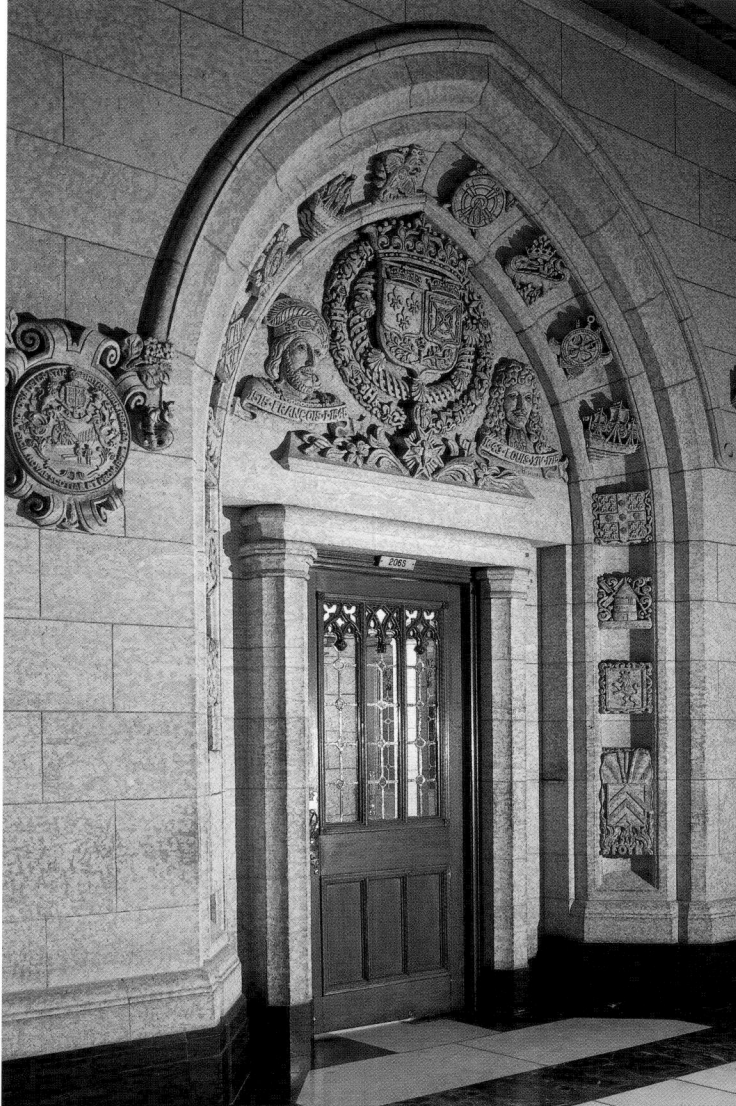

Above and left: Former kings of Britain and France keep watch over the "French" and "English" doors of the House of Commons. Henry VII, the first Tudor sovereign, and George I, first of the Hanoverians, are commemorated in the English (West) entrance. François I, king of France when Jacques Cartier explored the St. Lawrence Valley, and Louis XIV, the first monarch to rule New France directly, are portrayed in stone over the French (East) entrance.

Left page: The main entrance to the House of Commons chamber. These impressive oak and iron doors feature exquisite hanging tracery and wrought-iron handles, surrounded by an archivolt ornate with Canadian and provincial coats of arms in use around 1920.

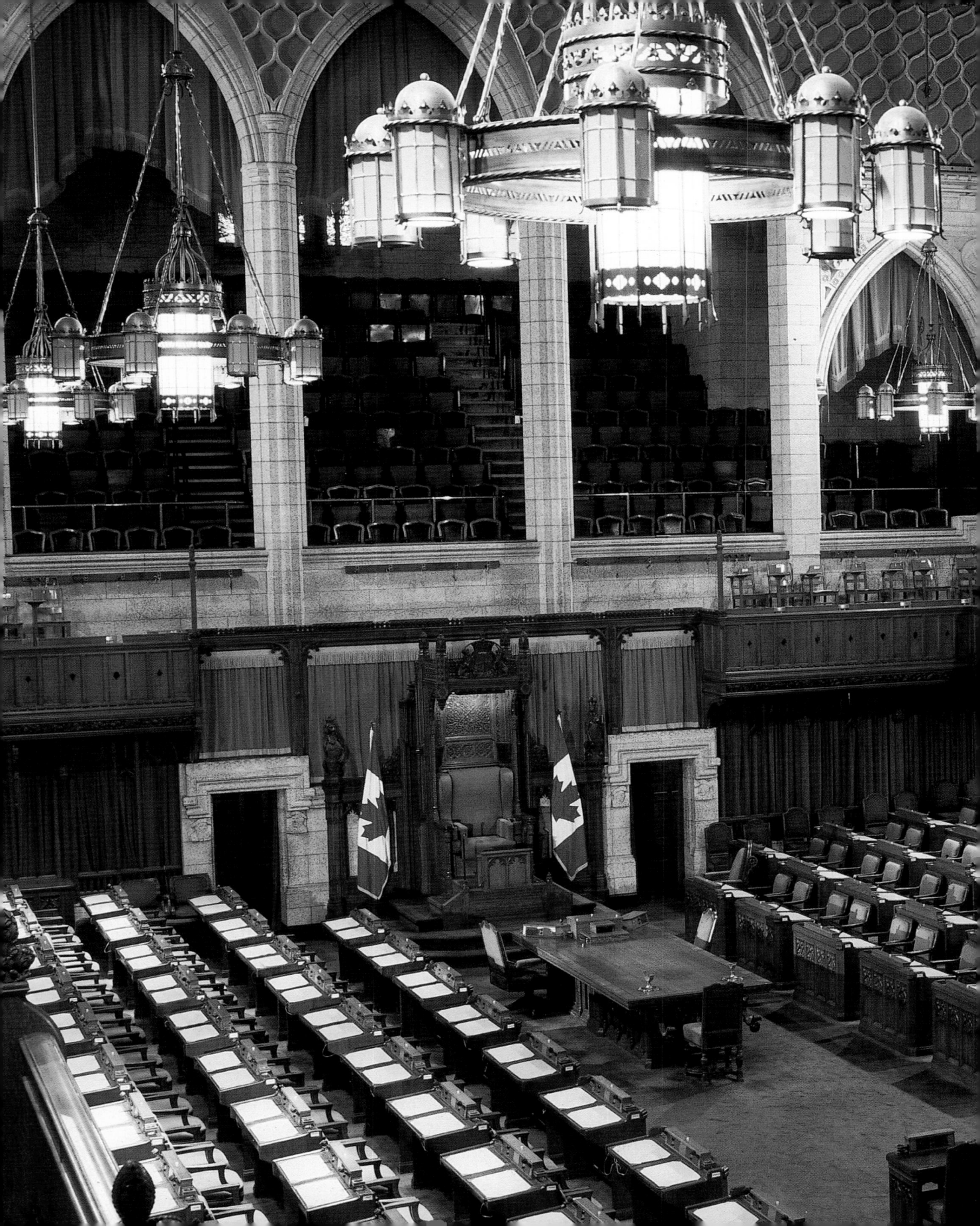

e
focal
of
To
re the
ment
of
es sit
e
e

s and
ghout

d by

inces
ws of
ons.

fter

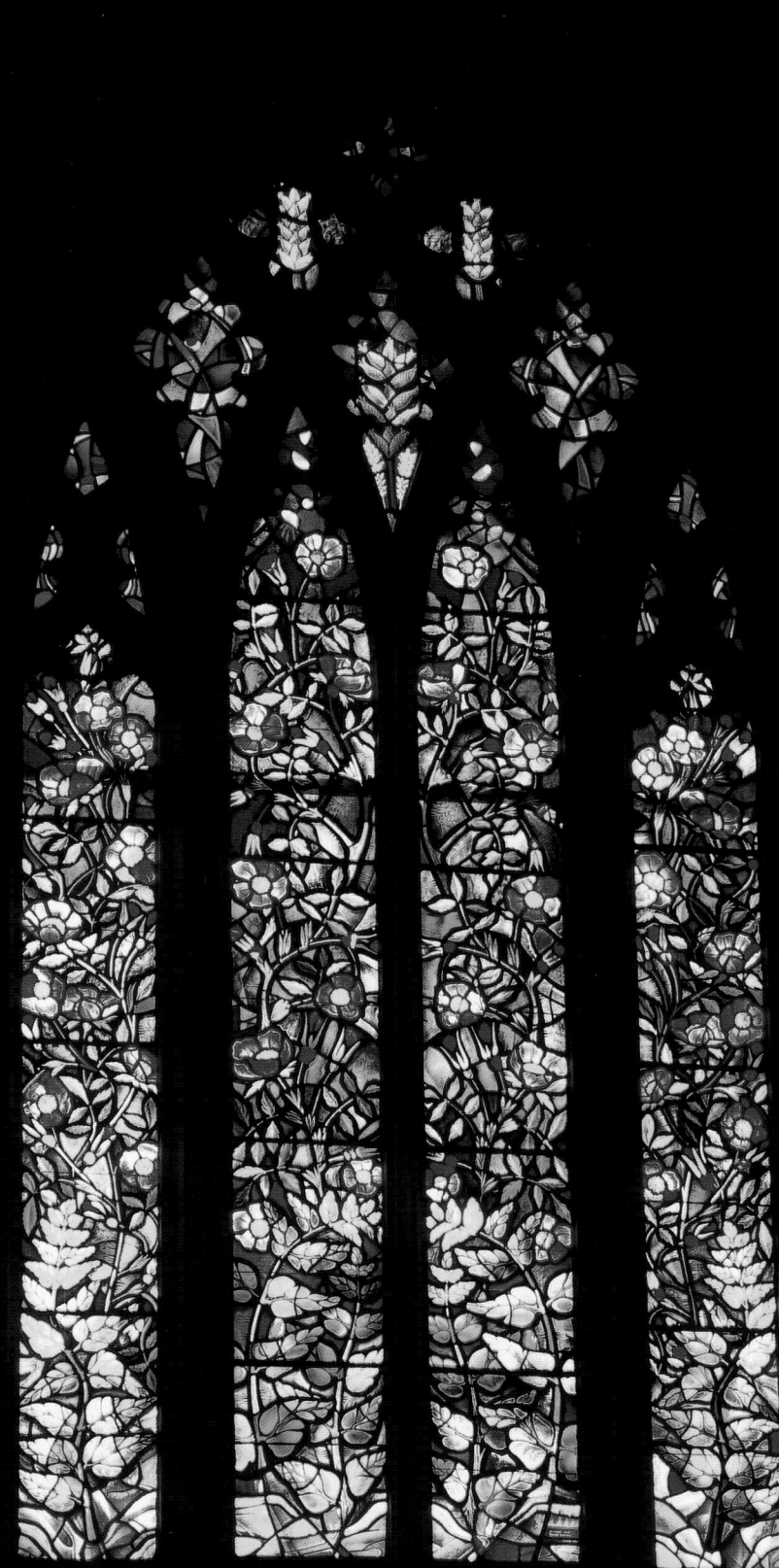

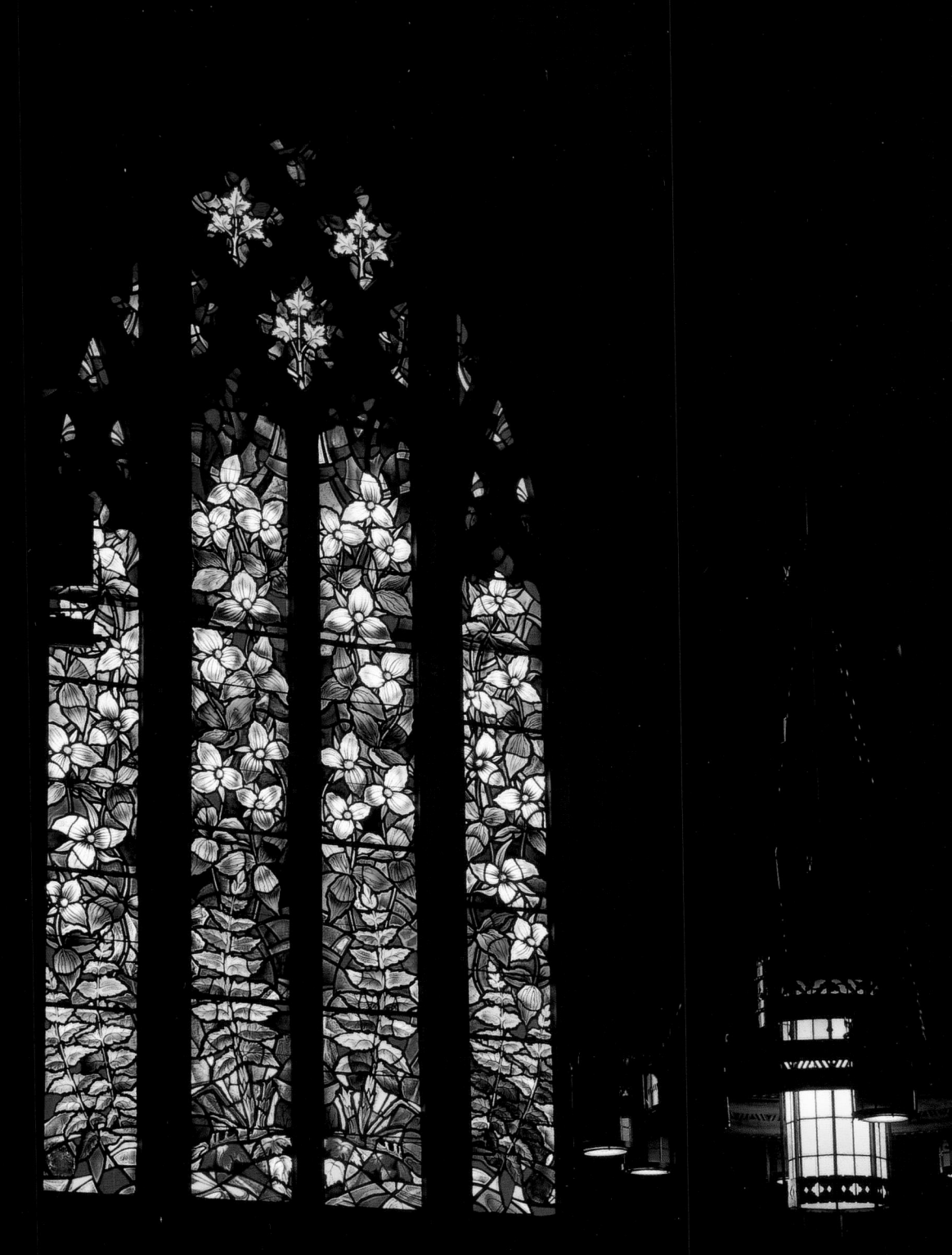

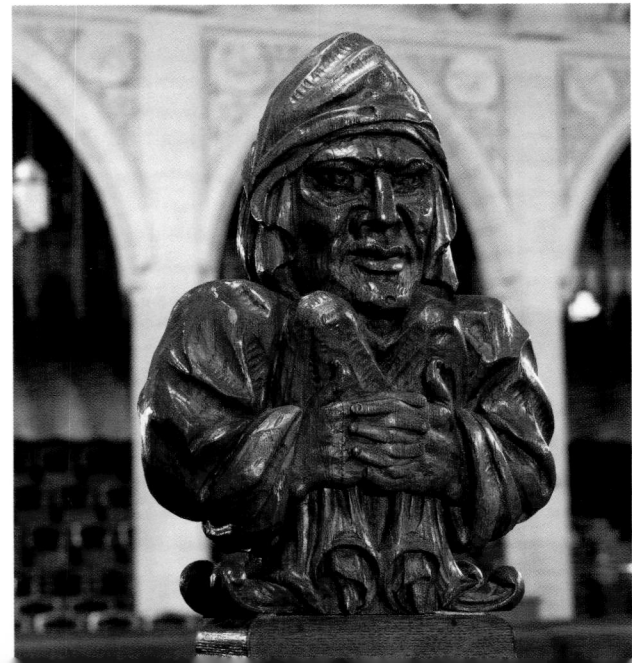

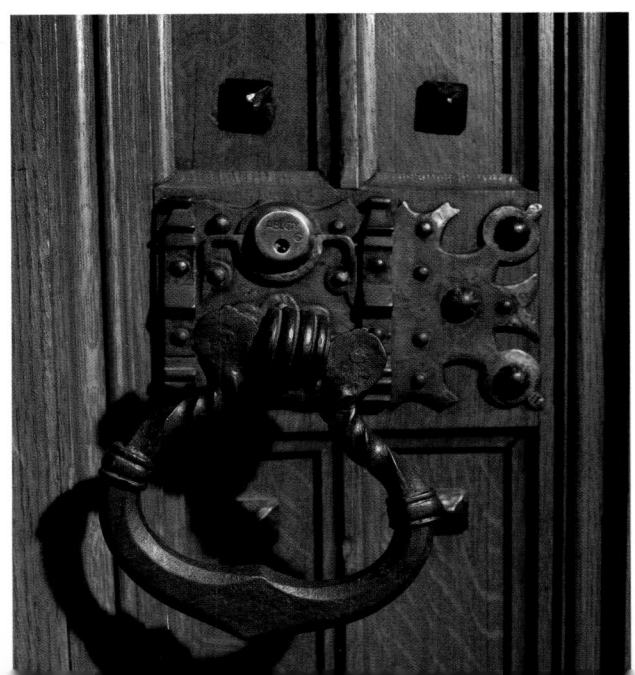

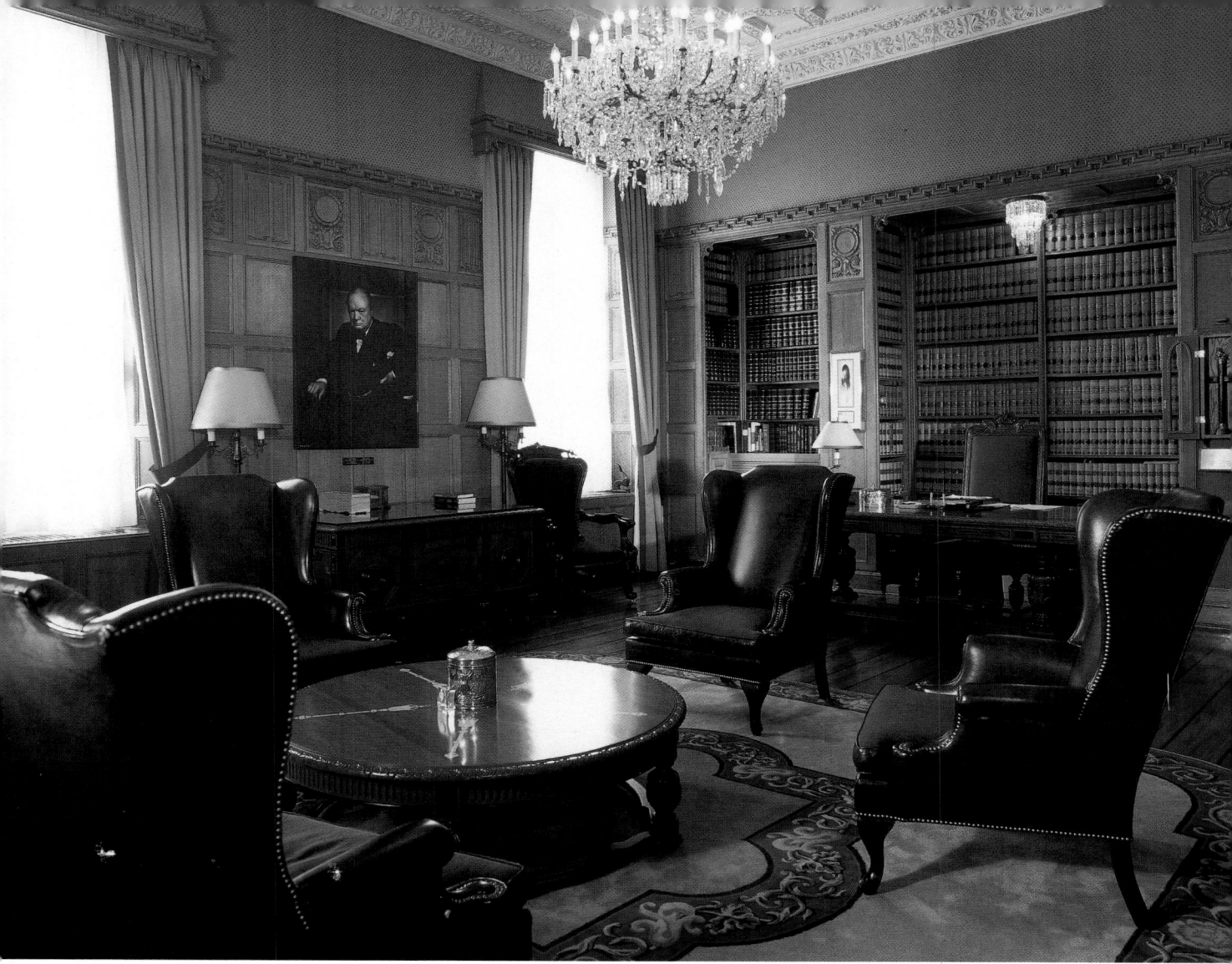

Above: Yousuf Karsh's famous portrait of Sir Winston Churchill, taken during the British prime minister's visit to Ottawa during the darkest days of World War II, watches over the House of Commons Speaker's library.

Opposite page top: The prime minister's office, with its antiques and Canadian art, reflects the simple elegance of a Centre Block office interior.

Opposite page bottom left: The oak carving of a meditative imp is perched high at the level of the public galleries in the House of Commons.

Opposite page bottom right: Wrought-iron crafting on the main door of the House of Commons turns a functional lock into a piece of art.

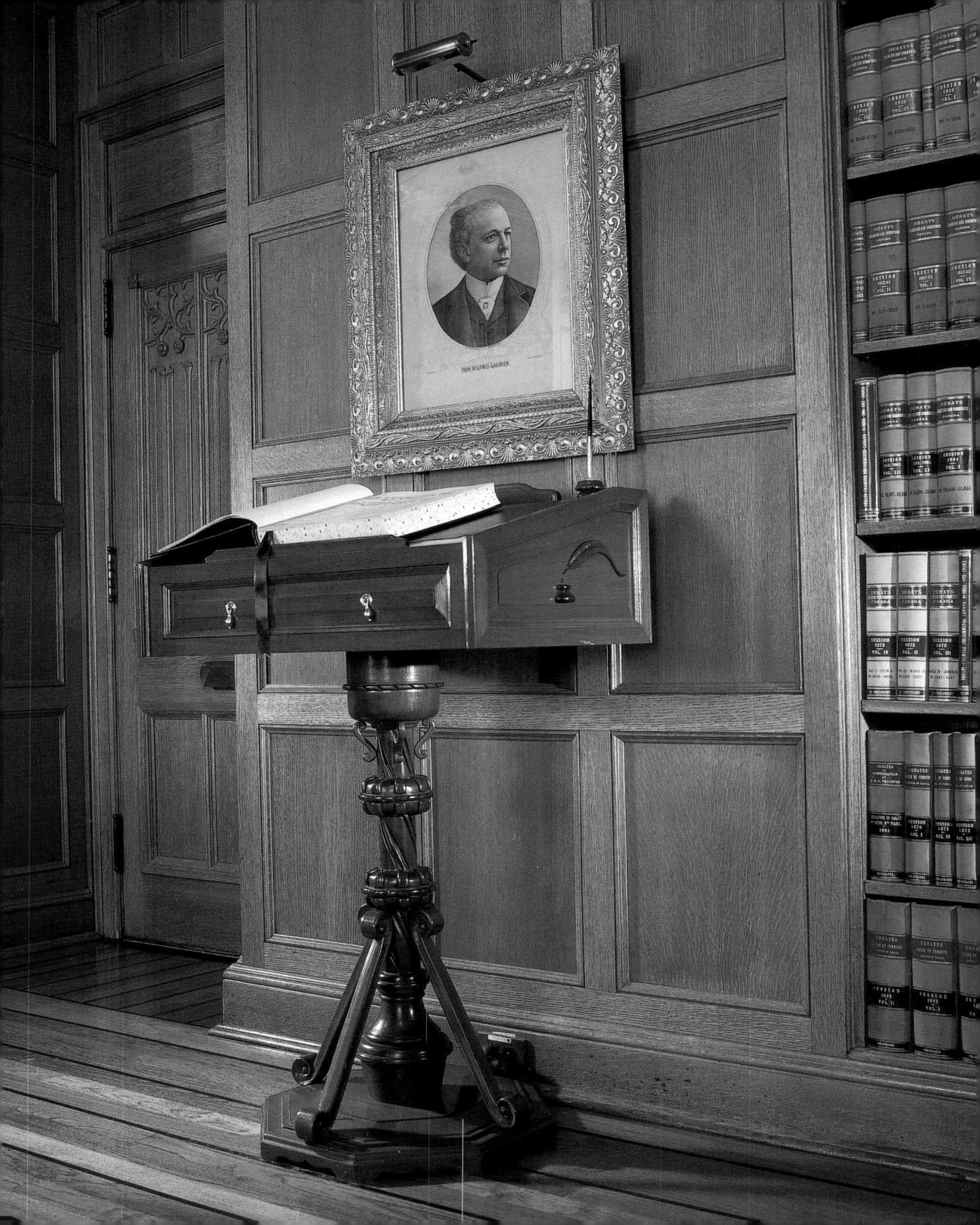

HON. WILFRID LAURIER.

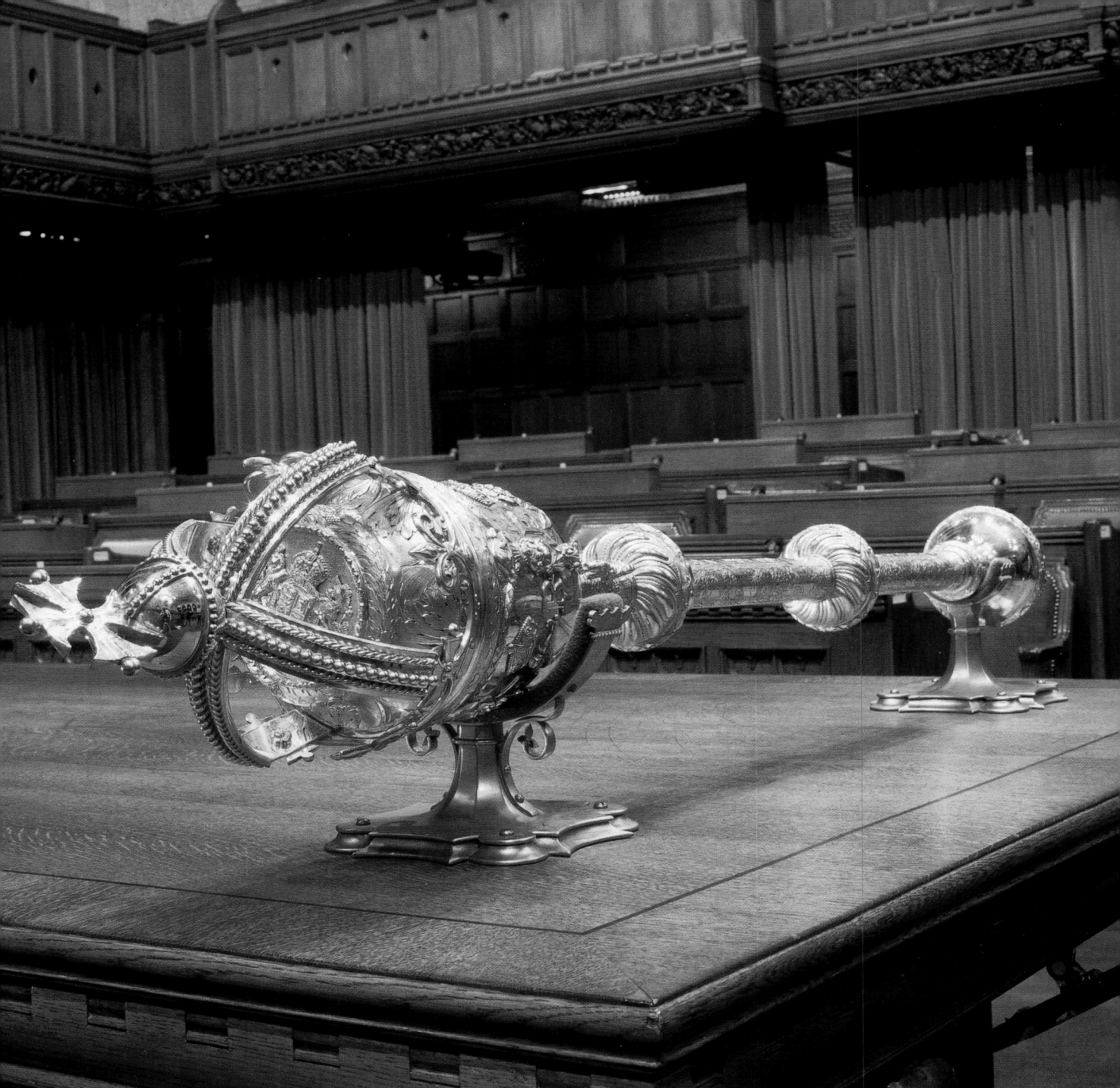

The mace is the age-old symbol of Parliament's authority. When the House is sitting and the Speaker is in the chair, the mace lies in brackets on the clerk's table with the orb and cross pointing towards the Government.

Left page: The guest book in the Speaker's office records the names of distinguished visitors to the House of Commons.

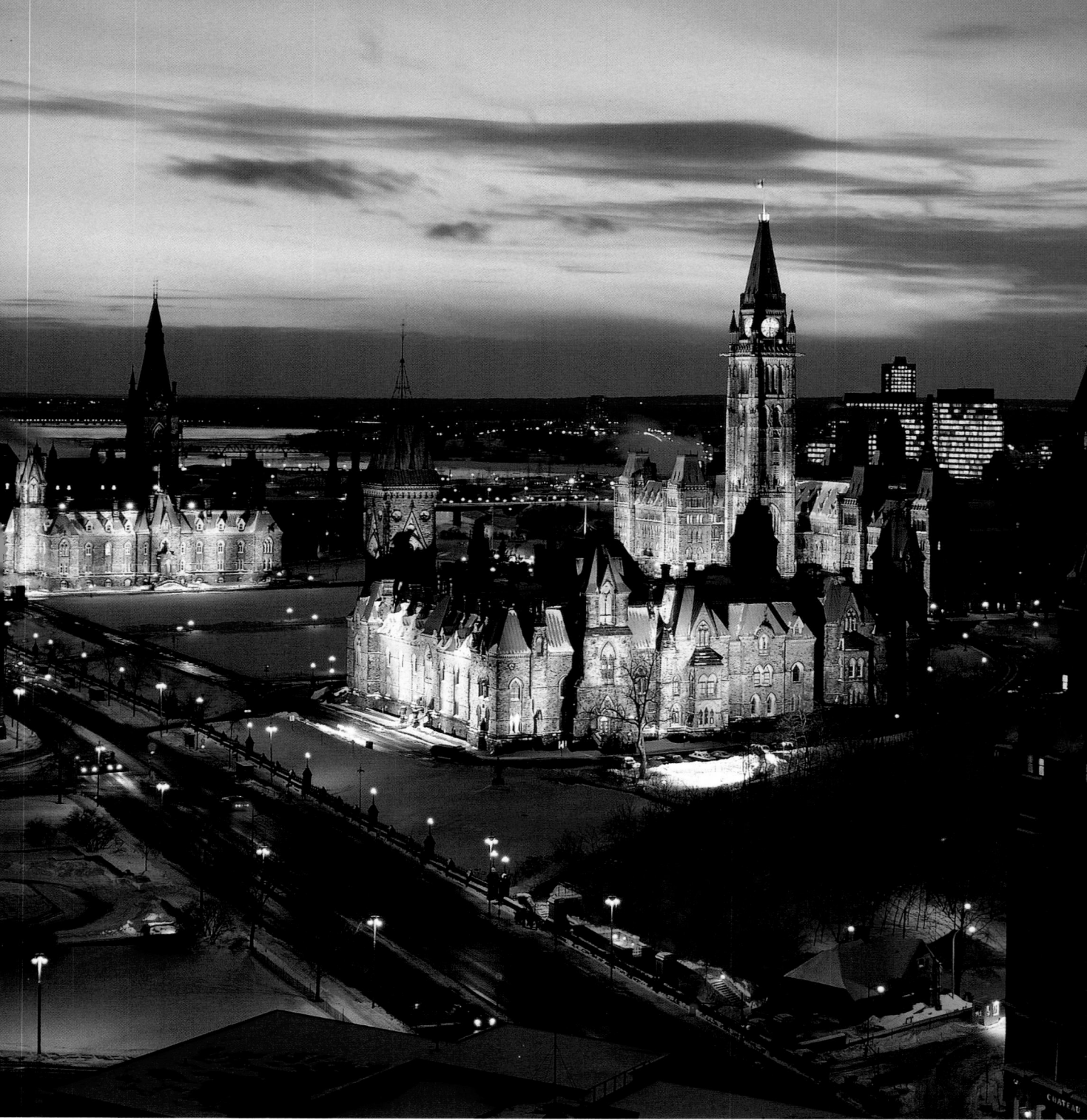

The towers of the three main buildings of the parliamentary precinct, one of the world's most beautiful legislative complexes, reach skyward into a dramatic Ottawa sunset.

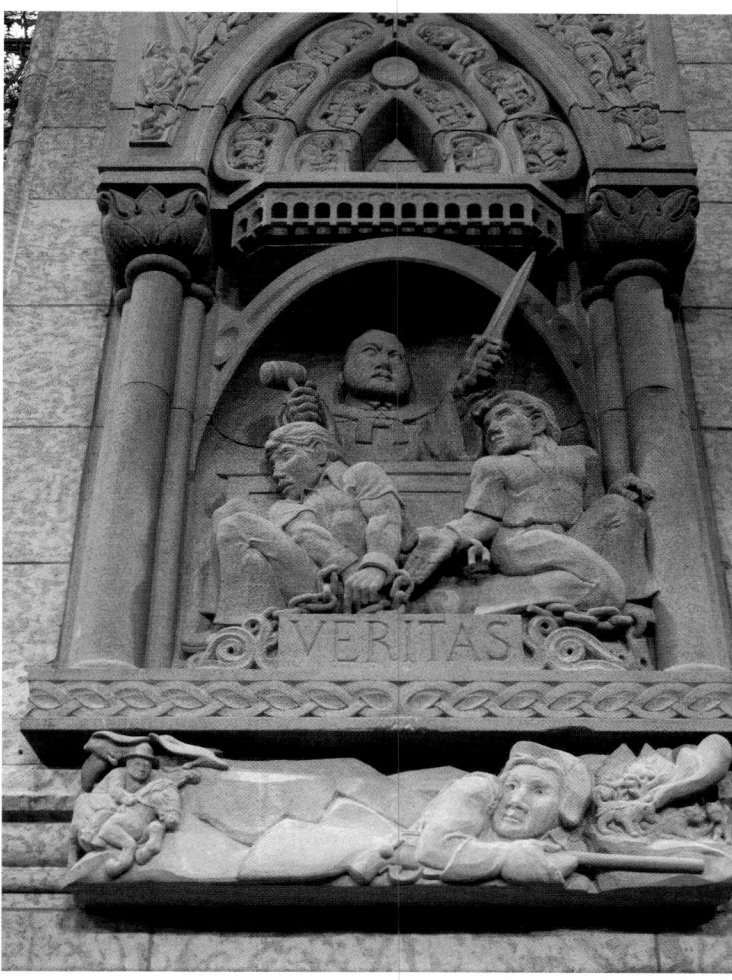

Above: The sculpture depicting Criminal Law uses the figure of a judge with a gavel and sword, a guilty man in chains and an innocently accused man with broken fetters. Below are the Royal Canadian Mounted Police.

Left: The first newcomers to Canada came from France, symbolized by the dolphin, and from Great Britain, portrayed by the falcon.

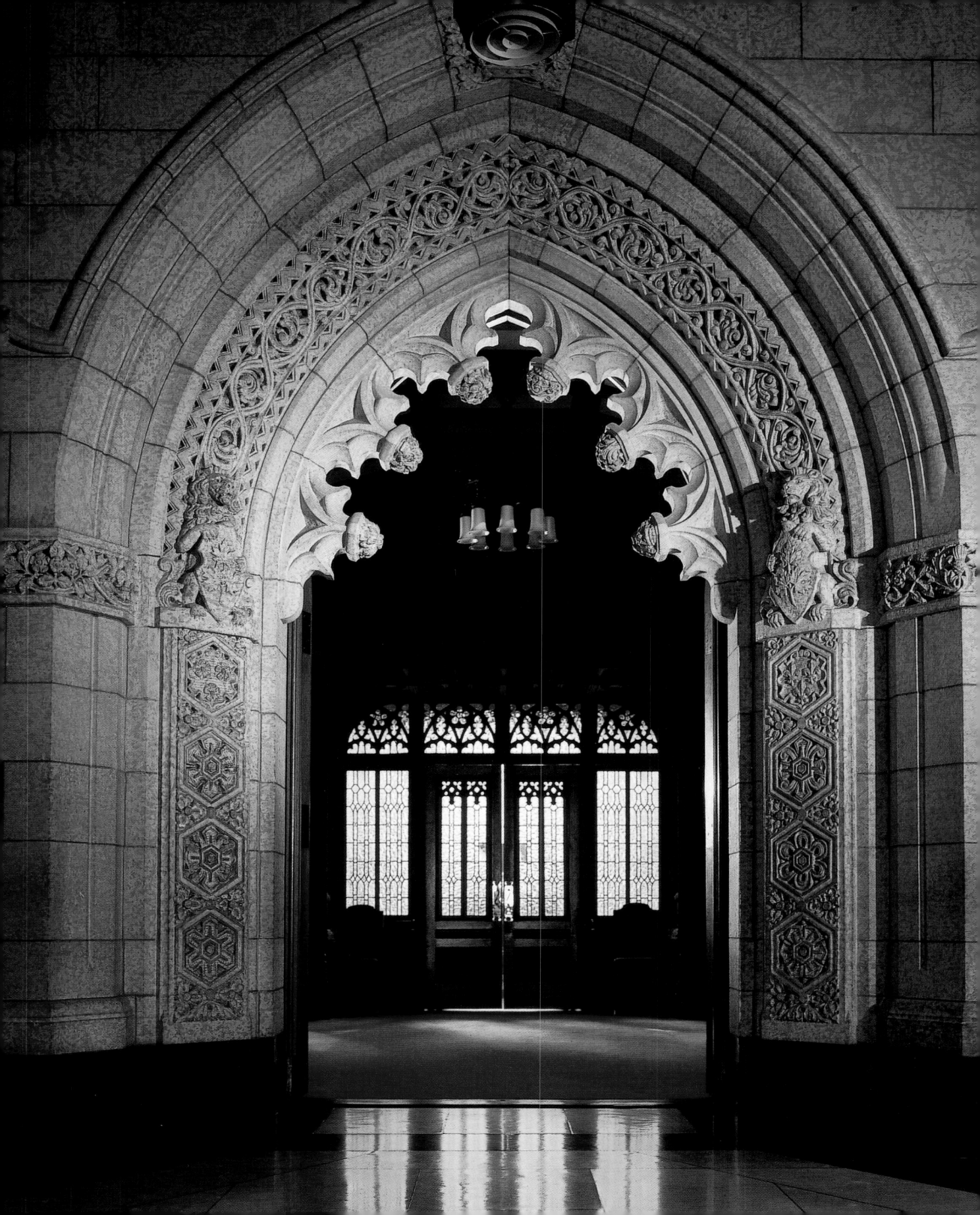

The Senate

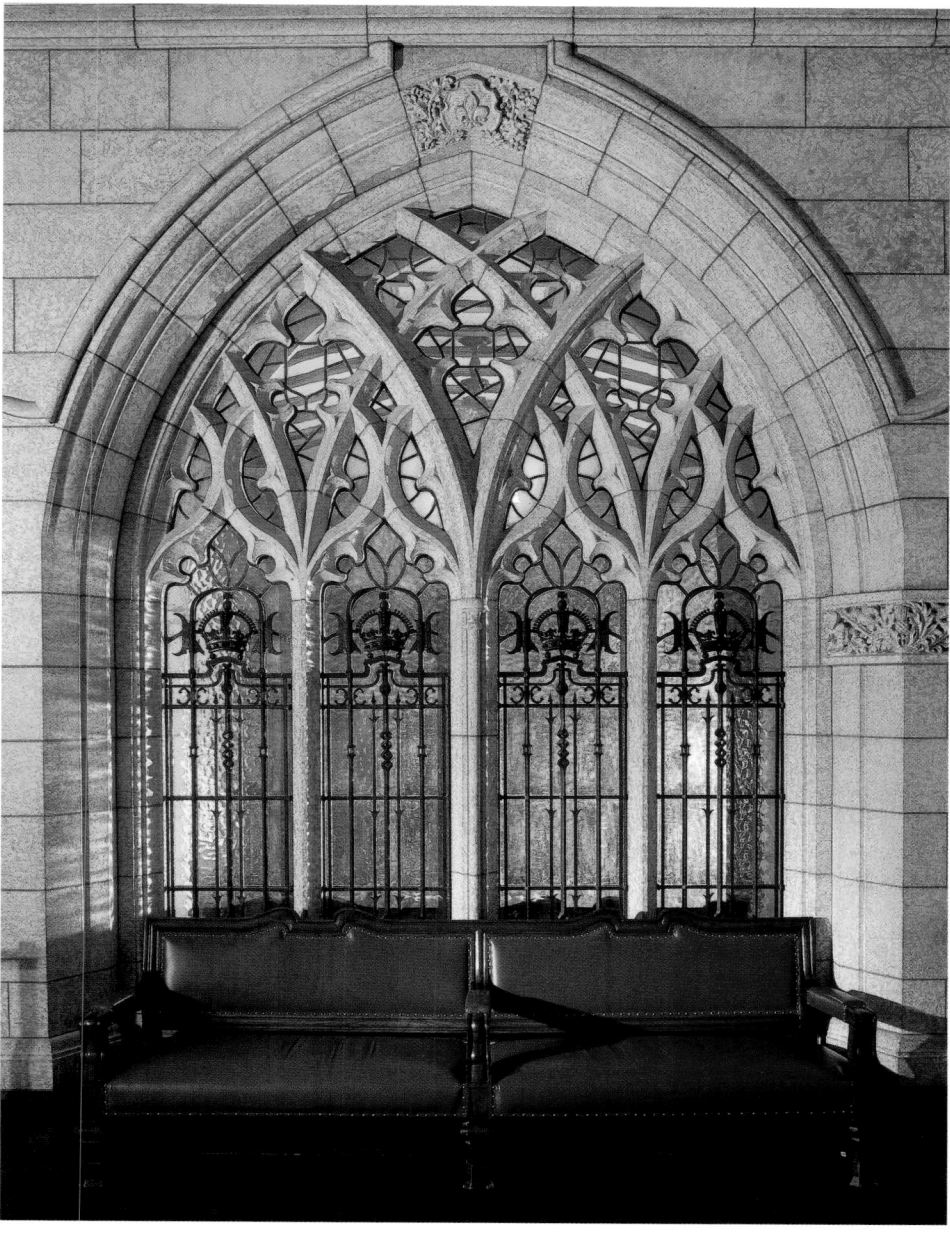

Left: Richly carved in Tyndall limestone, the ornamented cusped archivolt leads to the antechamber of the Senate.

Above: West window screen outside the entrance to the Senate chamber. Its wrought-iron grating, the artistry of glaziers and a carved panel displaying a shield with the fleur-de-lis, vine, leaves and oak are excellent examples of the sculptor's art.

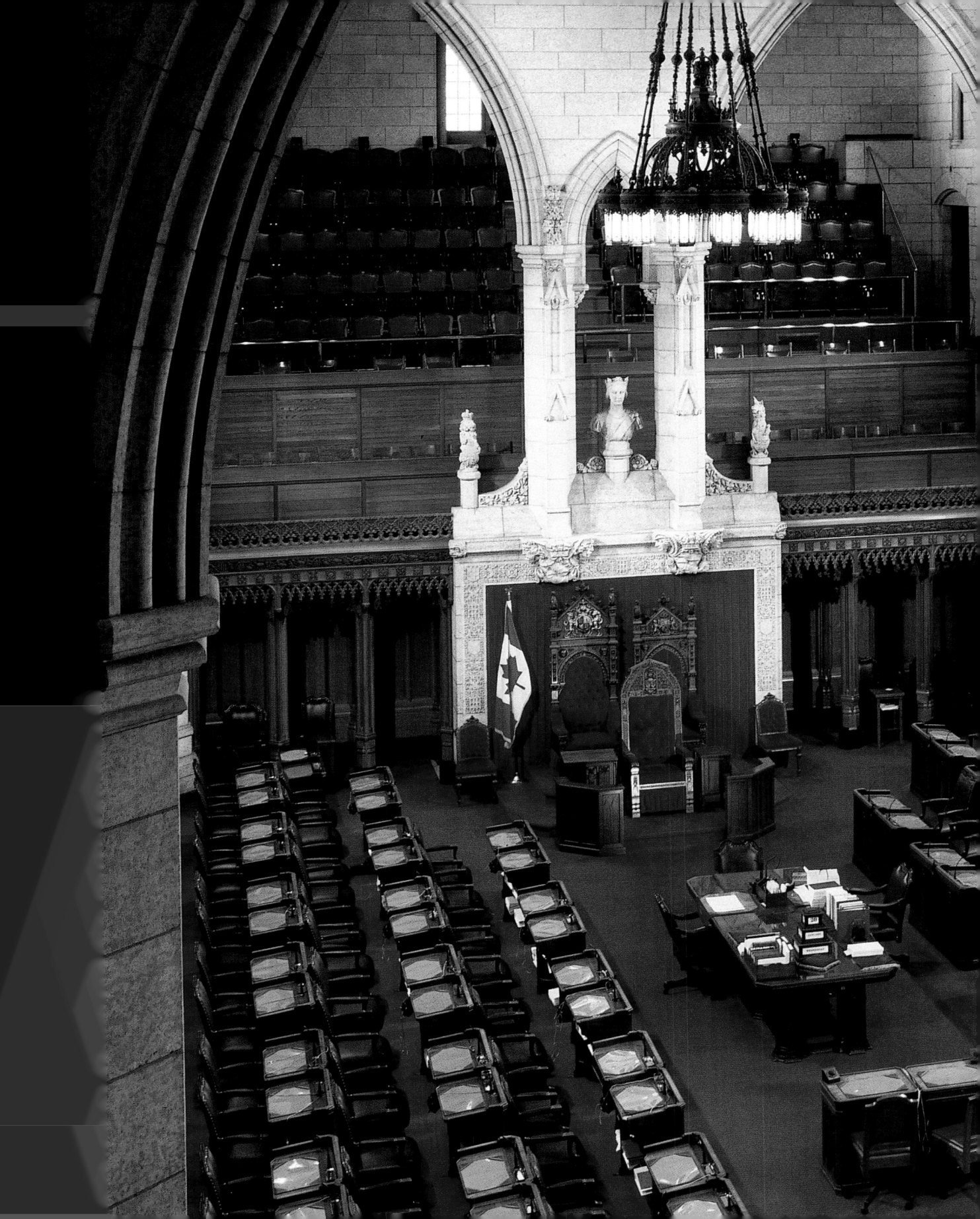

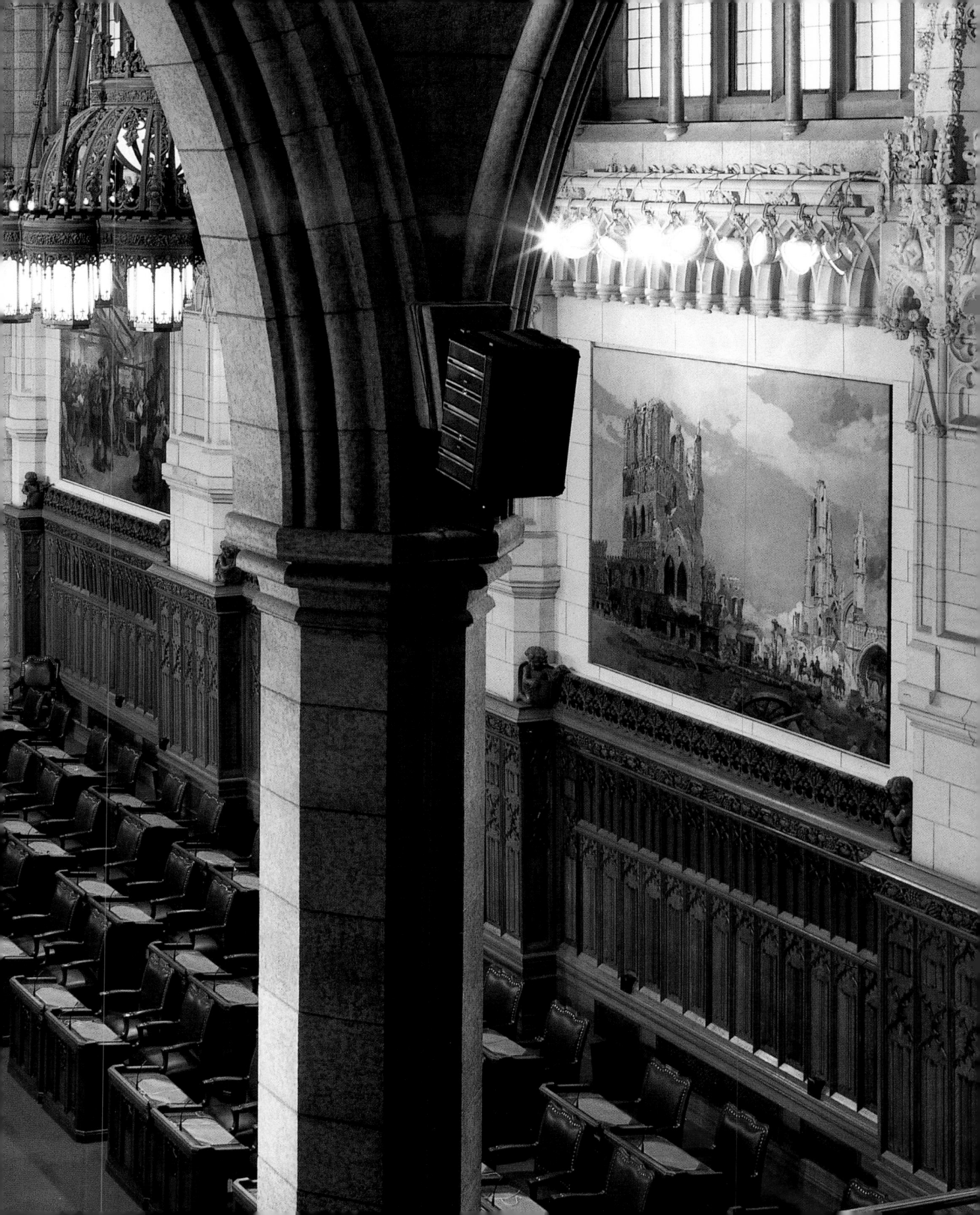

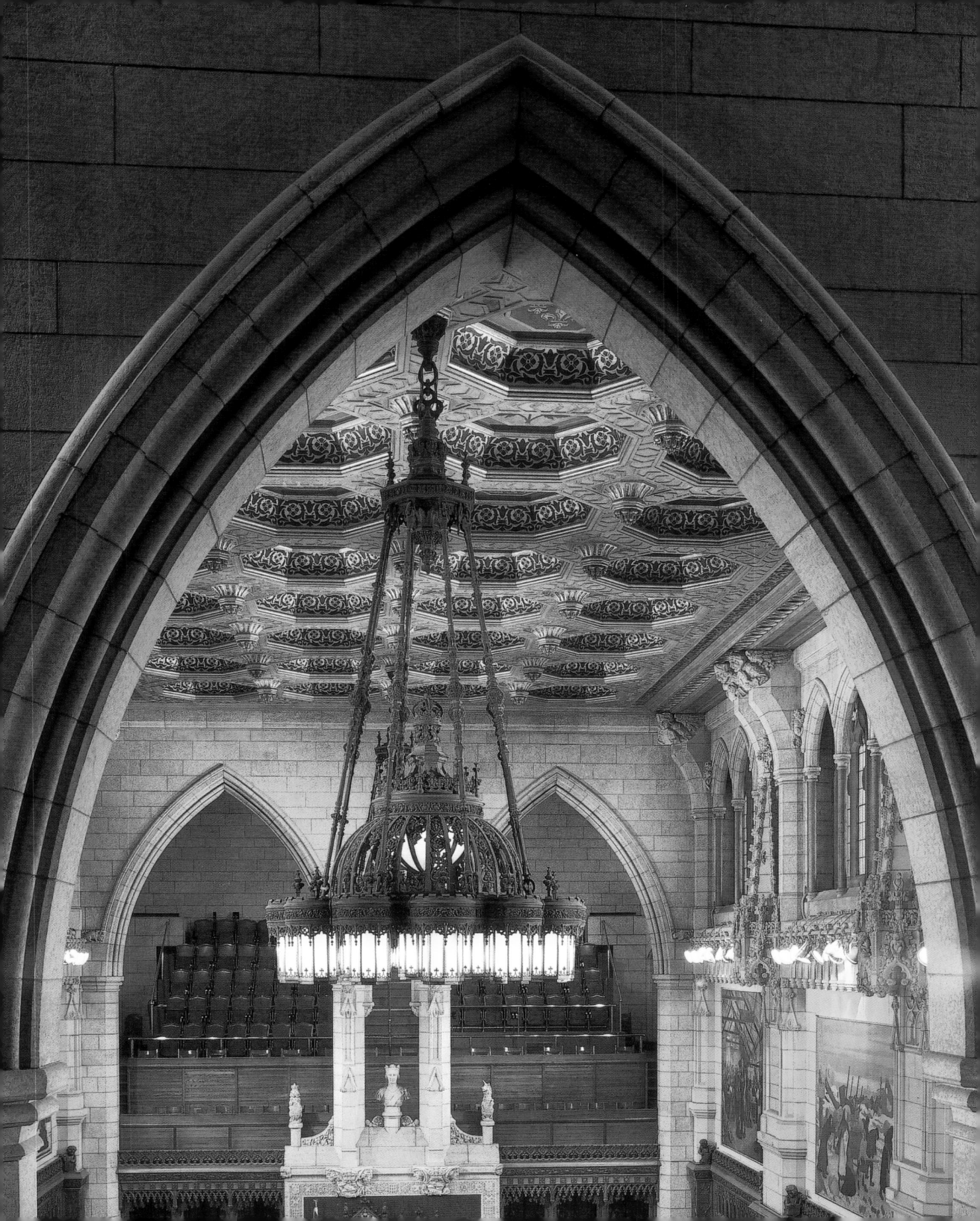

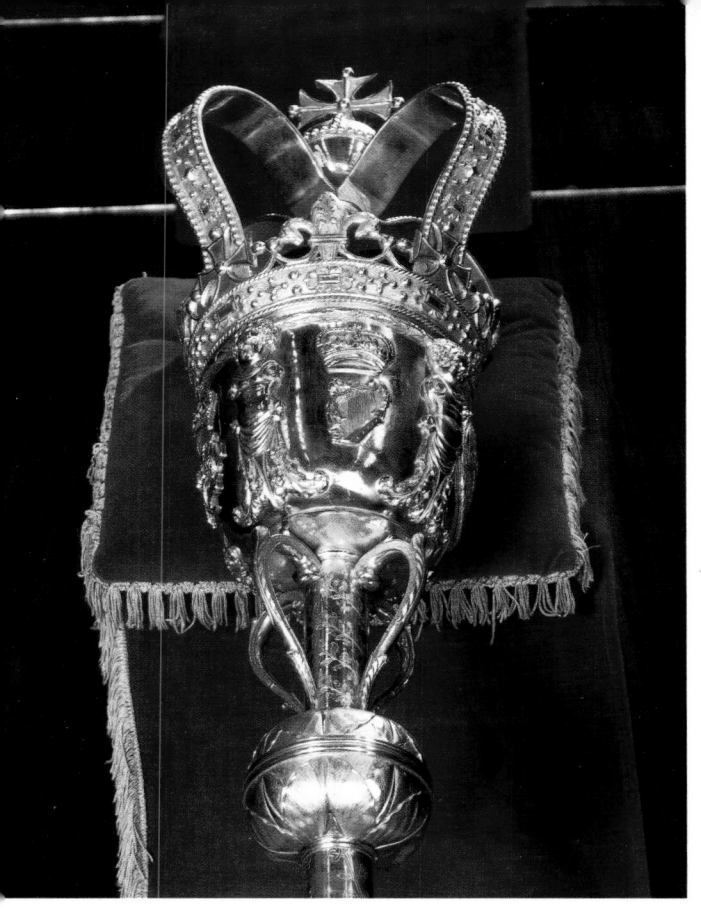

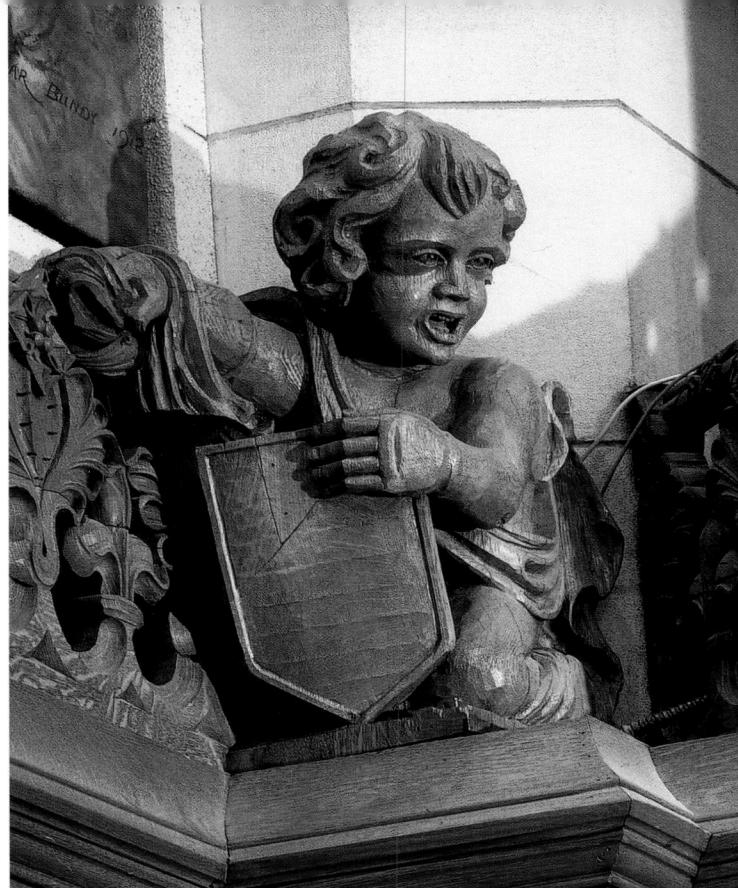

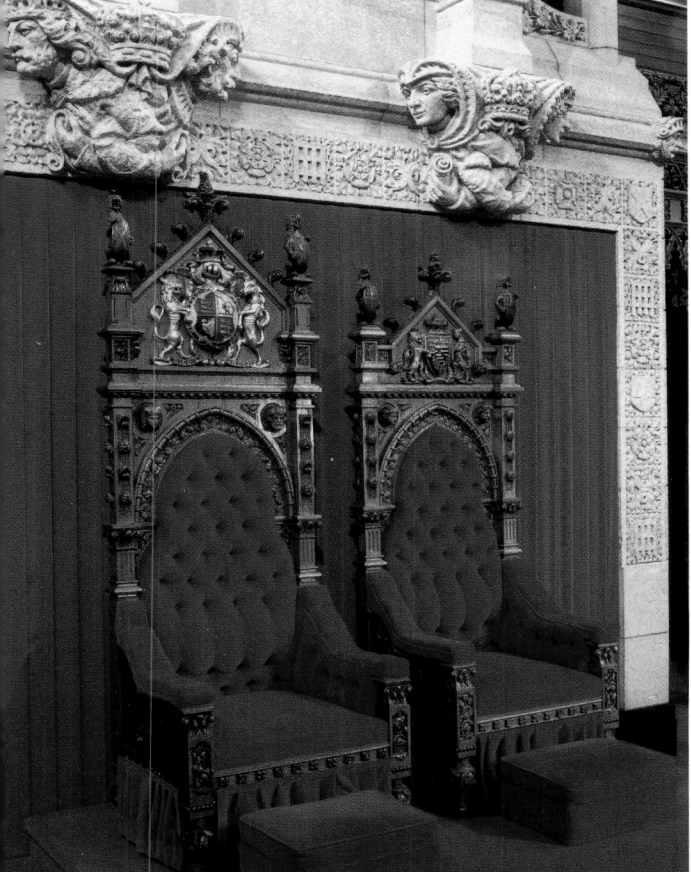

Top left: The mace of the Senate was saved from the disastrous fire of 1916.

Top right: Cherubs, heraldic figures and cresting are carved into oak panelling in the Senate chamber.

Bottom left: Canada's thrones, made in 1878, are used when the sovereign or governor general opens Parliament, and when royal assent is given to bills.

Left page: Two massive twelve-light chandeliers illuminate the Senate chamber. Each is made of statuary-cast bronze and weighs two tonnes.

Previous page: The Senate is the upper chamber of Canada's Parliament. Here, the sovereign or the governor general reads the Speech from the Throne to open Parliament and gives royal assent to bills. The red carpet is a reminder of the Senate's historical link to Britain's House of Lords. A Tyndall limestone bust of Queen Victoria stands behind the thrones of the sovereign and the royal consort, and the chair of the Speaker of the Senate.

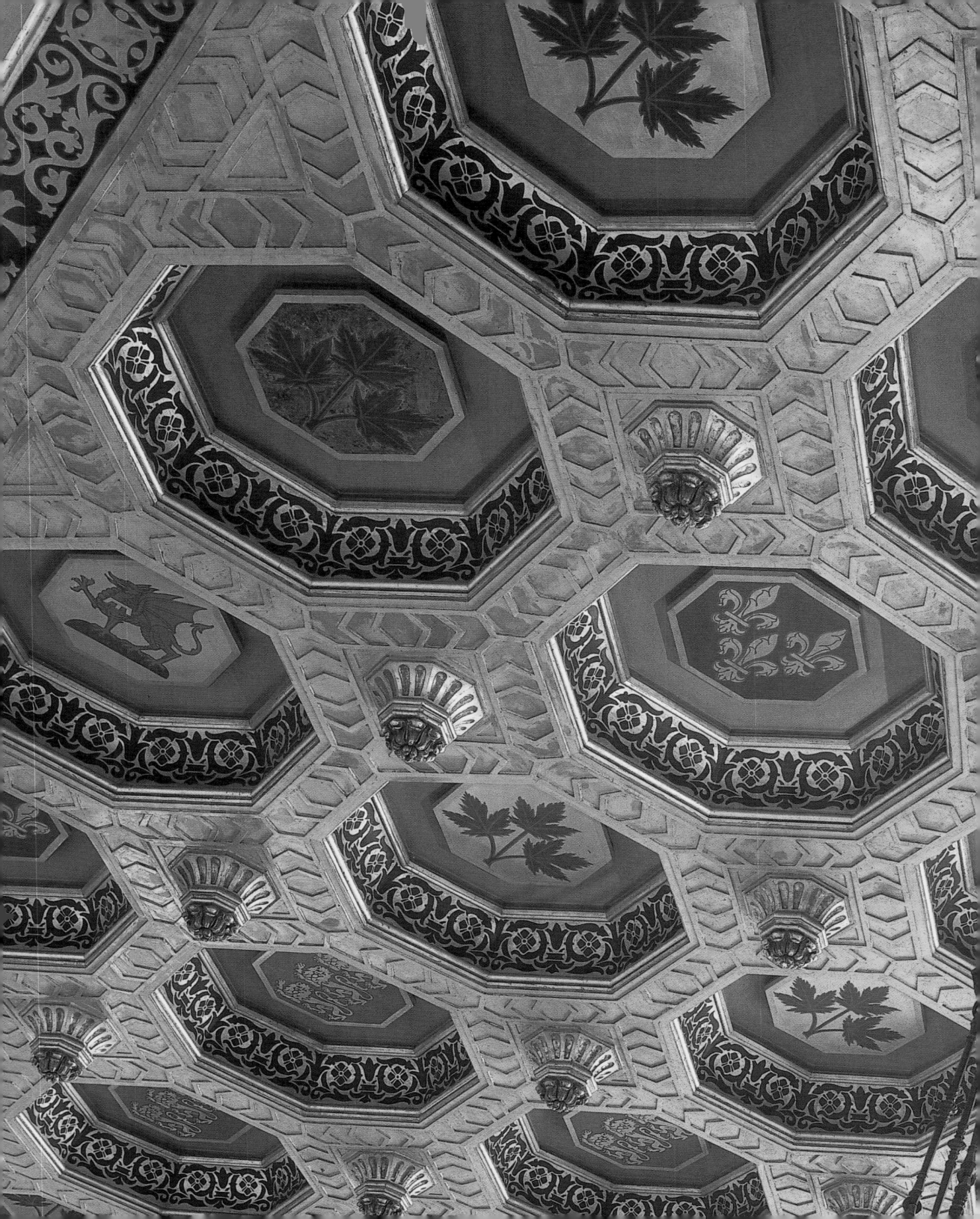

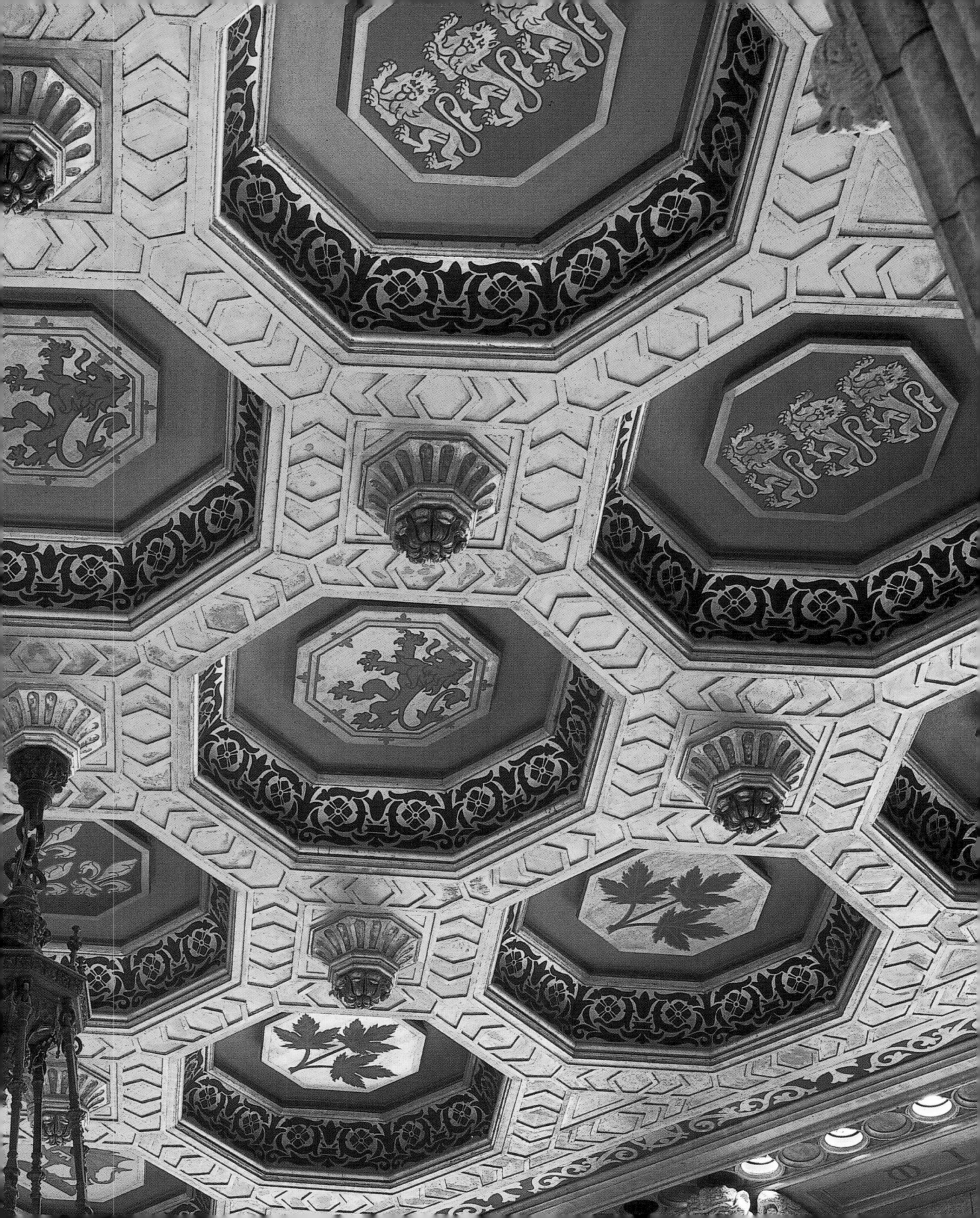

Previous page: Heraldic emblems of Canada, France, England, Scotland and Wales decorate the gold-leaf-coffered ceiling of the Senate chamber.

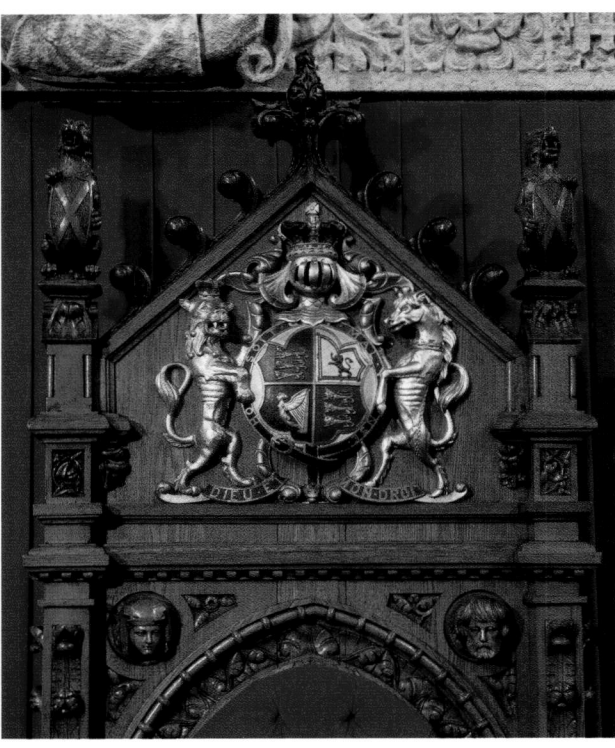

Left: The Royal Coat of Arms decorates the sovereign's throne.

Below: Hanging in the Senate chamber are eight magnificent paintings depicting war scenes. This painting shows the brutality of World War I and reminds lawmakers of the importance of wise government.

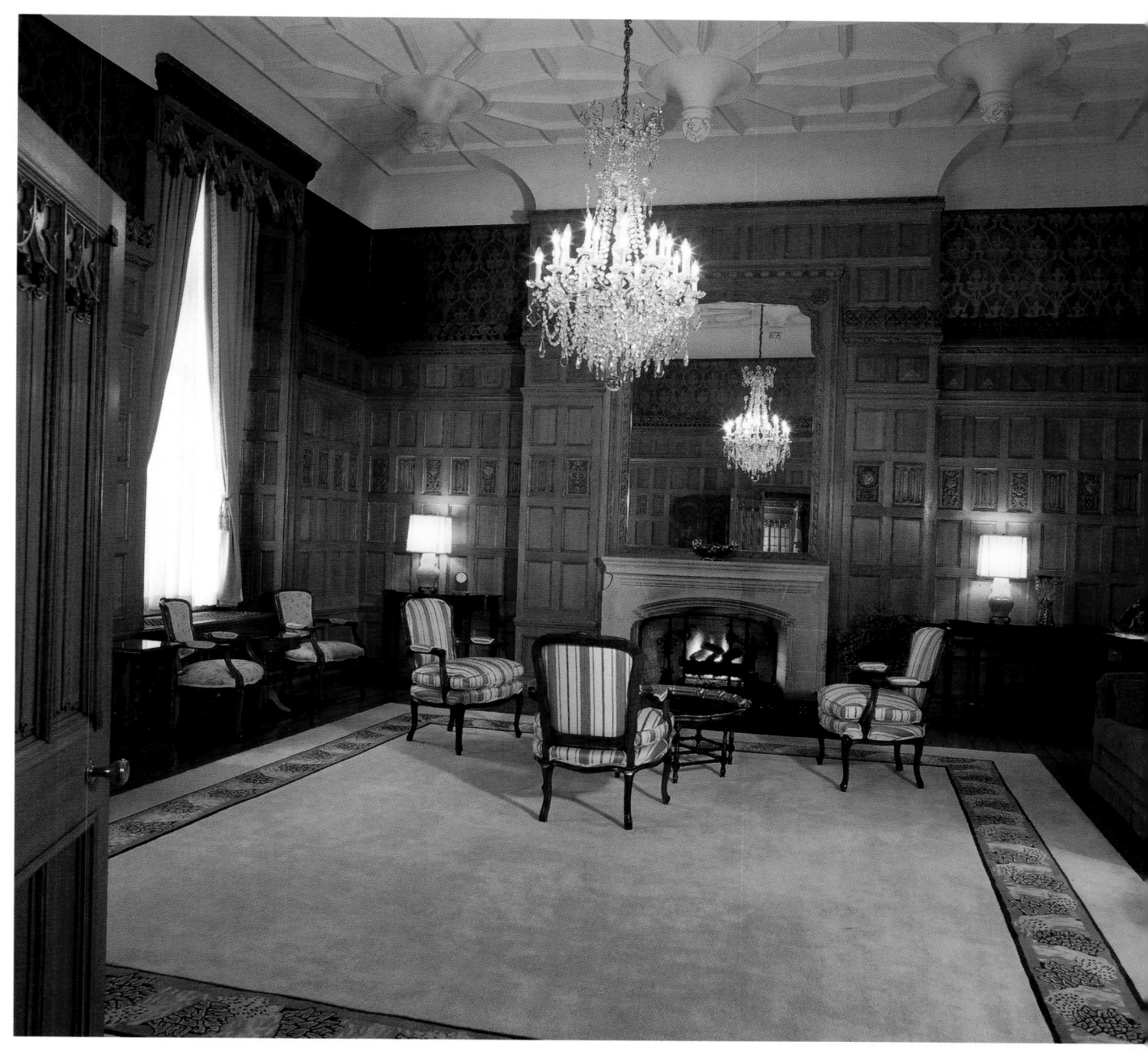

The Senate Speaker's
salon is inspired by early
sixteenth-century English
great houses of the Tudor
period. One of the salon's
striking features is its
Indiana limestone
fireplace.

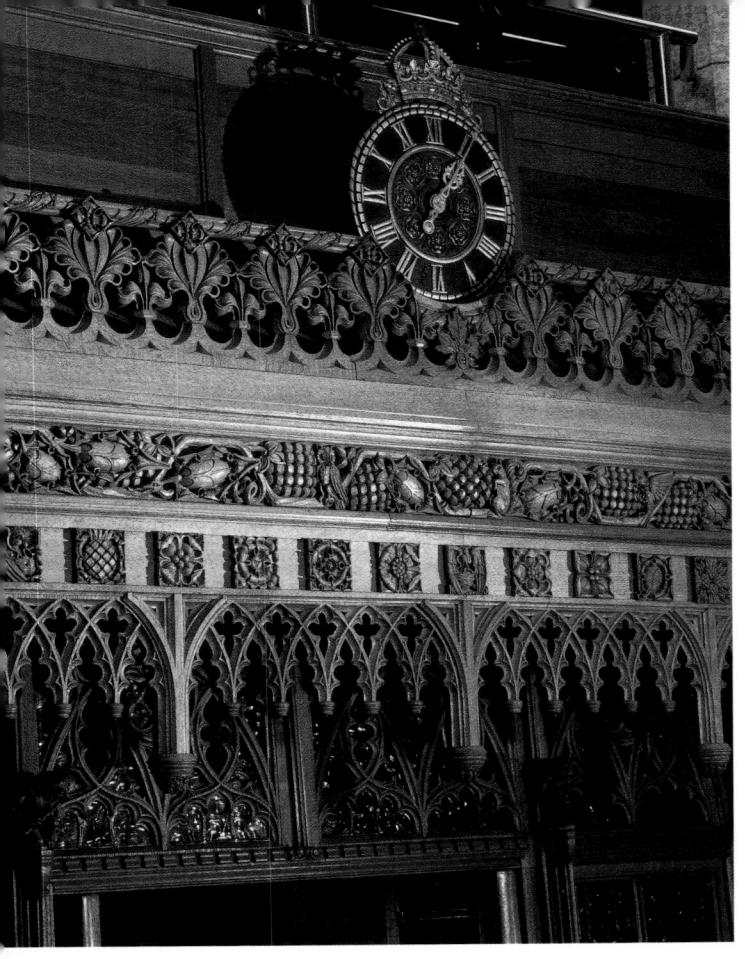

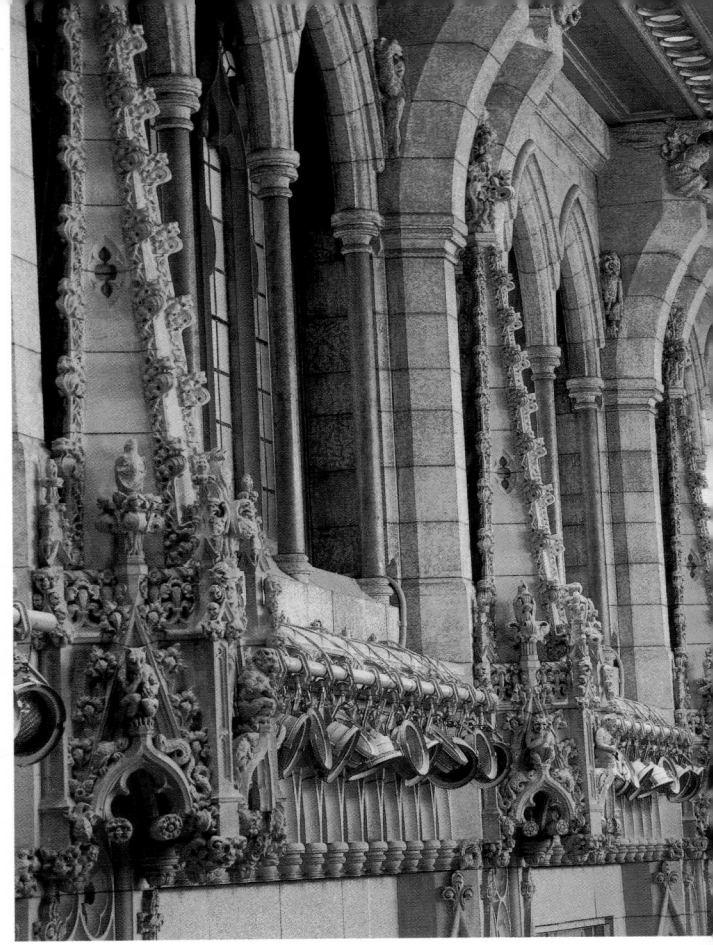

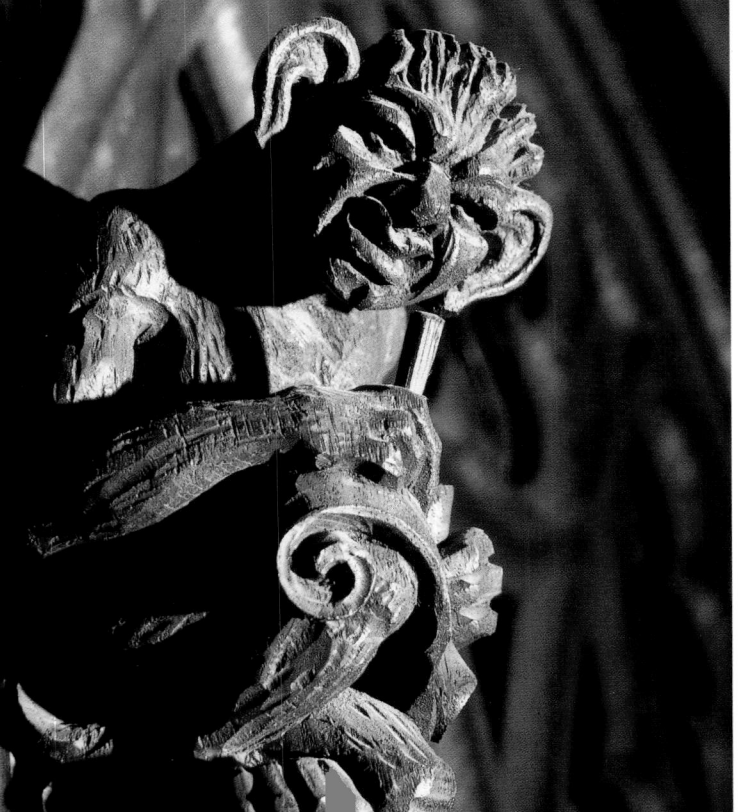

The Senate chamber is a masterpiece of stonemasonry and woodcarving. Heraldry, history and mythology are represented on virtually every surface. Below the ceiling, limestone canopies exhibiting miniature bosses and crockets resemble lace. A wooden screen is decorated with cresting, grapevine frieze and finely carved patere. A whimsical wooden figure shows the humour that went into much of the Parliament Buildings' artwork.

Opposite page: July 1: Canada Day fireworks cast their glow over thousands of Parliament Hill visitors and on the clouds above them.

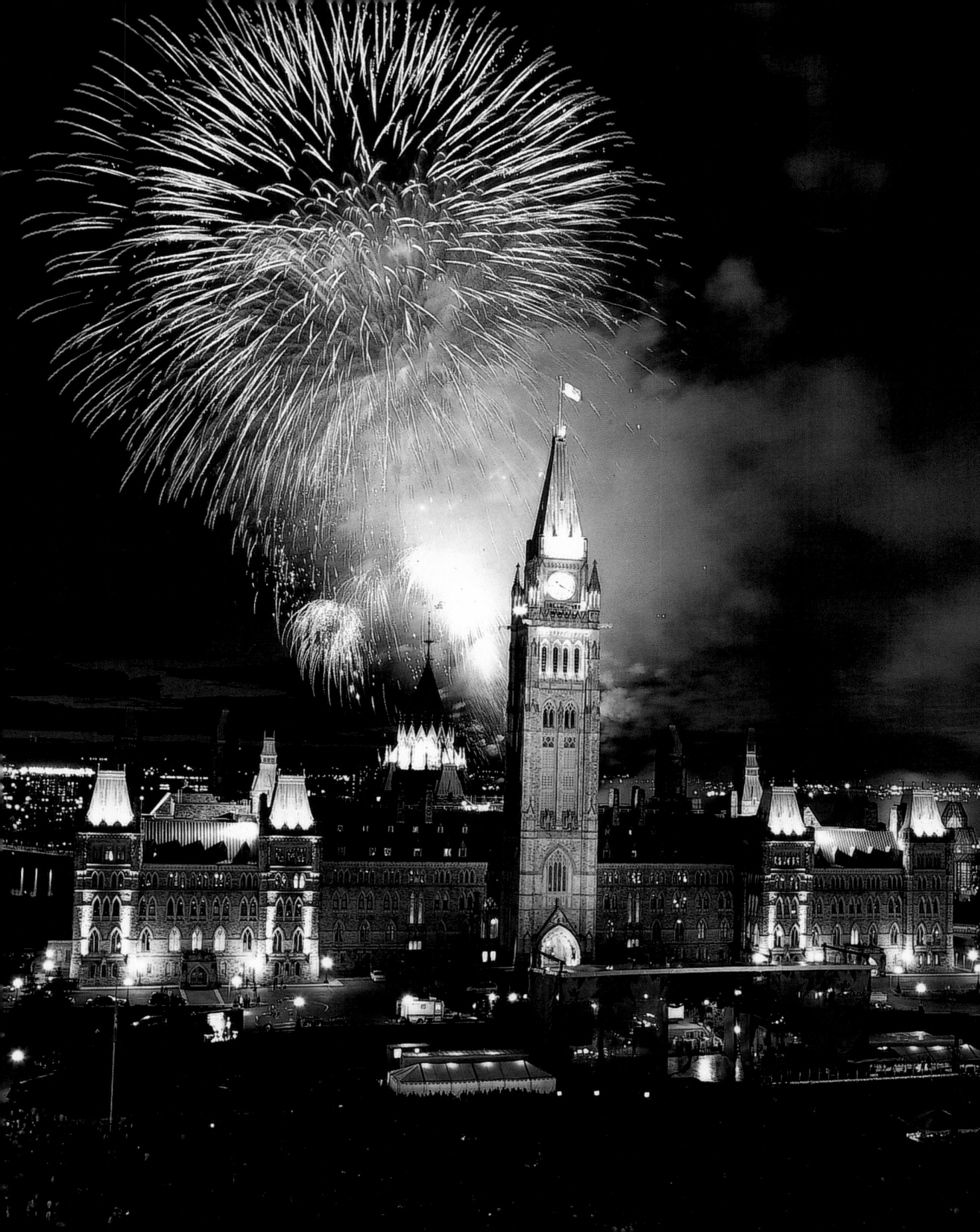

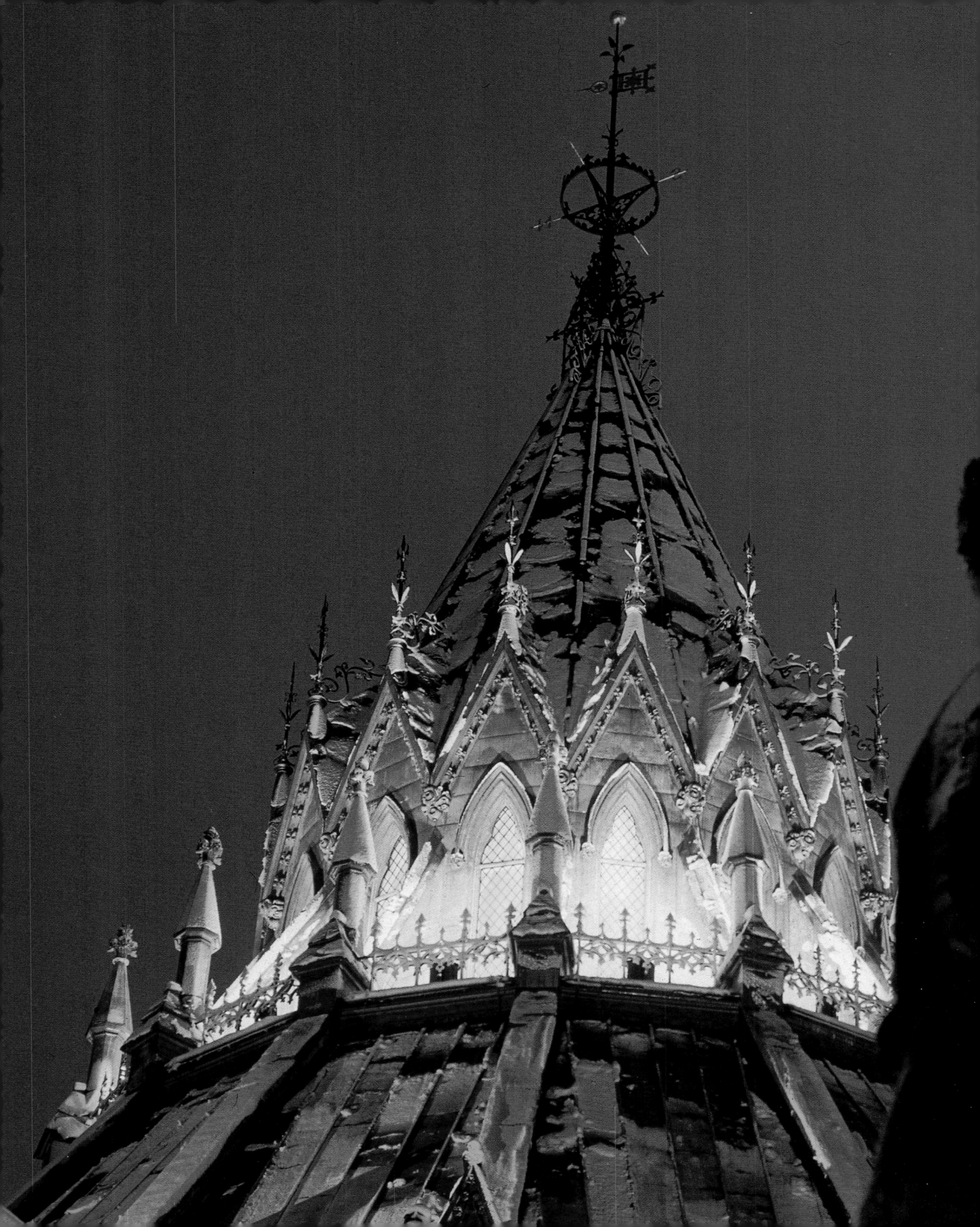

The Library

The statue of Irish rebel and Father of Confederation D'Arcy McGee was hidden by foundry workers in occupied Belgium during World War I before finding a safe home outside the Library of Parliament.

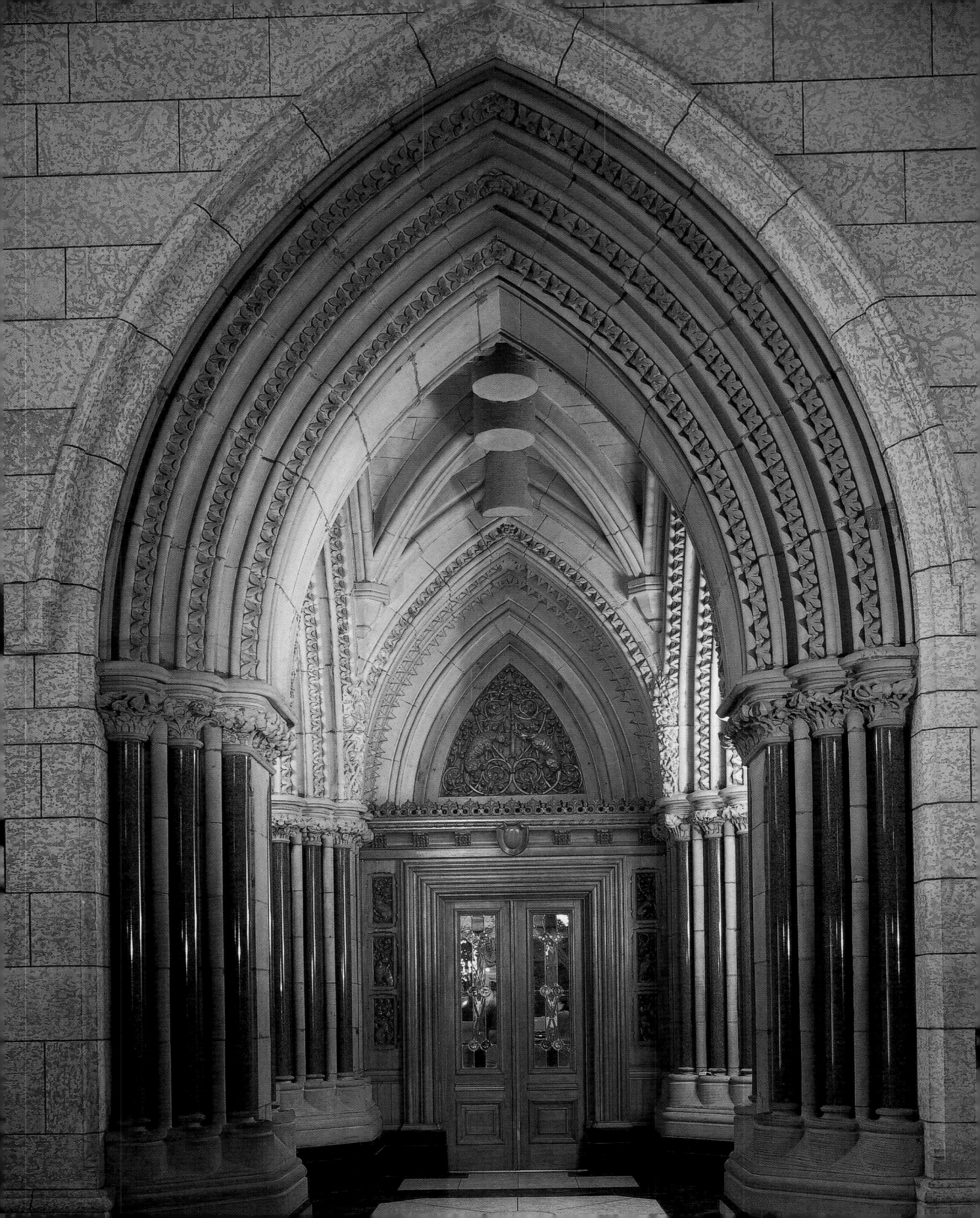

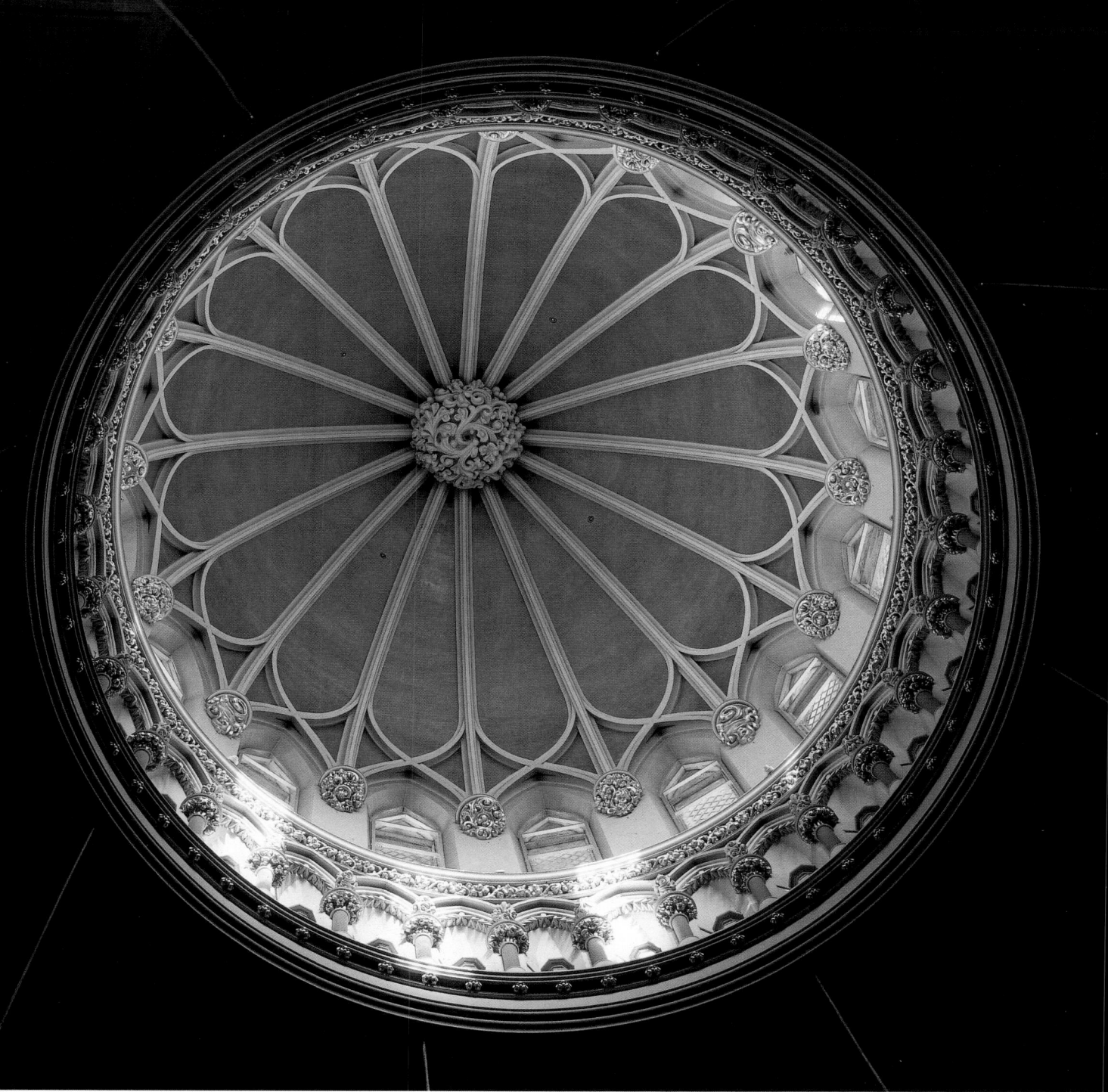

Above: The gilded cupola of the Library's lantern allows sunlight to illuminate the interior of the jewel of Parliament.

Left page: This stone and wood entrance links the Library of Parliament to the Hall of Honour. Behind the stained glass doors are a set of iron doors that saved the Library from the fire that destroyed the original Centre Block in 1916.

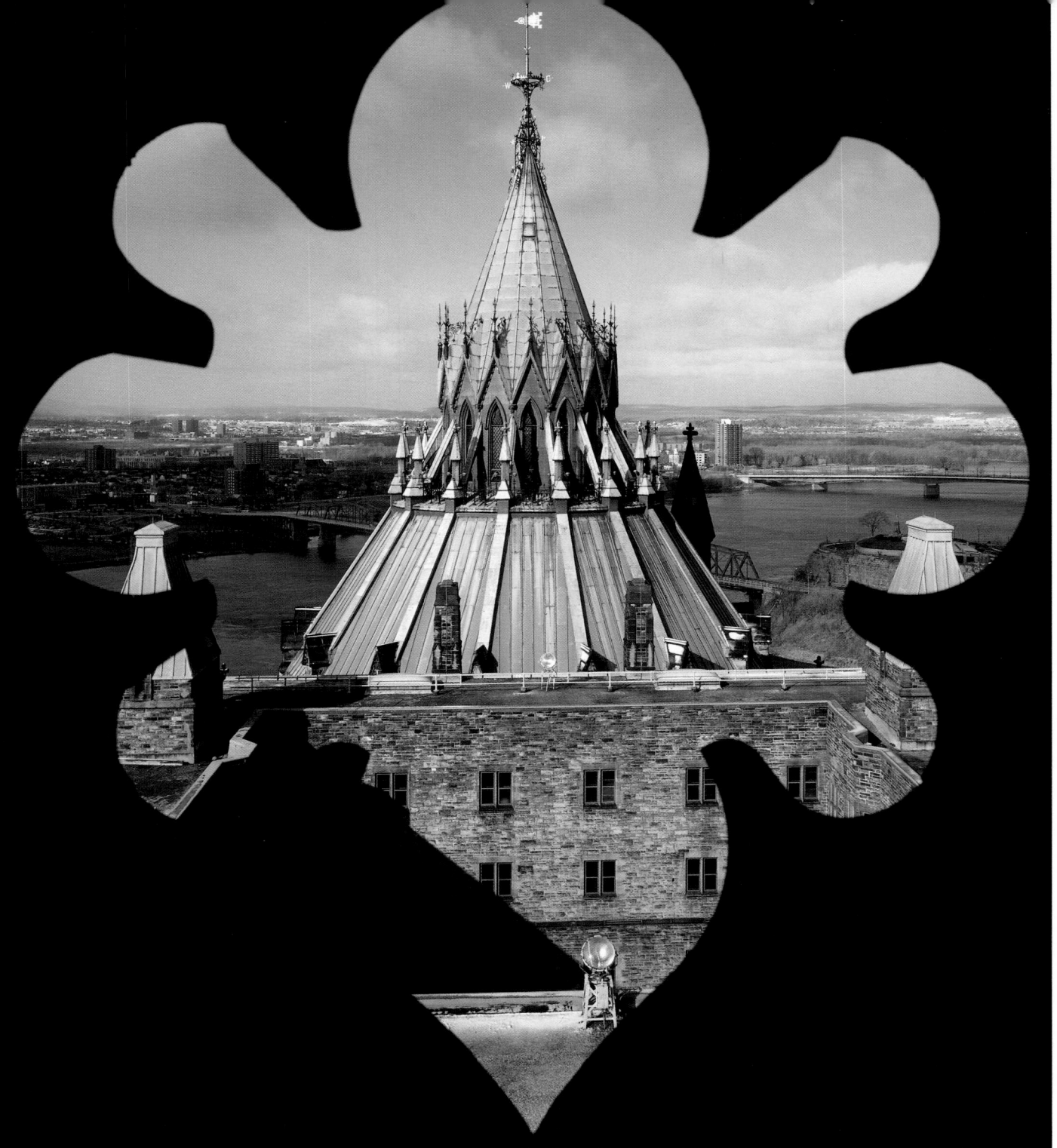

Above: While the capital region around it has evolved from a couple of rowdy lumber towns to a region of over a million people, the Library's steeple copper roof has remained unchanged since 1889.

Right page: A young Queen Victoria is surrounded by thousands of books on history, law and politics.

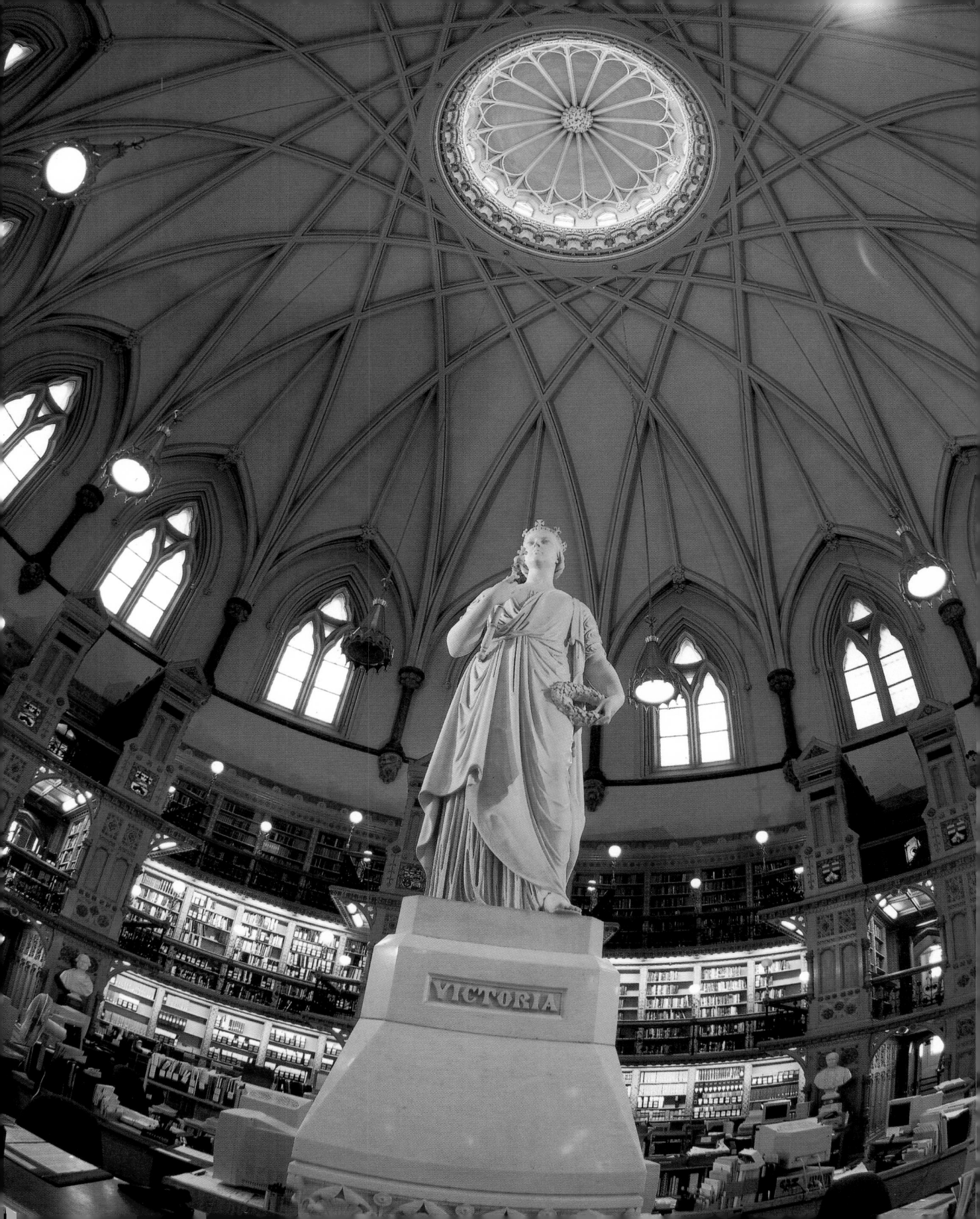

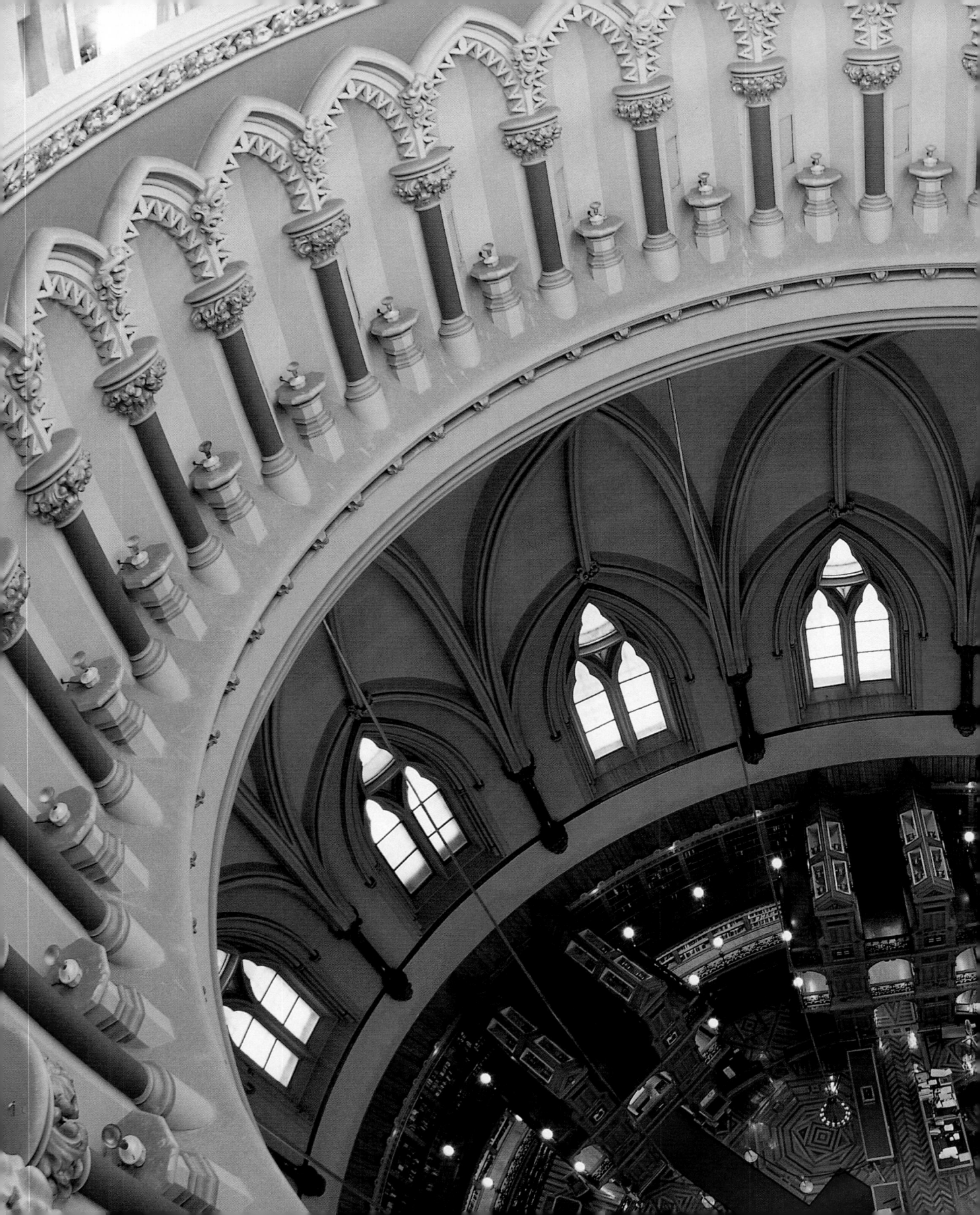

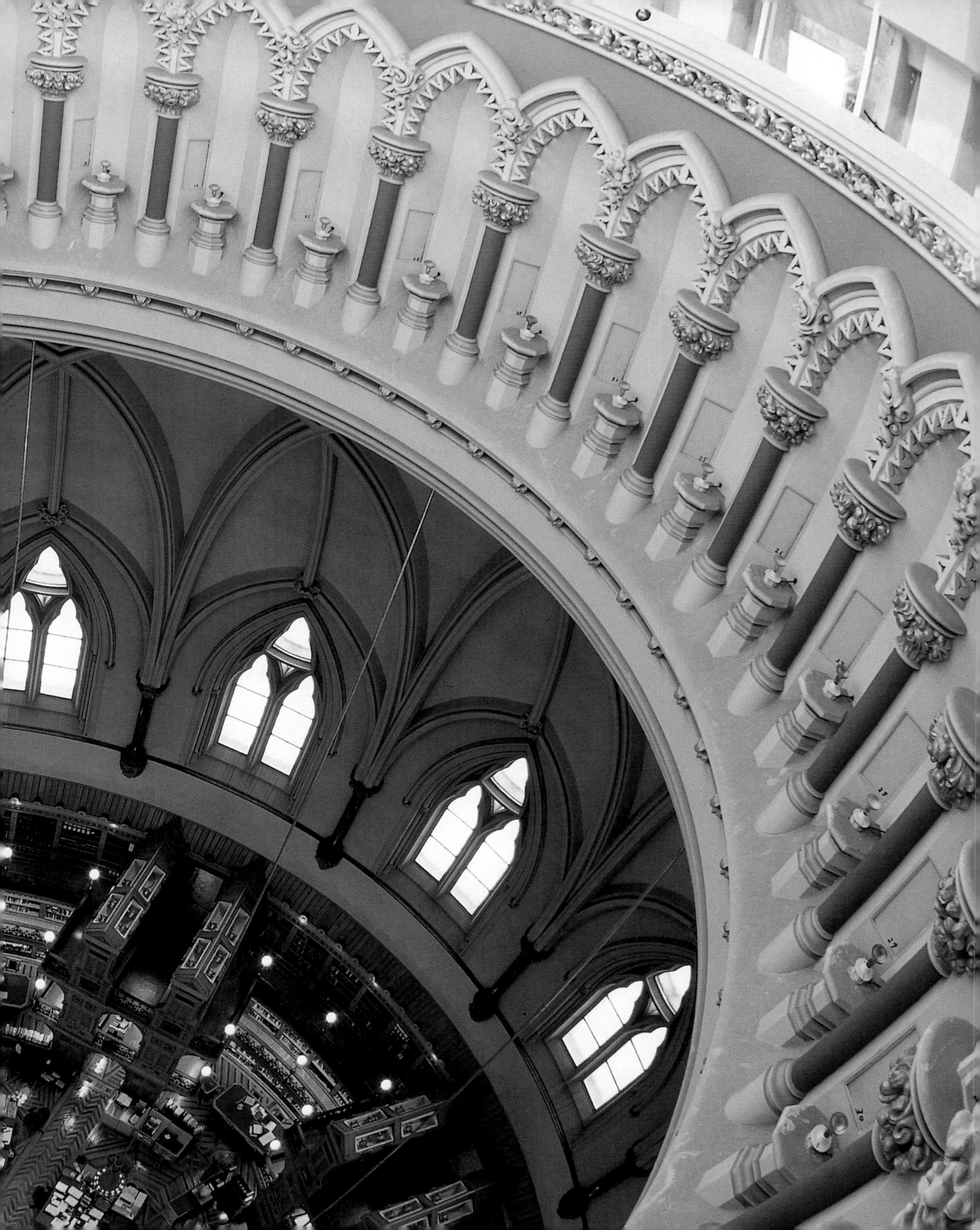

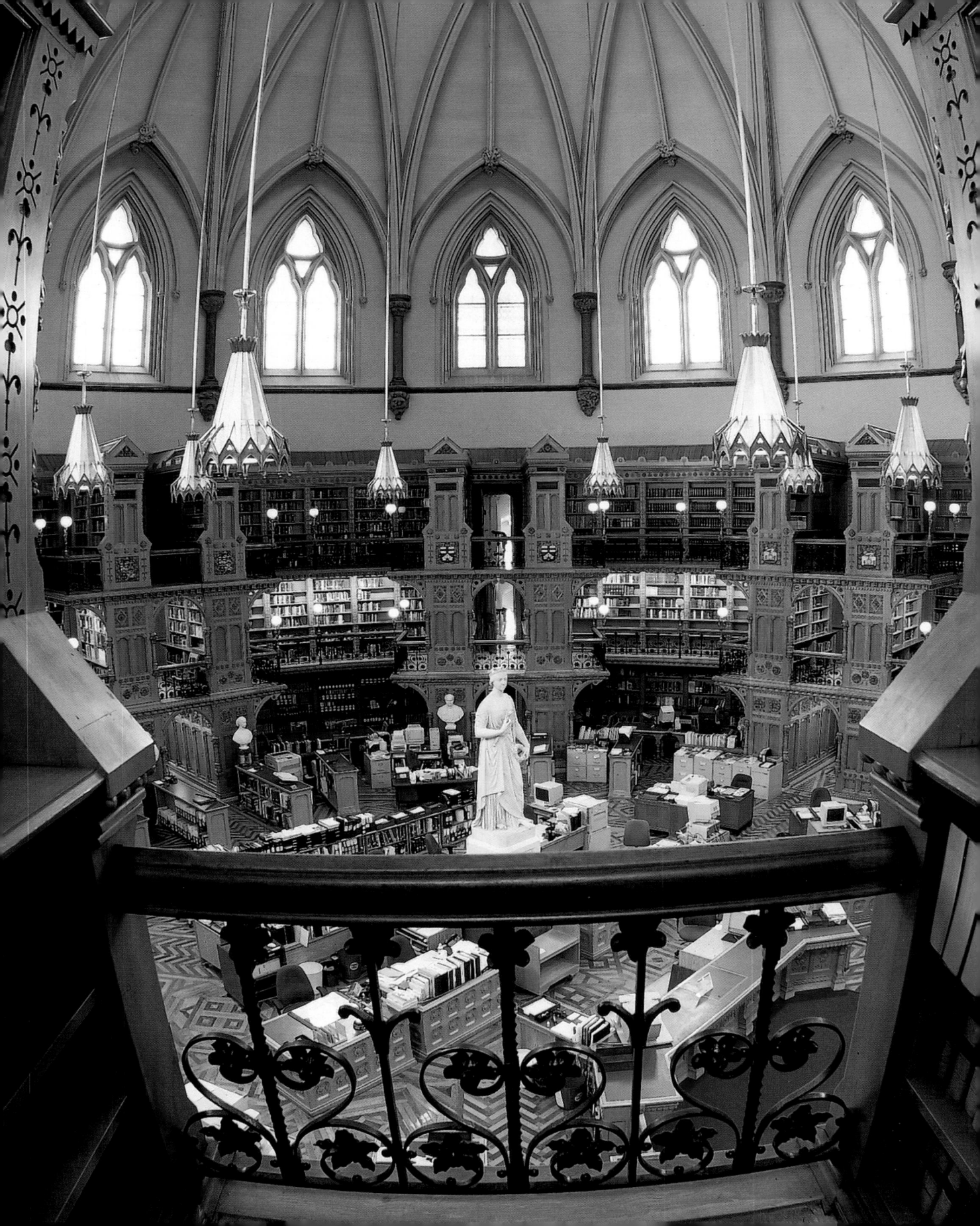

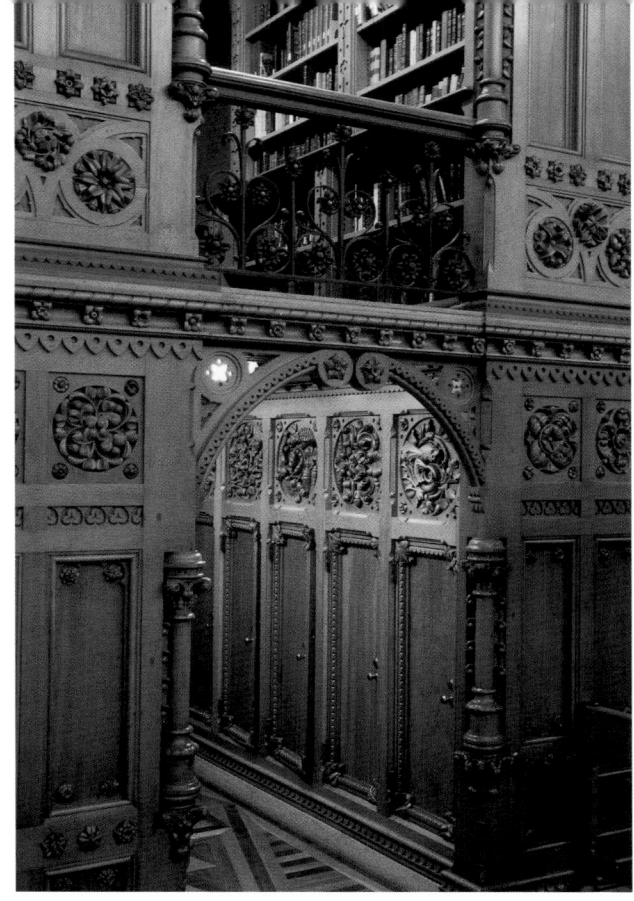

Previous page: The catwalk in the lantern's cupola gives a bird's-eye view of the Library. Below, librarians gather information for senators, members of the House of Commons, parliamentary staff and members of the press gallery. Hundreds of people visit the Library every day, standing on the wood floor and gazing at one of Canada's most beautiful interiors.

Left: Only a fraction of the books in the Library of Parliament can be seen from the galleries that link the stacks. The rest of the collection is in two floors below the Library lantern and in branch libraries on Parliament Hill, as well as in an off-site storage facility.

Below: The galleries that encircle the interior of the Library were crafted from white pine. Thousands of fine sculptures, such as rosettes and masks, cover the wooden panelling.

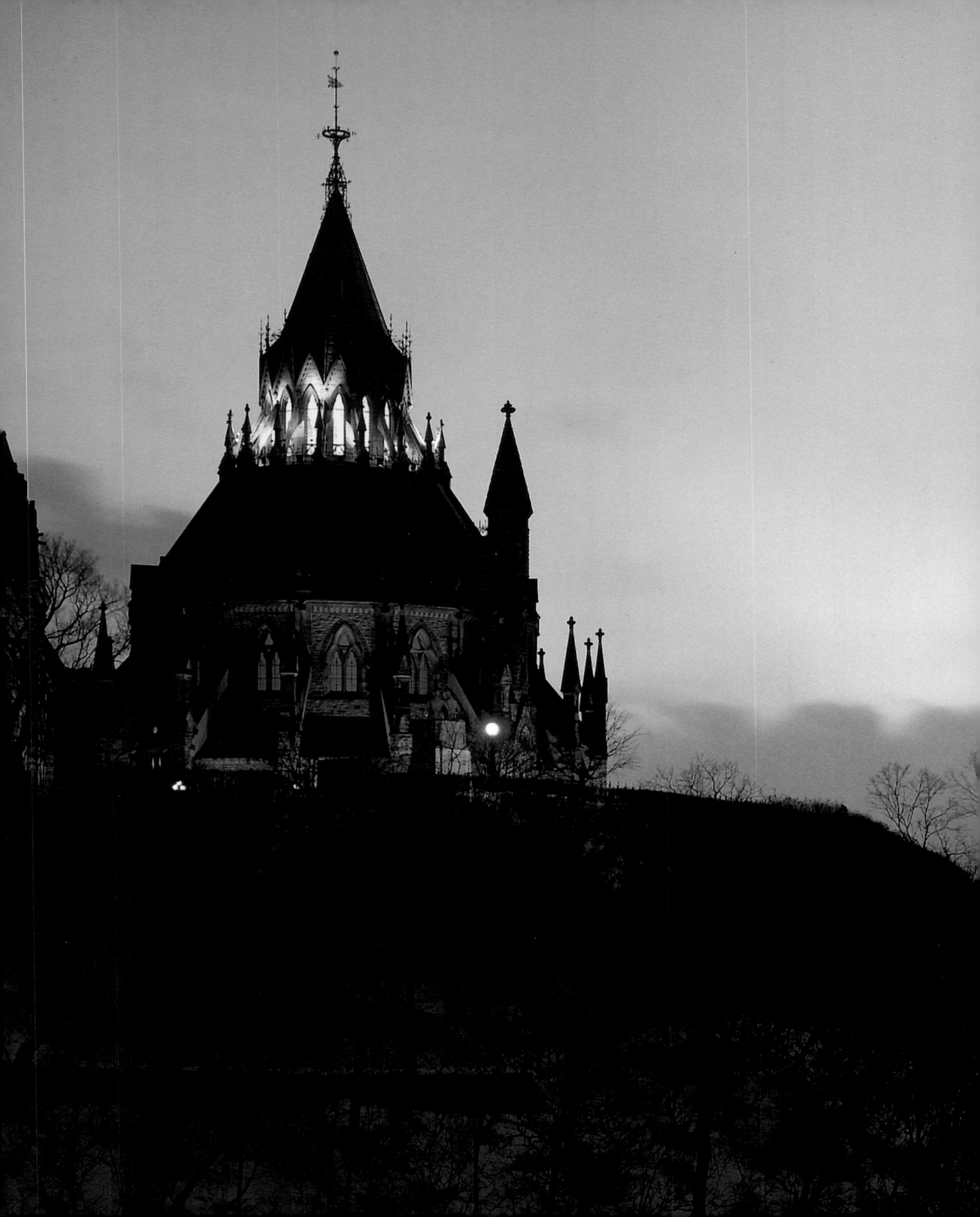

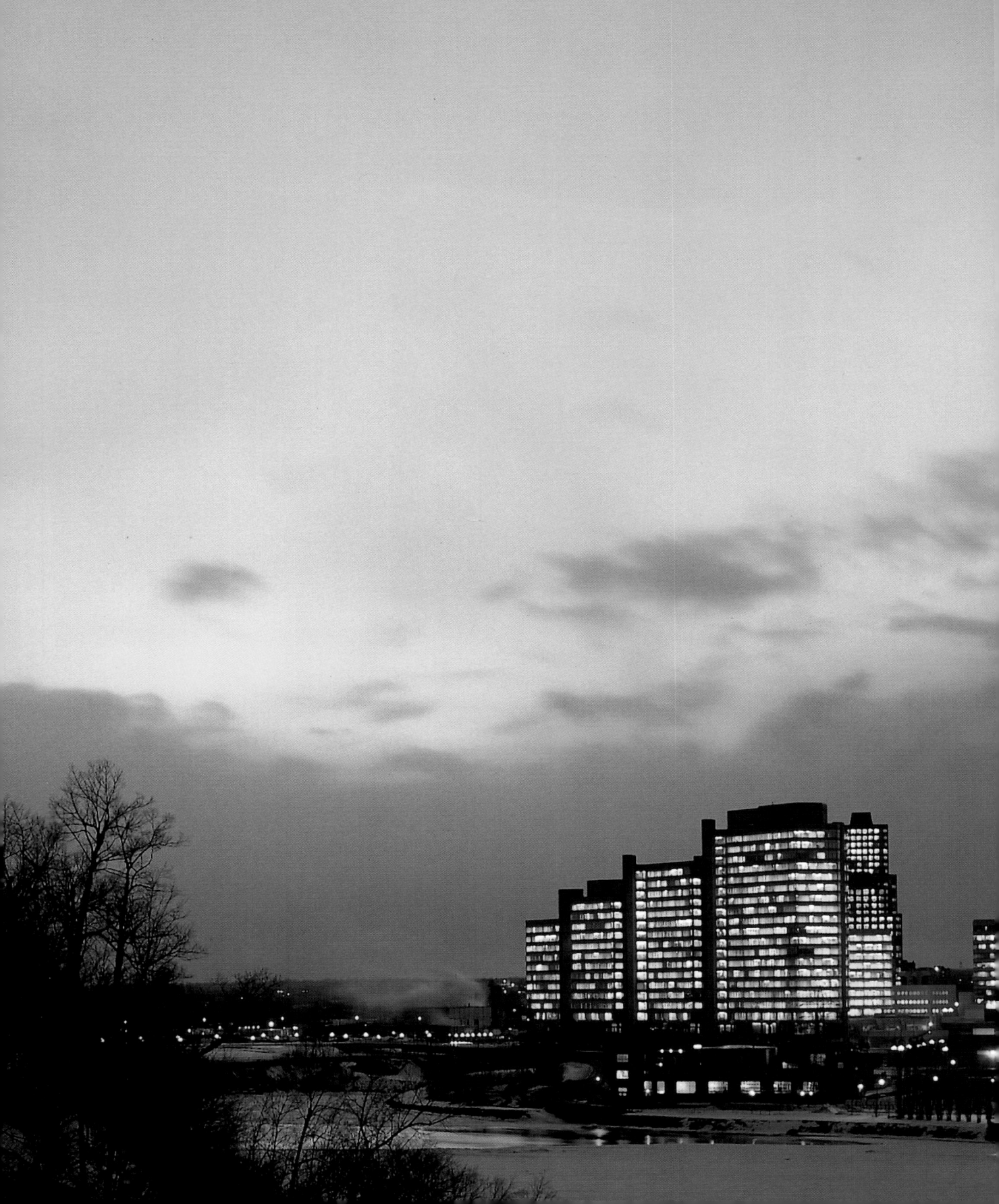

The East and West Blocks

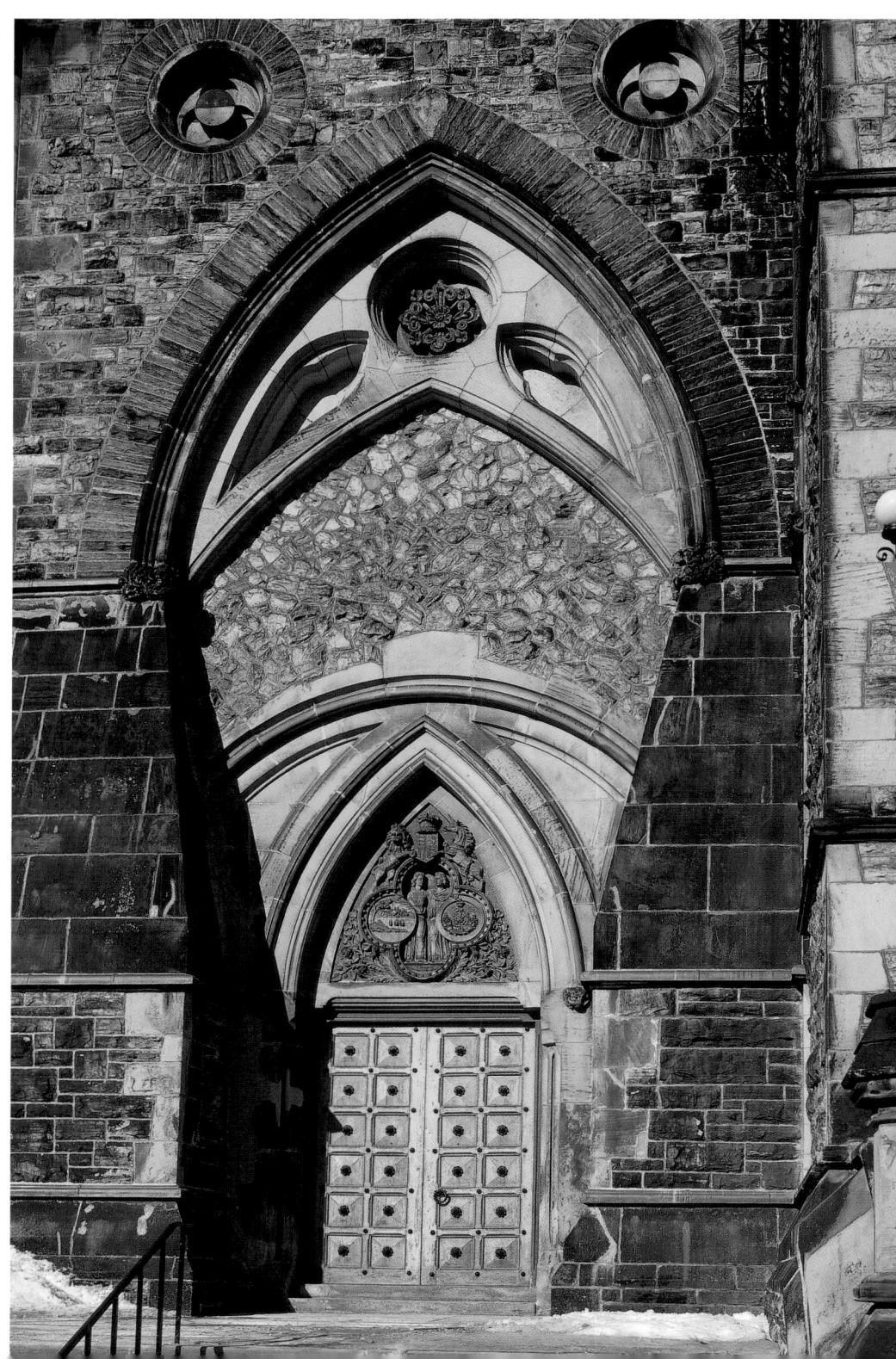

Previous page: On a cold winter night, the Library's stark exterior hides the warm elegance of the interior of this masterpiece of High Victorian Gothic Revival architecture. The modern skyline of downtown Hull contrasts sharply with the nineteenth-century lantern and flying buttresses of this enduring Canadian landmark.

Right: One of the main doors of the East Block is said to resemble a giant keyhole or a bishop's mitre. Construction on this building began before Confederation.

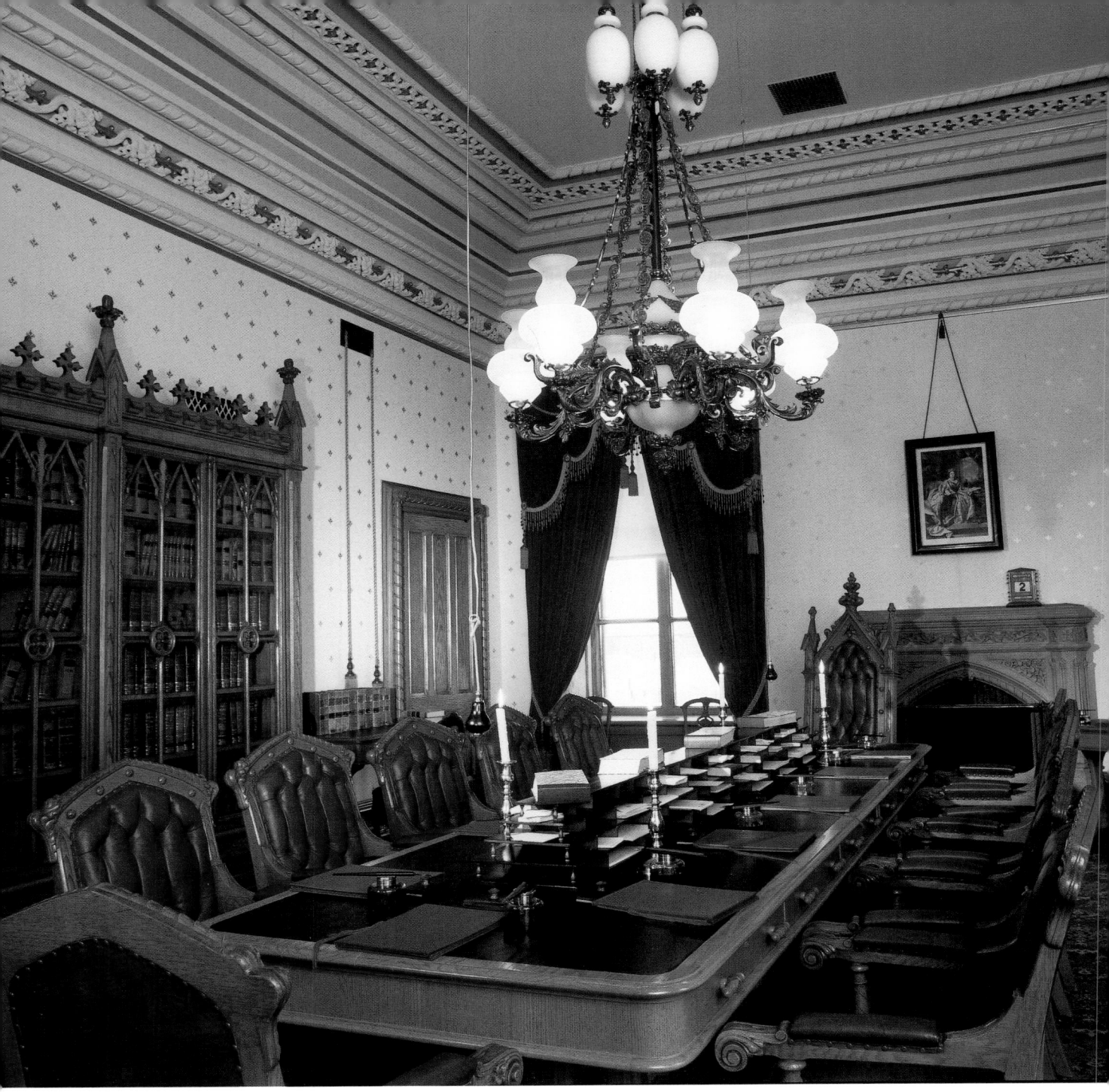

A reproduction of the original oak table used for cabinet meetings was made as part of the restoration of the East Block's historic Privy Council room.

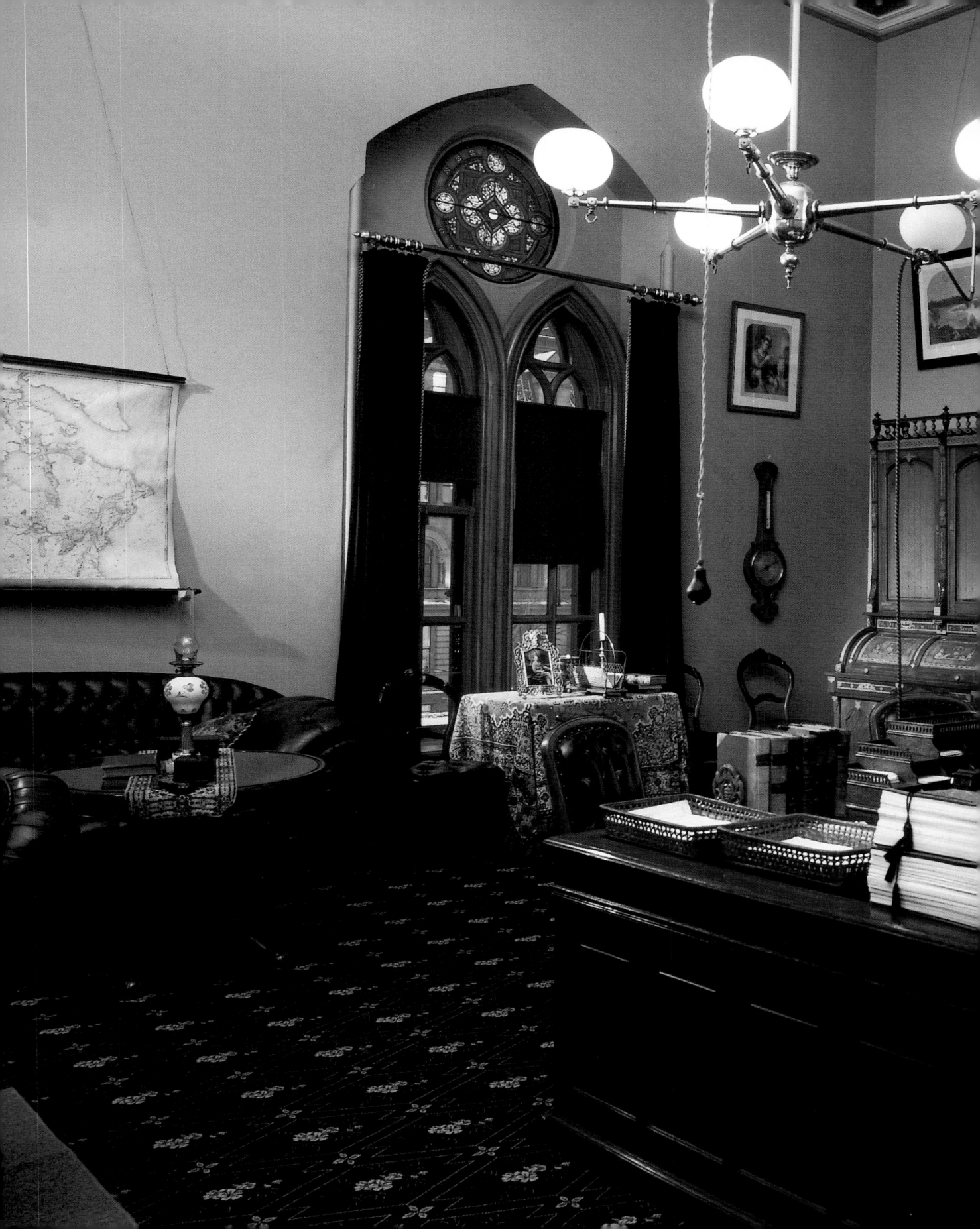

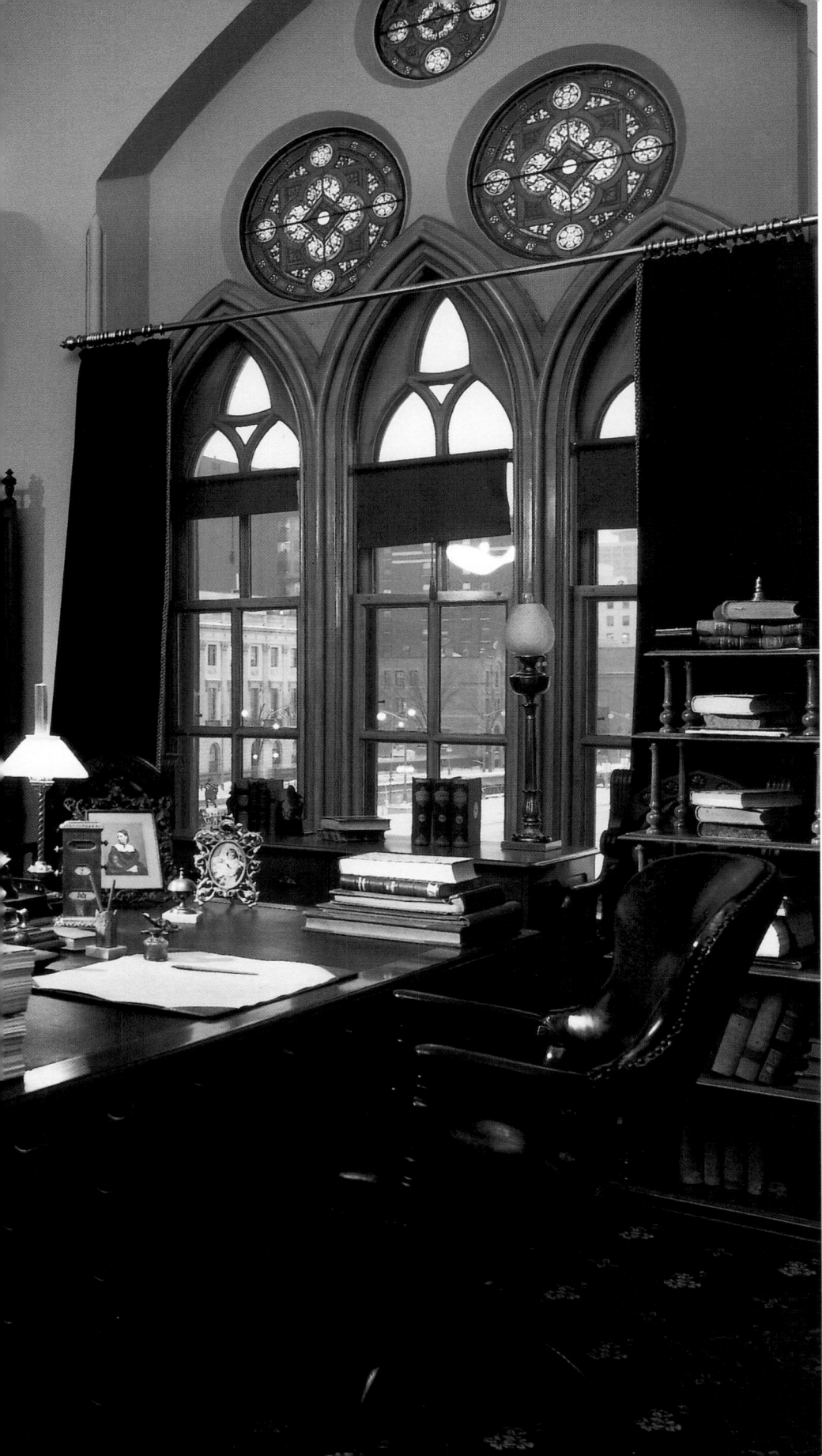

Prime Minister Sir John A. Macdonald's office in the East Block has been carefully restored and is open to the public.

Above: The East Block office of Lord Dufferin, one of Canada's early governors general, has been meticulously restored.

Bottom: Even the hats and scarves of Canada's early leaders have been returned to the East Block's restored rooms.

Opposite page: Although Sir George-Étienne Cartier was never prime minister of Canada, his importance to Confederation is commemorated in his restored East Block office, which Cartier occupied until 1873. A quarter of a century later, the room became the office for all prime ministers until the 1975 move across the street to the Langevin Block.

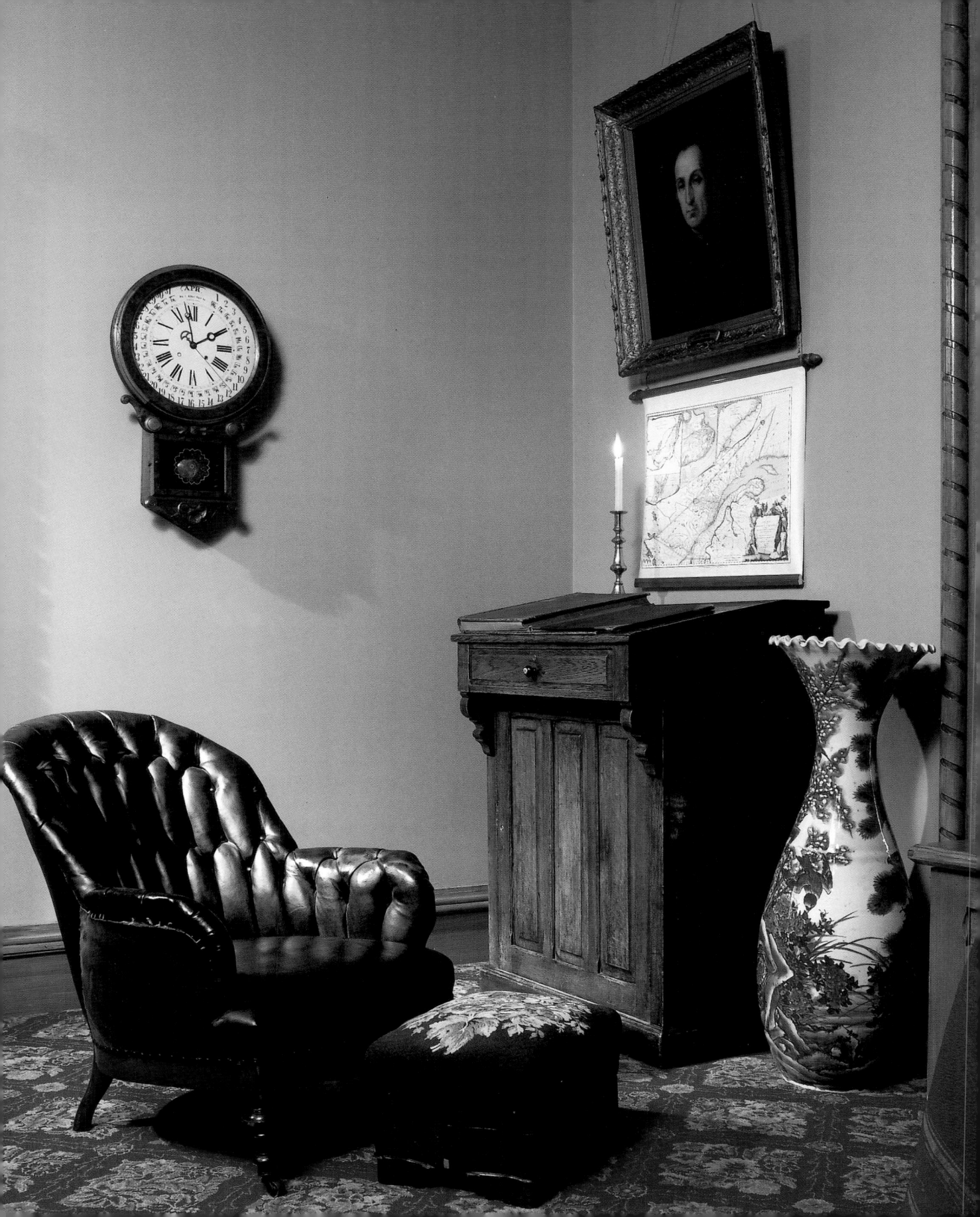

Above and left: While Prime Minister Sir John A. Macdonald worked at this desk, the nation's gold reserves were safely tucked away in these East Block vaults. Sometimes, the Prime Minister walked down to the basement to visit them.

Opposite page: Crystal chandeliers illuminate the ballroom in the West Block.

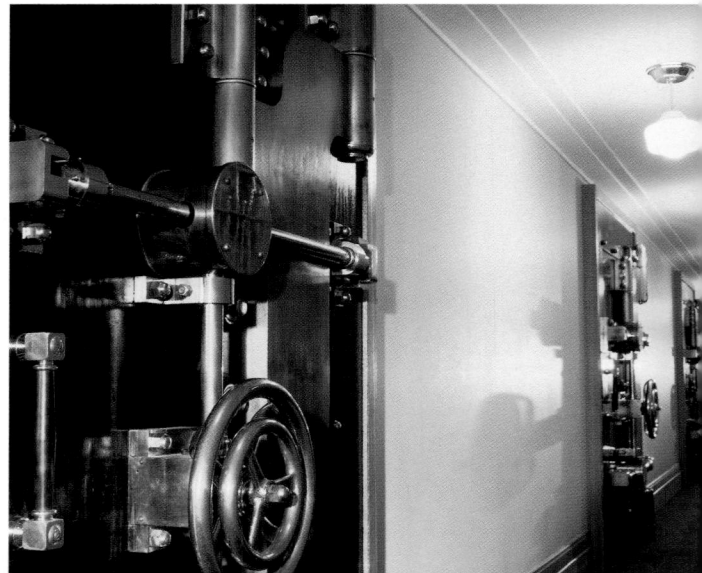

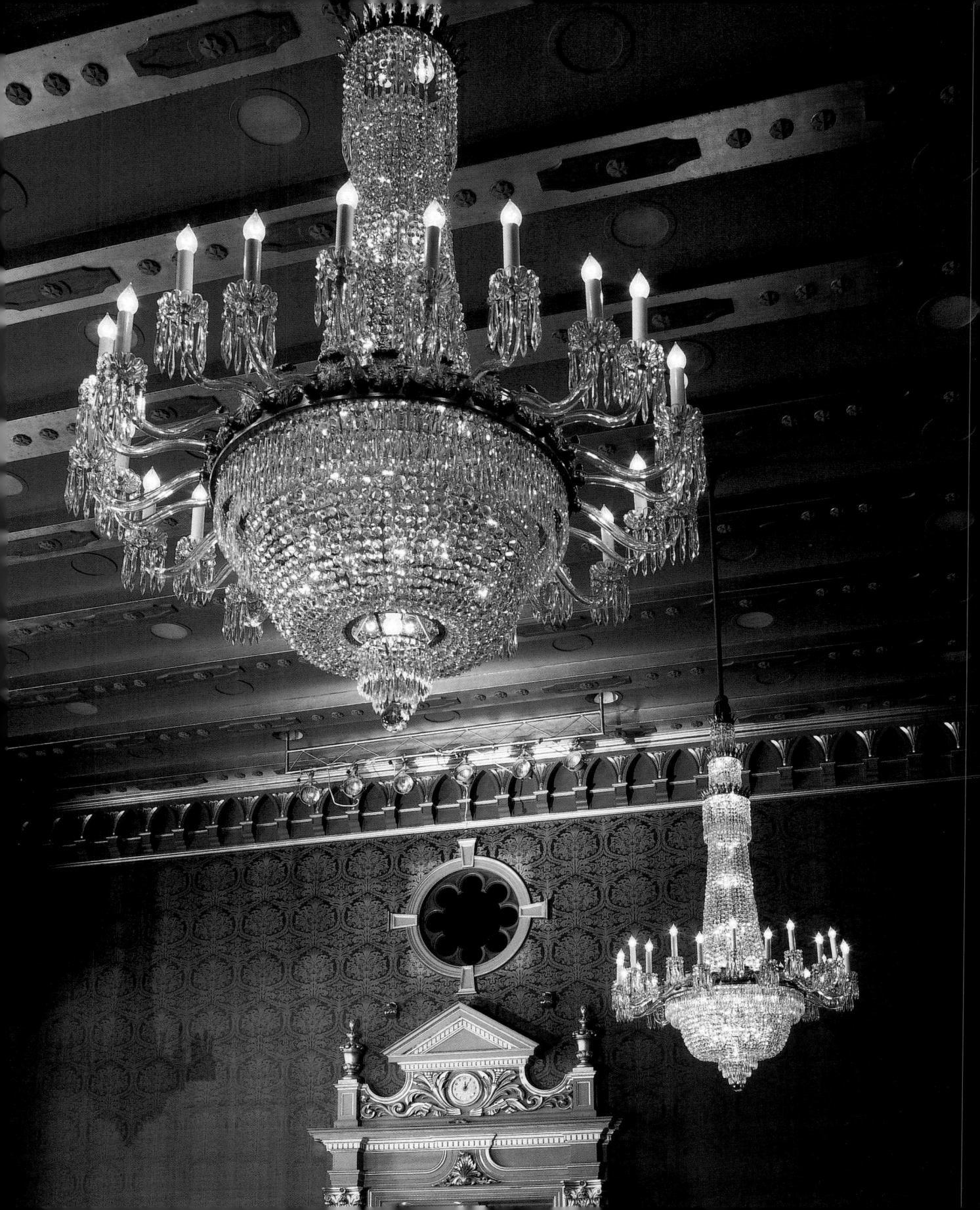

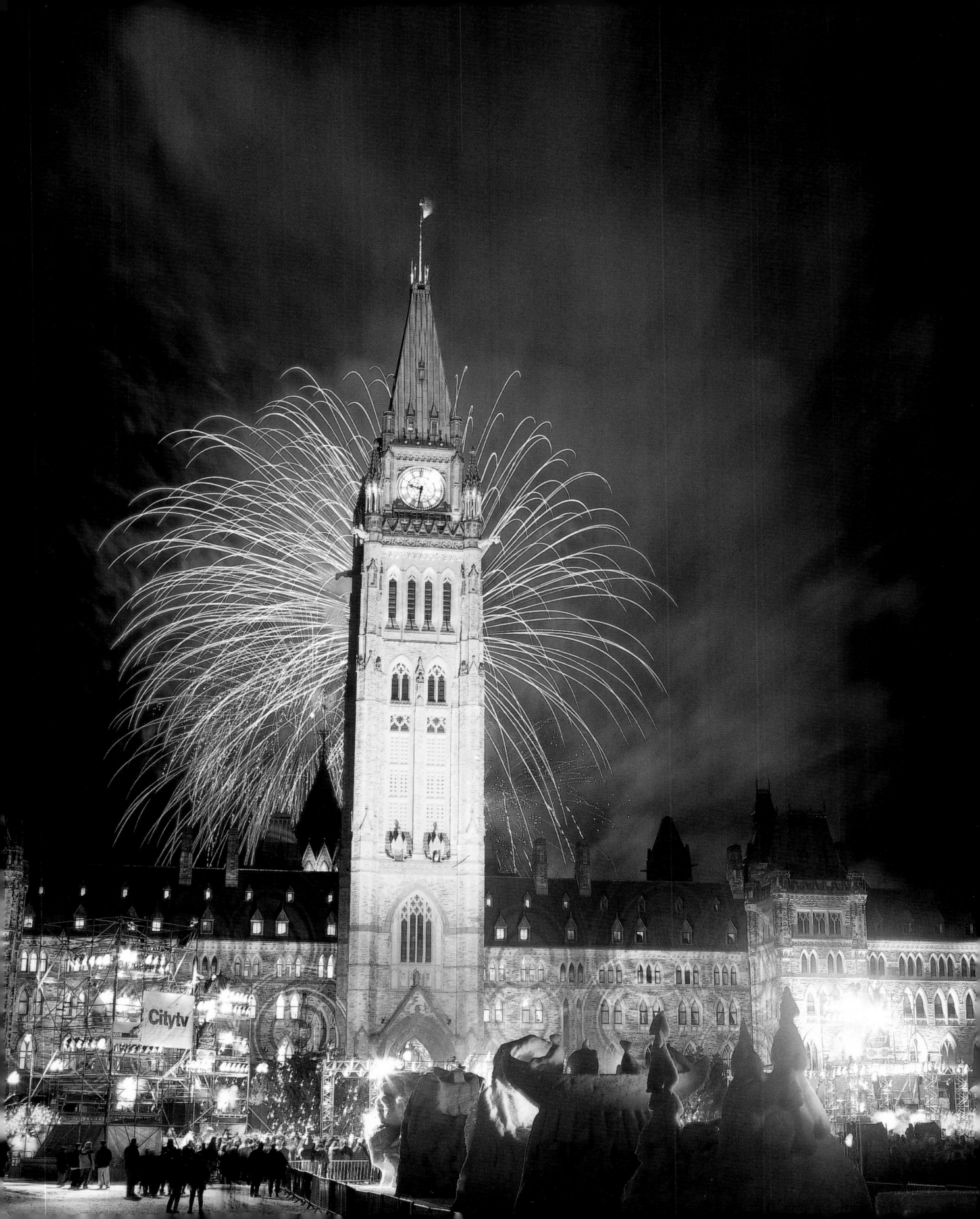

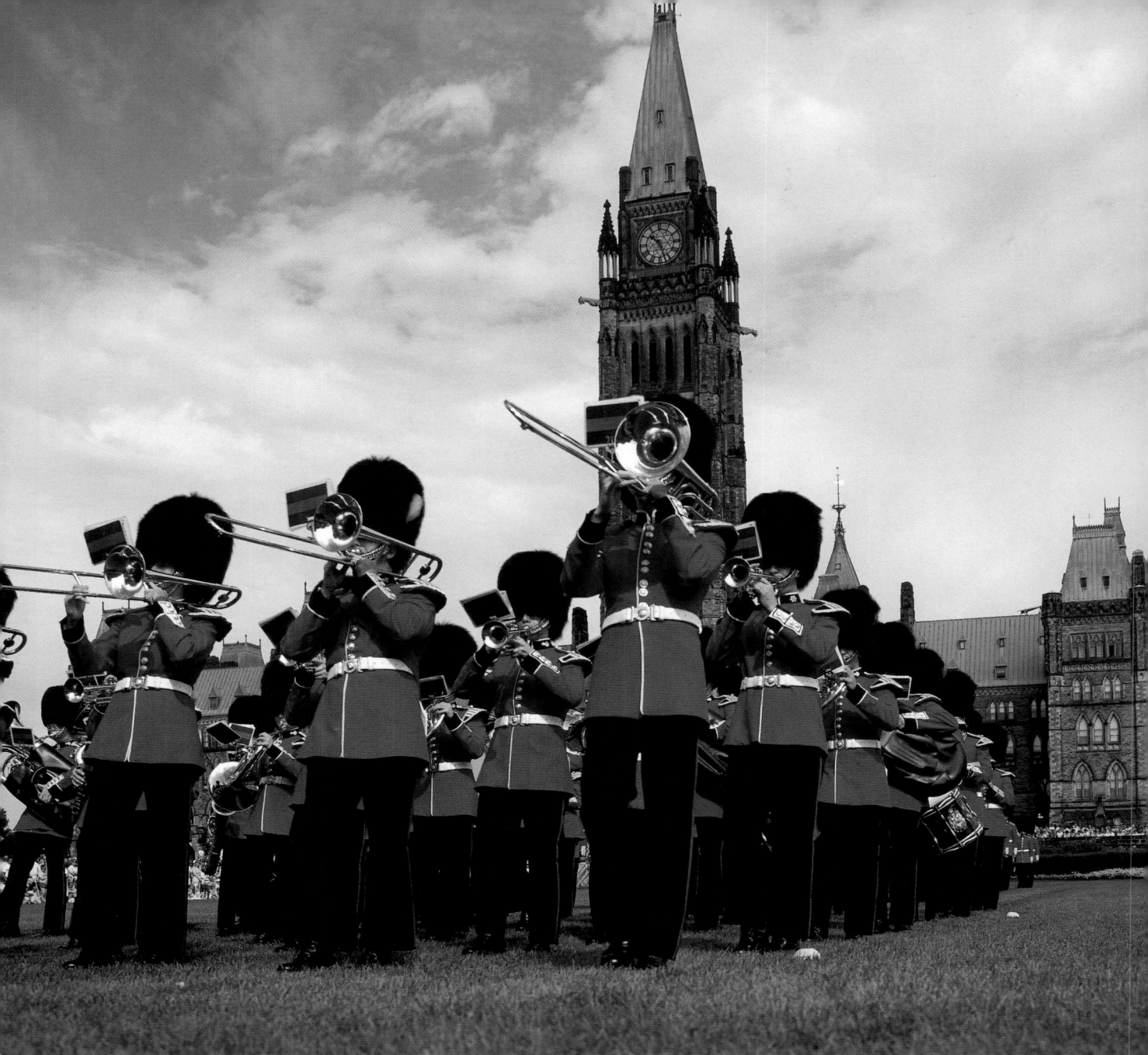

Left page: The Centre Block glows with floodlights and fireworks during the capital's Winterlude celebrations. Snow sculptors from each of Canada's provinces create short-lived works of art on the lawn of the parliamentary precinct.

The ceremonial summertime Changing of the Guard is popular with visitors to Parliament Hill.

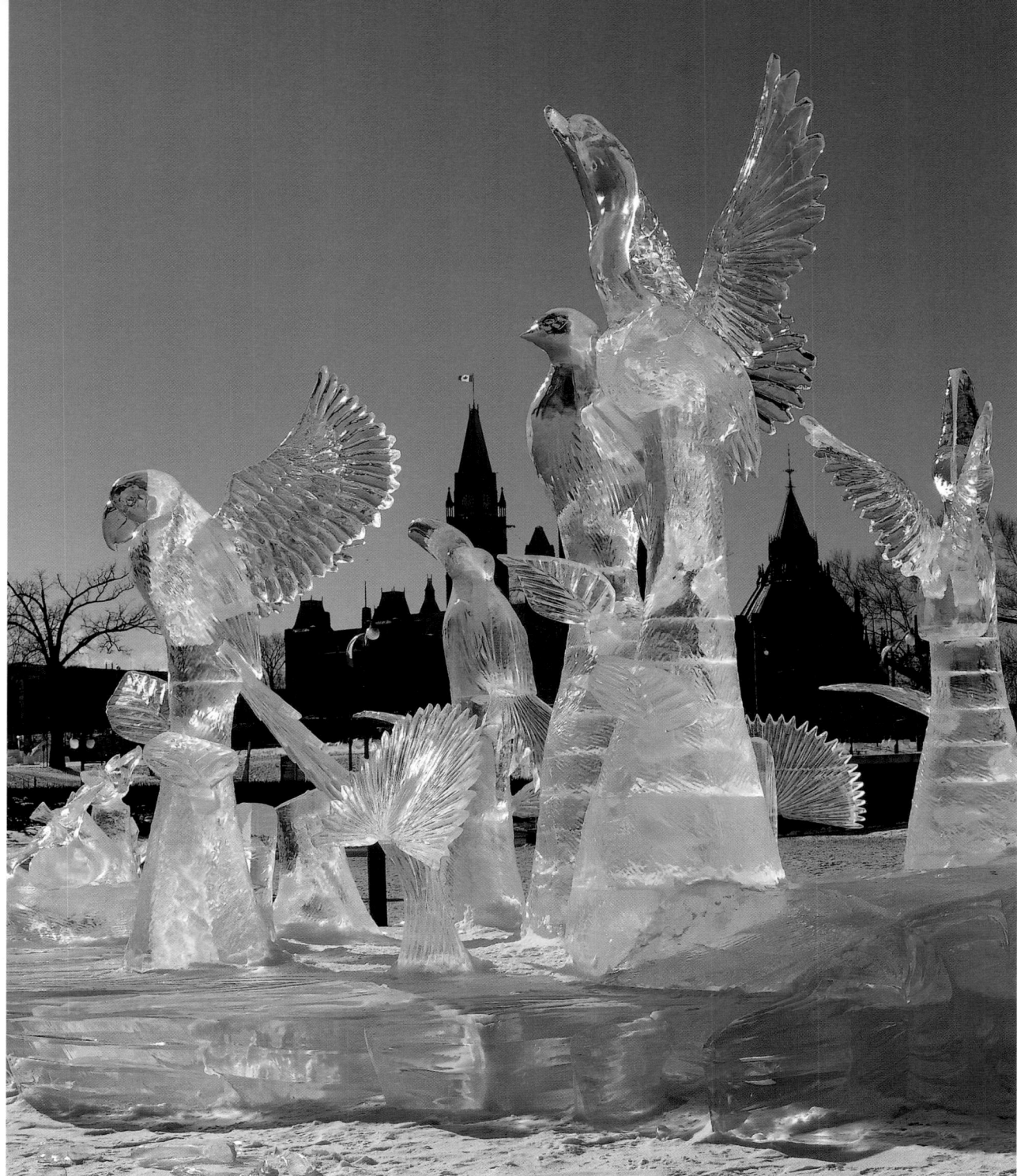

Above: Winterlude festival ice sculptures add beauty to downtown Ottawa during the cold weeks of February.

Right page: No other city combines the old and the new as well as Ottawa. Skaters crowd the Rideau Canal near the National Arts Centre, with Parliament Hill in the background.

Following page: A life-sized painting of King Edward VII, striking a majestic pose, in the foyer of the Senate.

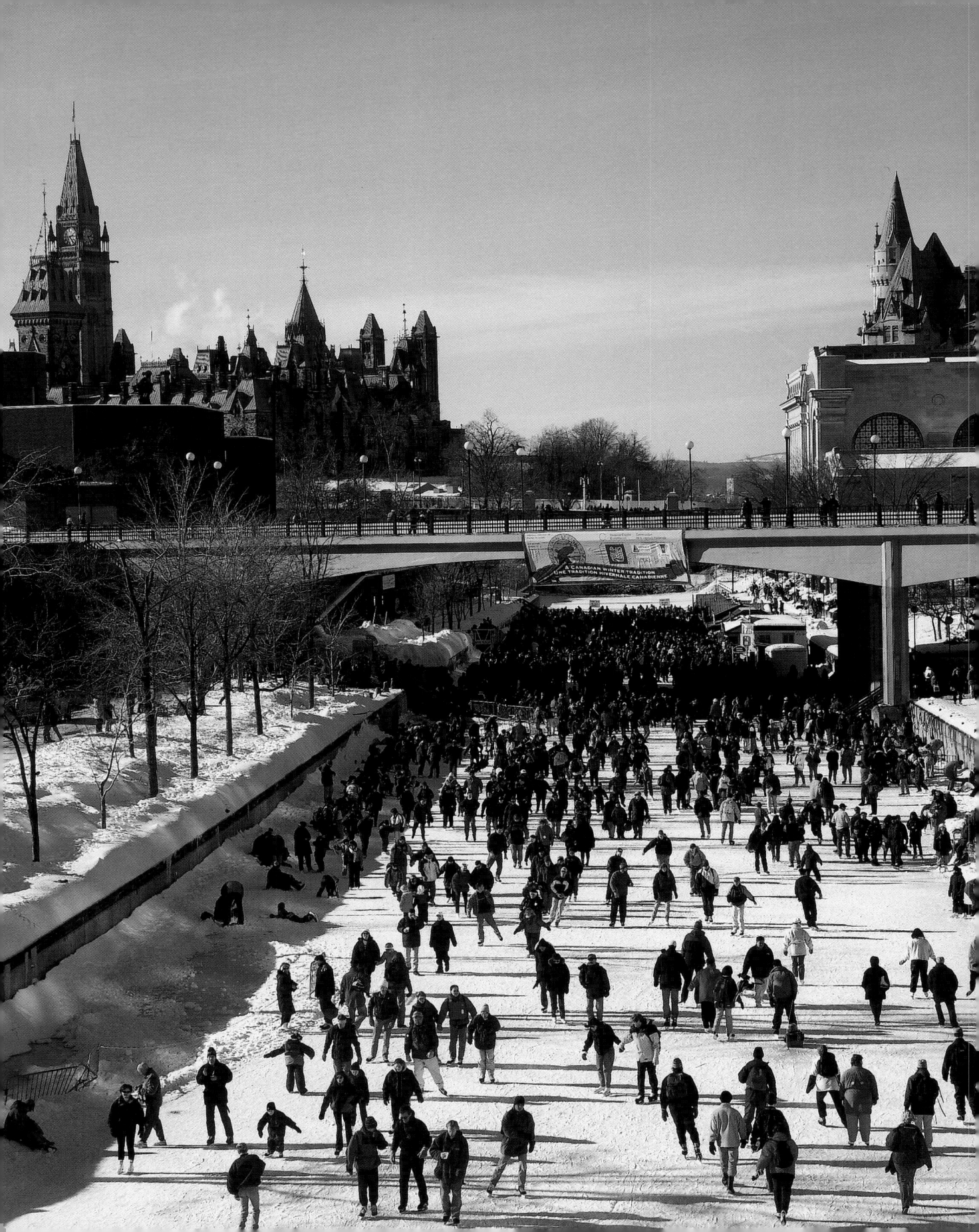

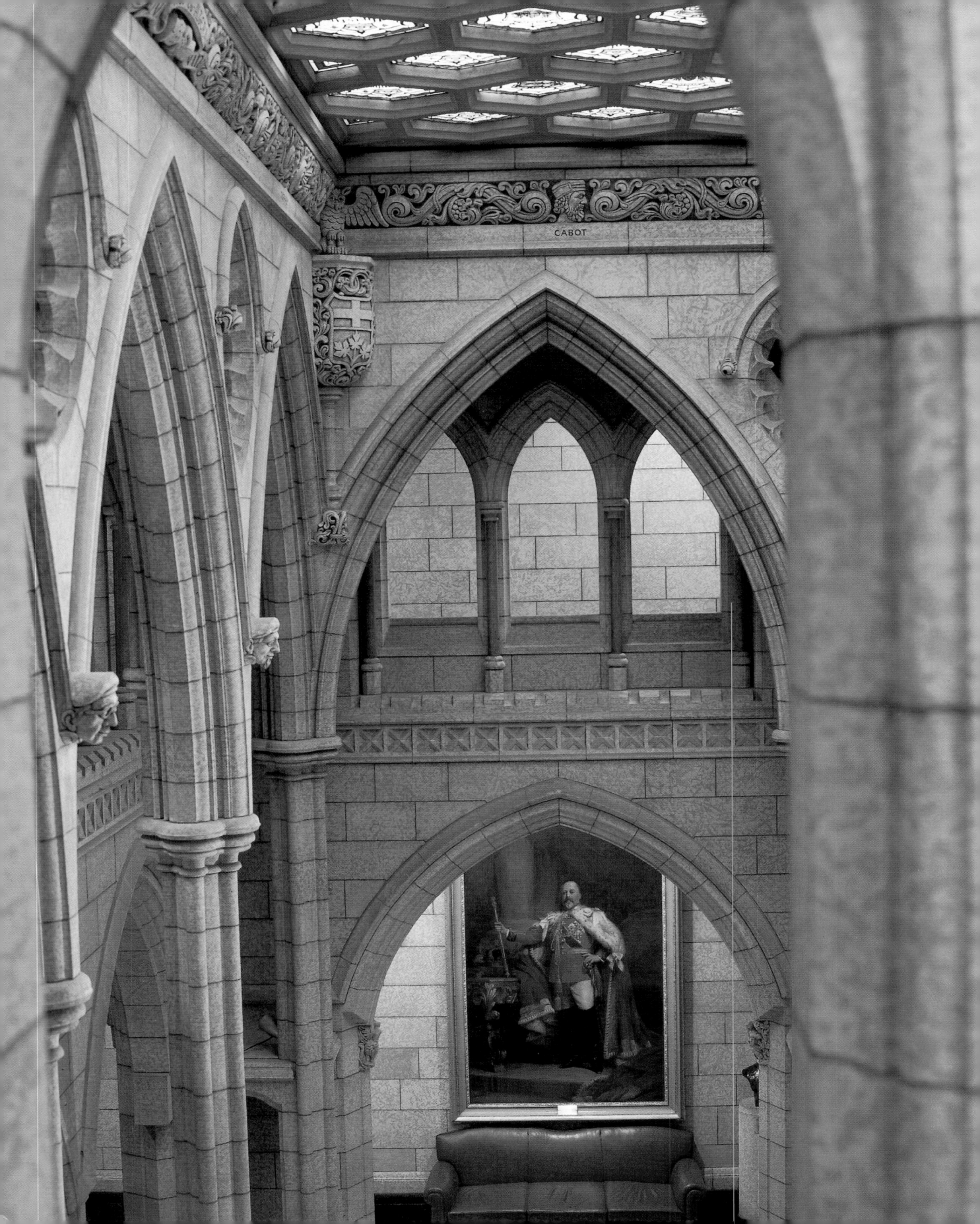

CABOT